Hard Luck Blues

Music in American Life

A list of books in the series appears
at the end of this book.

**Published in association
with the Library of Congress**

University of Illinois Press
Urbana and Chicago

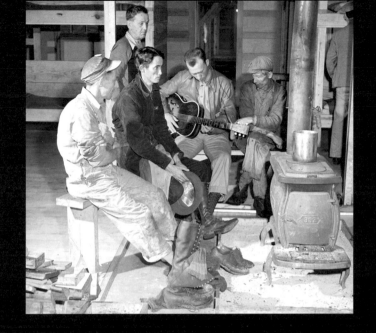

Hard Luck Blues

Roots Music Photographs from the Great Depression

Rich Remsberg

The University of Illinois Press is a founding member
of the Association of American University Presses.

Composed in Scala Sans Pro by Jim Proefrock
at the University of Illinois Press
Designed by Copenhaver Cumpston
Manufactured by Thomson-Shore, Inc.

University of Illinois Press 1325 South Oak Street
Champaign, IL 61820-6903 www.press.uillinois.edu

Library of Congress Cataloging-in-Publication Data
Remsberg, Rich, 1965–
Hard luck blues: roots music photographs from the
Great Depression / Rich Remsberg; foreword by
Nicholas Dawidoff; afterword by Henry Sapoznik.
p. cm. — (Music in American life)
Includes bibliographical references and index.
ISBN 978-0-252-03524-1 (cloth : alk. paper) —
ISBN 978-0-252-07709-8 (pbk. : alk. paper)
1. Musicians—United States—Pictorial works.
2. Depressions—1929—United States—Pictorial works.
3. United States—Social conditions—1933–1945—
Pictorial works. I. United States. Farm Security
Administration. Historical Section. II. Title.
ML87.R47 2010
779'.9780973—dc22 2009020125

Dedicated to Fred Campeau, Art Thieme,
and the memory of Will Counts

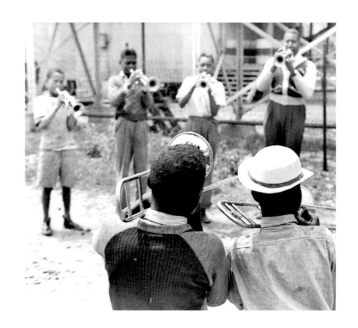

Contents

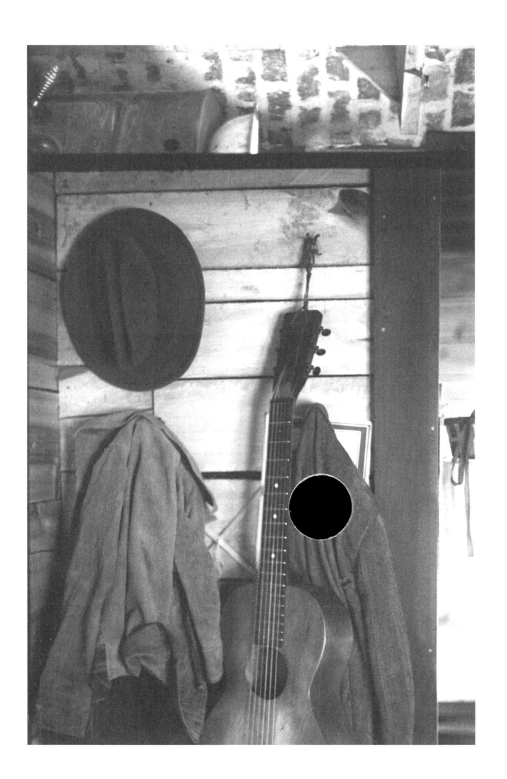

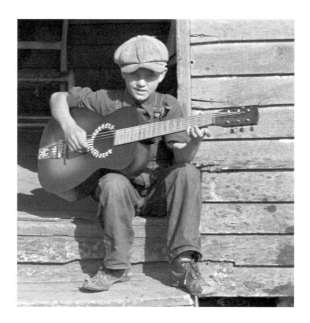

Foreword

Nicholas Dawidoff

When we think of the celebrated photographers of the big American out-there—Robert Frank, William Eggleston, Lee Friedlander, Gary Winograd, William Gedney—besides the specific images themselves, something that a person also sees in their pictures is the photographed America that came before them. It's impossible to look at any significant post-1945 series of pictures depicting the United States and not simultaneously experience the version of the nation captured through the stunning aperture of that national treasure known as the Farm Security Administration photographs.

Nothing was larger and wider than FSA administrator Roy Stryker's charge to some twenty of America's greatest midcentury photographers: Go get me the country. But fortunately, ambition runs deep in the American creative grain. From Melville to Dylan to Welles to Frank Lloyd Wright, whatever the best American artists are thinking, they tend to be thinking it epic-long and wide, and here was a case where the achievement was up to the ambition. The 170,000 photographs Stryker's team produced between 1935 and 1943 are of such profound and varied quality that you can't look at the prints without feeling removed from place and time, without thinking about the photographed United States—for an awed moment at least—in terms of Goethe's lament about Shakespeare: This is the nature of it, and for those who come after, there remains nothing more to do.

Perhaps the best way to appreciate what the FSA did is to notice what happens when somebody comes along and culls the full trove into a smaller, topically ordered collection. With *Hard Luck Blues,* the talented archivist Rich Remsberg has presented a classic portrait of American roots music during the Great Depression. But what makes his book even more impressive is that it exists as something way beyond a mere series of music photographs. It's a testament to both Remsberg and the FSA that when you have finished looking carefully at these two hundred photographs of American musicians, you believe you have seen not only the music, but the country.

Hard Luck Blues positively glimmers with astonishing images. There is a happy alchemy here in the yoking of two nonliterary forms of description—sound and picture—because more than anything else, these photographs are noteworthy for their ability to express the personality of emotion. In keeping with the hard times of that most dismal period in the American economy, the majority of these photographs portray hard-hit people: men, women, and children down on their luck, or worse. It's an old saw that says the greatest inspiration to creative beauty is scarcity, and Remsberg has the faces to prove it. Look only at the guitar pickers. There is Arthur Rothstein's Virginia squatter's son sitting in the doorway of a nearly vacant shack strumming an instrument nearly as big as he is—so big it looks like some kind of rocket that's going to lift him right out of that dreary life he's signed on for. Ben Shahn's towheaded North Carolina singing guitar boy is similarly transported by the music, soaring off into a religious rapture of tune. For Shahn's four weather-beaten black men sitting outside a hovel in Scott's Run, West Virginia, the handsome instrument one of them holds helps to dress them all up. What's more, the picker knows it. Among the collection's truly stunning photographs is Marion Post Wolcott's portrait of two Mexican immigrant children, a little girl looking up in adoration at her older brother, who is smiling down at his guitar with such joy that you'd never believe he was spending his days picking cotton on a Mississippi plantation and his nights sleeping at the railroad station. Meanwhile, Wolcott's rendition of a lanky Natchitoches, Louisiana, father with guitar and two young children holds them there in relief, each so stoic and composed that the trio might as well have been painted by Grant Wood. One could go on and on. (I got a little lovelorn watching Russell Lee's pensive girl playing her guitar at a house dance in Oklahoma!) In all cases, the image is vivid enough that instead of a bleak monochrome of Depression-era poverty, what is achieved instead is that most elusive and satisfying human condition—intimacy.

The guitar players are just the start. These American men and women with their horns and squeeze-boxes, brows heavy as they fiddle fast, singing or drumming or strumming chords on a flophouse bed, they are the American quotidian. They come from everywhere—from rural settlements to urban juke joints, from New Hampshire to California, to a remarkable stop in North Platte, Nebraska, where John Vachon caught the effect of lusty Mildred Irwin's singing on two scheming barflies. There is hot jazz in the Chicago ghetto and creaky bands in Florida trailer parks. We visit boardinghouses, main streets, blind men on the corner, ski lodges, and prisons. Always the music is at the forefront of the photograph but, much like the glimpses of the secular world shining in the background of pre-Renaissance European religious paintings, here the real story is often behind the music: on a clawed Appalachian hillside; in a shabby small-town Tennessee post office;

or over there, in that tired road across from the ugly West Virginia lawn where a fat man all in white is rehearsing his little jug band. Most of these people don't have enough, so they turn to music and it fills them up—makes them themselves.

The true beauty of this book is how much looking it can sustain. I could spend a day riding around alongside Russell Lee's Negro Musicians trying to go places with their accordion and washboard in New Iberia, Louisiana, just as I'd give a lot to sit in that immaculate Greene County, Georgia, room where Jack Delano caught Mr. Cicero Ward playing his accordion with his eyes shut beneath a portrait of a formidable woman who I imagine must be his mother.

Who doesn't love a band? Or a choir? Or a pawn shop? Or an eager hand creeping too low at a dance? Or a clown? Or a late Saturday morning in a small southern town? Here is football and patched clothing and ex-slaves and merry-go-rounds and bare feet and piano movers and convicts putting on a show for Jack Delano's camera, them shimmying right out of their state-issue striped trousers while the unseen warden nods just offstage. Here are Creoles and Cajuns and migrants and Chicago cabaret dolls. Here is the country, as it was, as it is. Those FSA masters couldn't get enough of it, and now you won't be able to either.

Acknowledgments

I began this project about ten years ago while browsing the Web one afternoon at work. The Internet was still relatively new, and as far as I was concerned there was no better use for it than to make all of the Farm Security Administration photos available online, which, I was pleased to discover, the Library of Congress had done.

Looking through page after page of images, many of them unpublished outtakes, was exhilarating. I printed a few of the unknown music-related shots, made a stack on my desk, thought about them a little, scribbled down a few notes, found some more pictures, more notes, looked more diligently. Eventually that evolved into this book, and along the way I had the help and good company of many people.

My first thanks must go to all involved with American Memory and the Prints and Photos online catalog, especially those with the vision to initiate what was a pioneering digital effort. I think one of the most remarkable virtues of this book is that I was able to do nearly all of it from my desk. My hope is that this sort of project is what you envisioned by making the collections available in this way.

Nan Brewer was also helpful early on, letting me look through the FSA prints in the Henry Holmes Smith Collection at the Indiana University Art Museum, not to mention relating stories about her family in the FSA town of Ambridge, Pennsylvania.

Another public institution making this book possible is C/W MARS, the outstanding

interlibrary loan program in Massachusetts. My thanks go to the staff of the North Adams Public Library for handling my many requests for books, CDs, and microfilm.

At times I have been frustrated with how long this book has taken to complete. The benefit to such a long gestation, however, is being able to make use of the information I gleaned from the FSA books that came out in the meantime. Building on the priceless foundational work of John Cohen, F. Jack Hurley, Beverly Brannan, Carl Fleischhauer, Hank O'Neal, Alan Trachtenberg, Robert L. Reid, and Larry A. Viskochil, I am grateful to have been able to draw upon the outstanding work of Maren Stange, Nicholas Natanson, Michael Lesy, and Miles Orvell.

The list of music scholars is far too long to acknowledge individually, so I offer this class-action thanks. They are a dedicated lot, whose focus and determination I find amazing.

Judy McCulloh is an editor above and beyond the call. This book began with her and ended up with Laurie Matheson. As an editor she is outstanding, and I deeply appreciate all she has done and how she has done it. Additional thanks to Tad Ringo, Cope Cumpston, and the rest of the crew at UIP.

I have had dinner with Jim Stone only twice, but each occasion has had a profound impact on me. Without his encouragement for this project, it would be nothing more than a pile of lo-res printouts sitting on my shelf. Thank you, Jim. I'm looking forward to our third dinner, which is on me.

Once the project was off the shelf and onto my desk, Andrea Barrett helped me wrangle my piles of music-trivia gibberish into something useful. In offering my thanks, my words are, once again, inadequate.

For reading drafts, looking at stacks of pictures, fruitful conversations about music and history, offering encouragement of various kinds, enduring my enthusiasm, and getting me out of the house when I needed a break, I am deeply grateful to Ben Anderson, Sam Bartlett, John Bealle, Jo Burgess, Joe Byrne, Cass Cleghorn, James Combs, Bruce Conforth, Jim Craig, Paul DeJong, Marc Fields, Rob Fischman, Peter Frumkin, George Goehl, Barry Goldstein, Garry Harrison, Meagan Hennessey, Janne Henshaw, Jim Johnson, Chris King, Steve Krahnke, Dave Lachman, Aida Laleian, Steve Levin, Dot McCullough, Rich Martin, Rick Nagy, Jim Nelson, Bob Orsi, Bruce "Utah" Phillips, Eric Rensberger, Shawn Rosenheim, Catherine Rymph, Steve Sauve, Ali "Amos Moses" Shashaani, Jim and Karen Shepard, Scott Southwick, Pete Sutherland, Elijah Wald, and Nick Zammuto.

Chris Smith has been involved in this book from the beginning, helping to shape it, answering technical and historical questions, and having good talks generally, and for this deserves special thanks. As does Hank Sapoznik, not only for writing the book's afterword but also for many sharp insights, being a solid sounding board, and engaging in discussions on all things folk revival.

Rich Markow has been turning me on to and teaching me about great vintage music for thirty years. Staying at his house is like sleeping on a hide-a-bed at the Library of Congress. His staggering knowledge speaks for itself, and his deep, genuine enthusiasm for the material and his eagerness to share it is a rare generosity.

Another experience that is like visiting the Library of Congress is visiting the Library of Congress. I am grateful to the staffs of both the Prints and Photographs Reading Room

and the American Folklife Center, especially Jan Grenci and Todd Harvey, for their expertise and untiring helpfulness. From beginning to end, Carl Fleischhauer was involved in several ways that I know of, and probably more that I don't. As much as I have appreciated the efforts of Helena Zinkham, Ralph Eubanks, and their staffs, they acted with such professionalism that I hardly knew how much work they were doing until it was done. This project would not have been completed without them. Peggy Bulger and Nancy Groce hosted a symposium on the seventy-fifth anniversary of the New Deal that allowed me to refine the manuscript in some necessary ways. David Taylor acted in his official capacity as head of research and programs at the American Folklife Center; even more important, he's good company out in the field, and he knows where the best flea markets are.

For me, the most exciting part of the book was doing the detective work to identify subjects who appear in the photographs. The network of people involved in this effort is huge and varied. It involved long memories from Provincetown to the Pacific, musicians, historians, local historical societies, reference librarians, and family members. It is another area where there are far too many individual people to thank publicly, but I will do my best to do so privately. I have a profound gratitude for all who helped. You make my work not only possible but invigorating.

I am grateful to Jonathan Shahn for being generous with his time and his insights into his parents' lives. I am likewise grateful to Mike Seeger for his insights into his parents' lives as well as those of the Shahn family.

When I began this endeavor, I thought I had a pretty good grasp of the history of American music. In the course of working on it, I came to realize just how vague much of that knowledge was. I appreciate being able to draw on the facts and understanding of people who really know the music well, especially Dave Baas, Kerry Blech, Raoul Camus, Joyce Cauthen, David Greely, Ann Allen Savoy, and Jenny Vincent. They and others occasionally disagreed with me on points of fact or interpretation, so where I have it wrong, they should be considered absolved of responsibility.

Likewise, I acknowledge my photo pals, with whom I've had good conversations about the FSA and other aspects of photography over the years: Doug Benedict, Sarah Burns, Yara Clüver, Robb Hill, John McDermott, Mark Murrmann, Kent Phillips, Sam Riche, Dan Schlapbach, and Ruth Witmer. For many reasons, I am sad that Will Counts did not live to see this book. I'm sure he was the person who first introduced me to the work of the FSA. Will grew up on a Resettlement farm in Arkansas, and it was probably his story about sneaking off at night to spy on his parents at the local barn dance, where they played covers of Bob Wills tunes, that planted the seed for this book in my mind.

Both of my parents, Chuck and Bonnie Remsberg, exposed me to good music when I was growing up—my mother mostly folk, my father mostly country. There is little in my life that hasn't been colored by that. Thank you.

Growing up, my sister, Jennie, and I spent hours in her room spinning the worst 45s of the '70s on a cheap portable record player. I've never enjoyed listening to music more.

And, of course, for listening to music most civilians aren't subjected to, hauling boxes of 78s to the truck, watching *Hee Haw* (and actually liking it), and offering encouragement, insight, humor, and living with me for all that entails, my deepest love and gratitude goes to Lisa Nilsson.

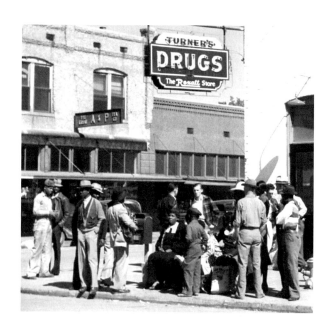

Introduction

On a Saturday afternoon in 1939, Marion Post (later Marion Post Wolcott) was taking photographs in Belzoni, Mississippi. She made exposures of the rows of cars and horses at the town center, the offices of the local cotton cooperative, crowds watching an itinerant salesman working from the back of his truck, and in what would become one of her most famous images, a man climbing the stairs to the "colored entrance" of the local movie theater.

She also shot six frames of the street corner in front of Turner's Drug Store, where the dissipating crowd revealed a small man with a guitar playing to the passersby for change. In the course of about a minute, she created perhaps the clearest and most dimensional existing photographic record of a Mississippi Delta blues musician plying his trade. And it was a fleeting thought while on assignment for an obscure government agency charged with bettering agricultural conditions.

Her photos, along with the others in this book, were culled from the collection of the Farm Security Administration (FSA), a New Deal initiative that went well beyond its mandate of helping needy farmers and created a legacy as the storyteller of the Great Depression. The FSA has conveyed to all subsequent generations not only the facts of the era but also its textures, its emotions, its complexities, and sometimes its ironies.

This collection comprises what is almost certainly the best visual documentation of vernacular musical performance during this time, a period so vital to the development and identity of American music.

In our contemporary imagination of the Depression, with the wheat fields waving and the dust clouds rolling, music and the documentary aesthetic are inextricably linked. Woody Guthrie is the most immediate example, but it reaches far beyond that. Bob Wills's "Dusty Skies" is as vivid as a newsreel and as plaintive as a diary, and it is hard to find a more stark articulation for feelings of the time than the Carter Family's "No Depression in Heaven." Even in popular music, cutting through all of Tin Pan Alley's dreams and castles and moonlight, "Brother, Can You Spare a Dime?" endures as perhaps the most powerfully iconic emblem of the era.

During this time, photography also flourished as never before. At the heart of most documentary photography lies a tension created by the human inability to adapt to an industrial society. Whether the subject is rural poverty, drug addiction, victims of mercury poisoning, or living in the shadow of the bomb, a good deal of the tradition's eloquence stems from this dissonance.

In the thirties, when the failures of industrial society were writ large, documentary photography reached a flash point. Margaret Bourke-White and Erskine Caldwell published their landmark book, *You Have Seen Their Faces;* James Agee and Walker Evans created the work for theirs, *Let Us Now Praise Famous Men;* the Photo League was established; the launch of *Life* magazine marked the first of dozens of American mass-circulation

photo magazines; and individual photographers, including Bernice Abbott and André Kertész, worked in—and defined—the documentary style. Fueled by improving camera technology and often by political ideology, all of these photographers built on the tradition begun by Jacob Riis and Lewis Hine to show "how the other half lives."

Outstanding among documentary photography of this period—indeed of all time—is the work created by the Historical Section of the Information Division of the Farm Security Administration. It was the most ambitious and, arguably, the best photographically.

More than that, the body of work created by the FSA became the foundation of our visual vocabulary, not only of the Depression but also to a large extent of our national character and mythology. It is the bedrock on which we base our belief, well placed or not, that at the core of American nature are grit, resourcefulness, determination, endurance, and a belief in democratic values.

It was a perfect storm of sorts: portable camera technology and political impulse met the right amount of psychological tension, a flattering national self-image, textures that look good on black and white film, and men's hats that provided reliable compositional elements. And perhaps there is something of Stephen Crane's creature in the desert, who explained about eating his own bitter-tasting heart, "I like it because it is bitter, and because it is my heart."

The FSA began as the Resettlement Administration (RA), a New Deal plan designed to ease poverty among farmers and sharecroppers through a combination of loan and cooperative farming programs and the establishment of model rural and suburban communities. When the RA was reorganized in 1937, it was renamed the Farm Security Administration.[1]

It its helm was Assistant Secretary of Agriculture Rexford Tugwell, who created the Historical Section to document for Congress and the public the need for the agency as well as the work it was doing. He named his former Columbia University teaching assistant, Roy Stryker, to run it.

Stryker was a great believer in the power of photography, and, with the opportunity, he built a formidable program. It was not the only government agency to commission photography—most federal agencies used photos in the 1930s—but it was the most distinctive.

"It was our job to document the problems of the Depression," FSA photographer Arthur Rothstein explained, "so that we could justify the New Deal legislation that was designed to alleviate them."[2] So the photographers showed soil erosion and other environmental effects that resulted from farming marginal land and the misuse of fertile land. More important, they recognized the persuasive value in photographing the effects these practices and conditions had on people, and they began also to cover slums, fruit pickers, foreclosure auctions, and destitute people camped along the road.

Stryker envisioned a comprehensive photographic index of American life, a "contemporary visual history," as Bernarda Shahn, the widow of FSA photographer Ben Shahn, described it, "which would be directed toward the documentation of rural poverty and want."[3]

John Collier, the last photographer hired at the FSA, later reflected, "For Stryker documentary photography was not about propaganda or even politics. Stryker was first and last a social geographer and historian. He seized the FSA opportunity to look at the American earth, its rivers, valleys, plains, deserts, and vast western mountains. Artistically and academically Stryker wanted to assemble a model and each incoming picture was another unit in the puzzle that when assembled was the most sweeping record ever made of the American earth and culture."[4]

Over the course of roughly seven years, Stryker hired and dispatched a crew of photographers around the country to create this visual record. There were many involved, but the best-known names are Walker Evans, Dorothea Lange, Russell Lee,

Arthur Rothstein, Ben Shahn, Marion Post Wolcott, John Vachon, Carl Mydans, Jack Delano, and John Collier.

The result of their efforts is "the file," an estimated 120,000 frames of hundreds of towns and farms in every state and Puerto Rico.[5] Many of the images are thoroughly familiar to most Americans, if not the world, most notably Dorothea Lange's *Migrant Mother* and Arthur Rothstein's *Dust Storm*. To a great extent, "the file" did become the great American index Stryker had hoped for.

Because of its vastness, in recent years the collection has been combed and interpreted to look at a variety of subjects, including children, medicine, African Americans, religion, many of the states, and even a few cities and neighborhoods. Stryker and the photographers were not necessarily going after those subjects per se; it's just that their coverage of regular American life was so extensive and the quality of the photography so high that there is enough material to factor out photos along any number of thematic lines.

In the seven years the FSA was in operation, photographers came and went, and political conditions—internal and external—shifted, but the essential idea stayed the same: to photographically document the regular lives of regular Americans.

Largely because of what we usually see of the FSA, we remember the 1930s in bleak images: dust storms, bread lines, hungry migrant workers, drought-beaten farmers. It was a dark chapter, painful, lean, and for some, shameful. However, it was also a remarkable point in history when some beautiful moments happened as the Old World met the New.

Franklin Roosevelt issued the executive order that created the Resettlement Administration in 1935. It coincided with a unique moment in American musical history.

Nineteen thirty-five was a year when American music was defined as much by the Carter Family and Gene Autry as it was by George Gershwin or the end of the Harlem Renaissance. The year stood in the shadow of roots music's creation myths that took place in the late 1920s: Jimmie Rodgers and the Carter Family at the Bristol Sessions, Louis Armstrong bringing jazz up the Mississippi, and Lloyd Loar's perfection of instrument construction. The period had a few creation myths of its own, from the pure wandering spirit of Woody Guthrie to Robert Johnson's trip to the Crossroads to the invention of the electric guitar.

The mid-1930s was also the moment when the peak of vitality, or in some cases the last vestiges, of a number of musical traditions met the impulse and technology to document them. Along with the phonograph, photography was prominent among the means to do so, and like the folklorists of the era, it was to the vernacular situations that the FSA photographers were drawn.

Consistent with the agency's editorial line, the photographers had a directive to avoid celebrities and focus on average people. Stryker prided himself on the fact that the entire file had only one shot of Franklin Roosevelt. It isn't true, but it still says a lot about the prevailing attitude.

There are very few shots of sophisticated jazz clubs or opera, none of the Benny Goodman Orchestra, Stravinsky, Toscanini, or Copland. The photographers were attracted

to the amateur and the local. Among other things, they photographed the last of the generations to have learned without the influence of recorded sound, rustic characters scratching out war-horse fiddle tunes on homemade instruments and blind blues singers working the weekend crowds. Because no time is simple or static, the photographers also worked at a point when the documented record began, in turn, to have a significant influence on traditional music, and whole new types of music were being born.

The documentation found in the FSA photographs provides a rich picture of American vernacular music, and it was created by a means somewhere between coincidence and design. The photographers were not especially concerned with music as an area of focus. In many cases, these photographs are one-shots among larger series of living conditions or downtown happenings.

Astonishingly, when Stryker and sociologist Robert Lynd drew up an early set of field guidelines for the photographers, other than a passing reference to bandstands on the town square, they made no mention of music or musicians, although they did cite nearly everything else from cigar cases to fire escapes as being culturally evocative and significant.[6] Nevertheless, photographs of musicians made their way into the FSA file in three ways, of varying degrees of relevance to the objectives of the Farm Security Administration.

The first way was fairly direct and involved documentation of the Resettlement Administration music programs. In November 1935, the RA hired musicologist Charles Seeger to develop music programming designed to alleviate community tensions and foster a spirit of working cooperatively for common goals. In keeping with Seeger's political and musical attitudes, the program emphasized folk music and community bands over classical music, with the original plan calling for thirty-three musicians to work in three hundred Resettlement communities within six months.

Although that plan proved overly ambitious, quite a lot did get accomplished, including a good deal of song collecting and the establishment of a small number of music and dance programs. The music unit, however, did not last beyond the agency's reorganization in 1937.

A second occasion for photographing musicians came in the form of the photographers gathering general images that demonstrated need—or progress—in various FSA communities or in conveying the cultural and economic conditions of surrounding areas. Music, being part of that world, was sometimes included.

Finally, Stryker usually allowed a great deal of interpretive latitude in the photographers' assignments and encouraged them to shoot whatever they felt was important or

caught their eye, especially as the project grew and he became increasingly interested in creating a comprehensive photographic index to American life. Again, "roots" musicians, as part of the vernacular landscape, sometimes caught their eye.

In this process, the FSA conveyed a powerful sense of the Old World vanishing: the last generation to learn without sound recording, and street musicians, band concerts, and barn dances that were seen as archaic even then. Their ostensible mission was to photograph a rural population's economic difficulty, one that anticipated great change, and that lent itself to images of the homespun, the old-fashioned, and the obsolete.

But there is more to it than that. By its nature, documentary photography has an affinity for preservation, if only by means of the photographic record. Intellectually, this point of view can be understood to have elements of past, present, and future. Emotionally, as often as not, it carries the recognition of an inextricable relationship among beauty, sadness, and loss—what Richard Doud referred to as "the business of deterioration."[7]

With a concern for things on the verge of disappearing, the FSA was interested not only in subjects' aged-but-still-living traditions, but also in the historic reach of those traditions. John Dyson, the former slave whom John Vachon photographed in Maryland in 1940 (p. 17), was part of that present that would

soon be gone, and with it the past he carried with him. If he learned tunes from older people when he was young—not an unreasonable assumption—how far back does this reach go? The 1830s? The 1700s? The accordion was invented in the 1820s. How close to the first generation of players was he? Sadly, in this case, we don't know, but this and other photos do present a wealth of implicit information and intriguing questions.

If this was a period of recording the native music traditions, it was also a period of these recordings beginning, in turn, to have an unprecedented influence on the ways people made music. Although the sheet music of Tin Pan Alley affected folk traditions more than has been generally recognized, the advent of phonograph records and radio increased that influence exponentially, especially during the period the FSA was in operation.

"It was one thing to hear Roy Acuff on the Saturday night Opry," Colin Escott writes, "it was quite another to have his records and learn every nuance." He adds, "They [records] made it possible for Arthur Smith, Zeb and Zeke Turner, and Hank Garland to grow up in rural South Carolina and to study Django Reinhardt and Eddie Lang. Records cross-pollinated music with a speed that was unthinkable before their arrival."[8]

That's very true. And if we consider that even radio was still a relatively new development at that point, we see an even larger change in effect. Musicians went from

hearing only the performance of live music, seldom if ever from outside their limited geographic regions, to having the presence of radio *and* records, and that difference is a stunning one.

Robert Gordon describes this change nicely:

> Before the jukebox and way before blues radio, the way a person played a particular song could reveal the town or plantation where they'd learned it. Musical styles—indeed whole cultures—had been quarantined. Itinerant musicians, like birds dropping seeds, carried songs and styles; music was a communal experience shared through live performance, and techniques were exchanged through personal interaction. The popularization of recordings as a medium broadened the listener's horizon of experience; standing before a jukebox, one could be exposed to twenty different artists and styles, and a week later, twenty more. . . . Regionalistic traits began a slow melt into the national pool.[9]

New World or Old, these musicians were all the kind of regular Americans Stryker was after, especially with this sort of generational adaptation and continuity. The FSA, along with the Lomaxes and other folklorists, was part of a larger trend that attempted, in Joe Klein's words, to "rediscover 'the people' as a source of creativity."[10]

Throughout the project, Stryker's central rhetoric was that the people affected by the Depression were simply good folks down on their luck. They just needed a little boost and understanding, and the strength and virtue of the American people's character would endure and ultimately triumph over the hard times of the Depression.

Stryker drove his staff to produce the kind of images that would reflect and address that. At the outset, he was mainly concerned with demonstrating need: the direst of farmers, the greatest failures of our system, the alarms that could not be ignored. As the New Deal progressed, the file more heavily emphasized a story of encouragement and progress made. Stryker wanted pictures that showed people's resourcefulness and worthiness, not just their dependency, and that FSA programs were indeed working.

By the time Arthur Rothstein made his photographs of the string band at Visalia, California (p. 123), he was under specific instructions from Stryker to "show more positive images of the farm workers' camps." Even before that, when Marion Post joined the staff in September 1938, Stryker's instructions to her included, "get more photographs of the positive side of the FSA program and something different for the exhibits that could be used to contrast with other photographs; to show something other than the 'lower third' of the country."[11]

Most historians of the FSA have pointed out that the Depression brought with it a kind of national identity crisis, one that prompted a search for roots and rootedness, for native strength, for innate qualities of stalwart perseverance. This wasn't really a new idea in American mythology, but it did take on added intensity and focus.

"[There was] a widespread realization," Joe Klein writes, "that the American people were surviving the Depression without going completely haywire; that many had relied on resourcefulness, wit, and sheer willpower to get by; and that only an extraordinary people could suffer such hard times so extraordinarily. There was a growing sense that the victims of the Depression, those who'd suffered and survived, were special . . . perhaps even *superior* people; much could be learned from them. Intellectuals who'd sneered at small-town America throughout the cynical 1920s were awestruck by its resilience now."[12]

Stryker's vision fed this appetite for reassurance of rooted tradition and, despite all the upsets, the sense of an ancient, unchanging way of life.

Shelby Foote has suggested that the Civil War was the great adolescent trauma of the nation. If we see the Depression as the adolescent trauma of the twentieth century, perhaps it is worthwhile to point out that like adolescence, America dealt with the Depression largely by listening to its own music, and in doing so, established its own identity, one of cowboy, hillbilly, and other native archetypes in country music as well as the interracial and immigrant makeup of swing and jazz. Many folklorists, including the Lomaxes, Anne and Frank Warner, Zora Neale Hurston, and Herbert Halpert, began their most engaging work during this period, and John Hammond held his historic Carnegie Hall concerts, *From Spirituals to Swing*.

Is it any accident that around this same time, such artists as Edward Hopper, Thomas Hart Benton, and Grant Wood were creating an analogous American school of painting, or that parallels are to be found in literature, classical music, dance, and the other arts? It was when American culture found its own voice. So if Stryker was not interested in music specifically, he was profoundly interested in culture, especially the homegrown culture of the people.

Images of musicians date to nearly the beginning of photography, appearing in some of the earliest daguerreotypes. What makes those of the FSA remarkable? Aside from their timing, they are outstanding for their scope and style, which make them unique photographically and ethnographically.

The 1930s marks the beginning of a widespread photographic aesthetic that depicts situations in a way that we consider "real." Standing on the shoulders of such earlier photographers as Lewis Hine and Paul Strand, documentary photography of the 1930s—especially the FSA—moved away from romanticism and fostered an unprecedented sense of naturalism that was at once visually strong, had a remarkable degree of transparency (the photographer didn't get in the way of the picture), and could be read at multiple levels.

Technically, the photographers favored natural light. When artificial flash was used, it was plain, neither gimmicky nor imposing an artistic elegance. Likewise, on the occasions when situations were staged, they were done so in a way that strove for a re-creation of circumstances that did occur naturally.

The photographs had a point of view and compositional style that conveyed factual information without being stripped of emotional depth. They were intelligent pictures with feeling.

Lewis Hine and Jacob Riis both took pictures of musicians that are valuable ethnographic records as well as excellent photographs. But there are only a few. Extensive as their work was, they did not work at the same scale as the FSA.

When Doris Ulmann photographed Appalachian musicians in the 1920s and '30s, she gave us a record of something no one else did, and there is worthwhile ethnographic information contained in her pictures. But the contrived staging and dreamy pictorialist

style make for a presence that is so overwhelmingly that of a Park Avenue aesthete that the documentary value is hampered, and often misleading.[13]

The FSA shot with an unequalled sense of what we would consider realism as well as a great deal of compassion, which is different than honorific admiration or patronizing elevation. As F. Jack Hurley writes, "During that period the camera emerged from the idealized situations of the studio and entered the reality of the streets."[14] Their pictures were plain. Walker Evans, paradox that he was, created the most elegant photographs in the file, images laced with cynicism and lyrical beauty, but it was an elegance and cynicism based on—and never straying from—fact.

Stryker did a lot to educate the photographers, drawing up guidelines with Lynd, assigning them readings of treatises on cotton, and so forth. The photographers were all intelligent, but they shot from the heart, with tremendous feeling.

Also contributing to the FSA's sense of naturalism—and effectiveness—is the level of intimacy the photographs achieve. Where chauffer-driven Ulmann made photographs that suggest her interaction with her subjects was no more than was necessary to obtain her negative, the FSA body of work reflects a much warmer familiarity. There is a sense of the photographers (and thus the viewers) being invited into people's homes or working alongside them in the fields and cafés. Their street scenes have the living feel of a public place.

There is also an element of dignity to be considered. So much of documentary photography, particularly the FSA, concerns itself with the wretched desperation of the rural poor—the "perfect victims," in Lawrence W. Levine's words, describing both the desperation and the convenient categorization of people.[15]

Doris Ulmann, *Group of Four Kentucky Mountain Musicians, including African American Fiddler.* Rare Book, Manuscript, and Special Collections Library, Duke University.

The photographers were on assignment to seek out examples of the direst poverty, and the backbone of the file is made up of dirt floors and broken cars and underfed children. The family at the Nipomo Valley Pea Picking Camp in Dorothea Lange's *Migrant Mother,* for example, had just sold the tires from their car in order to buy food. They were living in a lean-to and surviving on vegetables from the surrounding fields and birds the children had killed.[16]

In Joe Klein's description, "occupancy was limited and, for the rest of the migrants, the FSA camps were a reminder of how awful their own lives were. To make matters worse, the government sent around photographers to record the Okies in their misery. The migrants scavenged their last shreds of dignity for the cameras, straightened themselves up and stared proudly into the lenses; their gaunt, Scots-Irish stoicism, in the face of having lost the farm and being tricked into the orchards by a handbill, was recorded for posterity."[17]

Stryker and the photographers were sensitive to this and made efforts to ameliorate it by showing people's dignity and dimension. In contrast to the FSA, F. Jack Hurley describes Erskine Caldwell's and Margaret Bourke-White's *You Have Seen Their Faces* by saying, "the writing aspired to objectivity. On a deeper level, however, the book was exploitative. The photographs, and the writing as well, often descended to a level of taste that would have been foreign to FSA photographers. . . ."[18]

On the other hand, Dorothea Lange, it has often been pointed out, frequently worked with a point of view of looking up at her subjects, providing a sense of respect, often heroism. Beyond that, as William Stott writes, "Everyone in her portraits has character; nearly all are handsome. Yet—such is her greatness—few are simple."[19]

For the most part, the FSA photographers were genuinely and deeply compassionate toward people and showed tremendous sensitivity to situations. Still, there was a great challenge for the photographers: how to convey dignity among such thoroughly beaten-down people.

Showing people in a social context has a tremendous humanizing effect. It might or might not have been done deliberately, but including the humanizing musical aspects of their subjects' lives goes a long way to stand in contrast to the steady drumbeat of defeat.

The FSA photos struck a unique tone. In F. Jack Hurley's words, they demonstrated "that a picture could be beautiful and still possess a social conscience."[20] They were perhaps more anecdotal than systematic, but they have unequalled photographic depth and, because of Stryker's insistence (and the photographers' natural inclination as well), they are also sociologically and ethnographically informed.

Again, though, other than the instances of illustrating the work of Seeger's unit, music, per se, was not of interest to the project, in that they were not methodically seeking it out or supplementing the photos with specifically musicological information. However, because they knew how to effectively photograph complex situations, because the net they cast was so wide, because they produced such sheer volume, they provided a compelling and unequalled view of this unique musical time.

With the theme and variation of such a collection, another phenomenon occurs. After a while, the central presence of music becomes more invisible, and the pictures become a lens through which to view a larger sense of social history.

In 1942, a number of things changed at the Historical Section. The mounting feeling in Congress that the FSA had done its job and was no longer necessary reached a critical point. Stryker had lost his political protection, first under Tugwell and later under Will Alexander. The budget was cut, and the national mood had changed following Pearl Harbor.

The focus of the government shifted, and the narrative of the national character had changed. The emphasis was now on supporting the war effort and fostering a sense of patriotism instead of themes of enduring hard times through self-reliance.

Rather than being abandoned altogether, the FSA's staff and the file were, by the fall, absorbed into the Office of War Information (OWI), and the tone as well as the substance of the photography was different. It had been moving in that direction anyway, but now it was nearly complete.

Early that year (1942), Stryker issued a shooting script that called for "pictures of men, women and children who appear as if they really believed in the United States. Get people with a little spirit." The pictures were, for the most part, simplistic propaganda for the war effort, focusing on "shipyards, steel mills, aircraft plants, oil refineries, and always the happy American worker," John Vachon remembered.[21] This sort of photographic pep rally lacks the depth and complexity of the photographs created during the FSA years.

The music-related photos of the OWI show occasional examples of the old mood—plainspoken shots of street musicians and the like—but much more common are very clean, well-lighted pictures of recitals, patriotic music, the Duke Ellington Orchestra, Bach festivals, Interlochen music camp, ballroom jazz, and other accomplishments of "high" culture.

In addition to the patriotism embedded in such an attitude is the implication that Americans were more advanced than—better than—the Germans. Similarly, the increased representation of "ethnic" music in the OWI suggests America's self-belief in its racial tolerance, standing in superior opposition to the attitudes of the Third Reich.

Finally, Stryker was under pressure to use his office to create material emphasizing war industries and other defense-related subjects rather than the looser, more interpretive coverage of small towns they had preferred. "Stryker was often forced to compromise the intellectual honesty of his group," F. Jack Hurley observes, "when demands came in for good propaganda pictures of 'typical' industrial workers or 'typical' farmers." This was a marked contrast from the latitude of the FSA that allowed for such a rich sense of individuality.

"I know your damned photographer's soul writhes, but to hell with it," Stryker wrote to Jack Delano. "Do you think I give a damn about a photographer's soul with Hitler at our doorstep? You are nothing but camera fodder to me."[22]

Indeed, the photos began to reflect the work of photographers who were nothing but camera fodder. Gone was the passion, intrigue, perfect balance, sense of dialogue, and unself-consciousness that had once been hallmarks of the agency's pictures.

To the extent that these photos stopped Hitler from crossing the threshold of our doorstep I'm sure we are all grateful, but looking back on it today, the pictures, as a whole, are of less lasting value. There are some interesting music images in the OWI collection, like Pete Seeger singing "When We March Into Berlin" (for a short time the OWI employed the Almanac Singers, until anticommunist pressure called for an end to it), photos of Paul Robeson and Marian Anderson, and small groups of GIs playing string band instruments. Unquestionably they are of historical importance—and sometimes they are good photos. But it wasn't the same.

Stryker didn't have the same administrative freedom, there was little money, the country was changing, and the project had run its course. Like missing the decisive moment in shooting a photograph or losing the groove at a jam session, the moment had passed. It was over. Stryker and a few of the FSA photographers would work within the OWI for another year and then move on to Standard Oil, where he headed another colossal documentary photo project until that, too, ended. Some remarkable photos resulted from these endeavors, but never again would there be anything like the Historical Section of the Information Division of the Farm Security Administration.

The photographs produced under the FSA reflect the remarkable contributions made by the musicians of that period, preservers of tradition and aesthetic innovators whose influence was not only enjoyed in their own time and communities but would eventually be felt and appreciated across lines of race, nation, class, and generation.

For many years, only a relatively small number of the FSA photos were widely seen—what Dorothea Lange referred to as "Stryker's 'cookie cutters'." The photographers' own viewpoints were different and wider. These other photos, including the images of musicians, bear witness that there was more complexity to the Great Depression than breadlines, dust storms, and, well, depression.

At its best, music rises above the borders imposed by politics. I hope—and suspect—that most readers will consider the climate in which these images were created but ultimately enjoy the lasting work of these remarkable artists.

Here we have an opportunity to see people hit hard by the Depression not with pity or constructed heroism but with a real sense of appreciation. In the midst of extremely difficult lives, they created something of genuine lasting worth and beauty.

A Note on the Photographs

Because these photographs are drawn from such a large collection, a bit of narrowing was necessary. In general, I selected images for their visual quality and musicological information. I included material from the Resettlement Administration and Farm Security Administration years but not the Office of War Information. I also did not include photos from Puerto Rico. This meant leaving out many good shots and worthwhile information, but the numbers would have made the volume and scope too unwieldy for a single book.

Similarly, I did not include images of dance, audiences, and other relevant situations unless there was a visible musical reference in the frame, nor did I include nightclubs, medicine shows, convict labor, and other sociological situations that likely had musical dimensions, unless the musical component was visually confirmed.

The captions accompanying the photos are the photographers' original words. In cases where there were no original captions, I have used captions from neighboring frames and presented them here in brackets. Information at the beginning of each section draws on the FSA general captions, other period accounts, and more contemporary research (my own and that of others). I have left photographers' misspellings in the individual captions and corrected them in my text.

In identifying people in the photographs, I was, on some occasions, able to make visual comparisons with other documented photographs or worked from visual clues and identifiers from neighboring frames. Other times I relied on the expertise of people well versed in their areas of music or community history. When possible, I confirmed identifications with second opinions. My sources for the Louisiana photos were David Greely and Ann Allen Savoy; for Skyline, Roger Allen; Provincetown, Marie Taves; Taos, Julia Jaramillo.

Finally, as with any treatment of the FSA collection, one should keep in mind that the project did not begin until 1935, when the worst years of the Great Depression had passed.

Hard Luck Blues

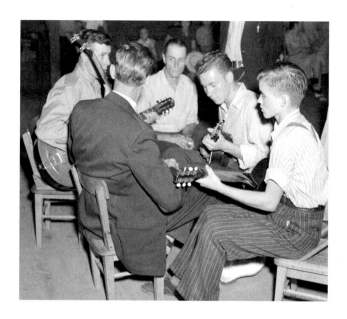

Southeast

The Southeast has always been a sort of Fertile Crescent for roots music, where folklorists and the early recording industry found many of their best subjects. In some respects this was also true for the FSA photographers. In 1937, almost certainly on Charles Seeger's recommendation, Ben Shahn attended Bascom Lamar Lunsford's Mountain Dance and Heritage Festival in Asheville, North Carolina (pp. 5–9), where he photographed a number of figures important to traditional music, most significantly Aunt Samantha Bumgarner, Ernest Thompson, and Fiddlin' Bill Hensley.

A banjo player and fiddler, Samantha Bumgarner made some of the earliest commercial recordings of old-time music and is usually considered the first woman to do so. Both solo and with fiddler Eva Davis, she cut twelve sides for Columbia in 1924. It was at the Asheville festival, a year earlier, that a young Pete Seeger first heard her play and was inspired to learn the five-string banjo.

Accompanying Bumgarner on the train trip to New York, where she made those recordings, was Ernest Thompson (p. 7, middle), a blind street musician who worked in North Carolina and Virginia, and who recorded for Columbia as well.

Bill Hensley appears in a few places in the canons of both photography and fiddle music. W. Eugene Smith included him in his 1947 *Life* magazine picture story on Ap-

palachian folksingers, the *New York Times* featured him at the center of a photo spread, and Alan Lomax photographed him at the Asheville festival in the 1940s.

He is also the subject of an early academic paper on traditional fiddle music, David Parker Bennett's 1940 thesis, "A Study in Fiddle Tunes from Western North Carolina," where Bennett described Hensley as "one of the few real old-time fiddlers left," and commented that he was free from the influence of jazz, radio, and phonographs. He cited the occasions where Hensley played as "log-raisings, corn-huskings, quilt parties, hog-killings, and Spanish War veterans reunions."[1]

Although beloved in western North Carolina as a fiddle player and colorful character, Hensley died before the folk revival could bring him much national attention. Nevertheless, the impact of his playing is significantly felt among younger players. Today tunes from his repertoire, including "Georgia Horseshoe," "Squallin' Cat," "Burke County," "Old Boogerman," and "Buckin' Mule" are played by a number of old-time fiddlers.[2]

Less well known are the details of Hensley's later life, including a 1948 drinking and shooting episode that landed him in prison. According to the *Asheville Citizen,* the incident first came to public light when Hensley reportedly walked to the home of his neighbor, Paul Alexander, and said, "Get somebody to call the ambulance, Paul. I had a little trouble up at the house and I reckon I killed a man." When the sheriff arrived at Hensley's home, he found a .12-gauge shotgun containing one empty and one loaded shell and the body of Clarence Harwood, twenty-four, slumped in a rocking chair. After a brief trial, Hensley, seventy-five, was convicted of second-degree murder and sentenced to three years.[3]

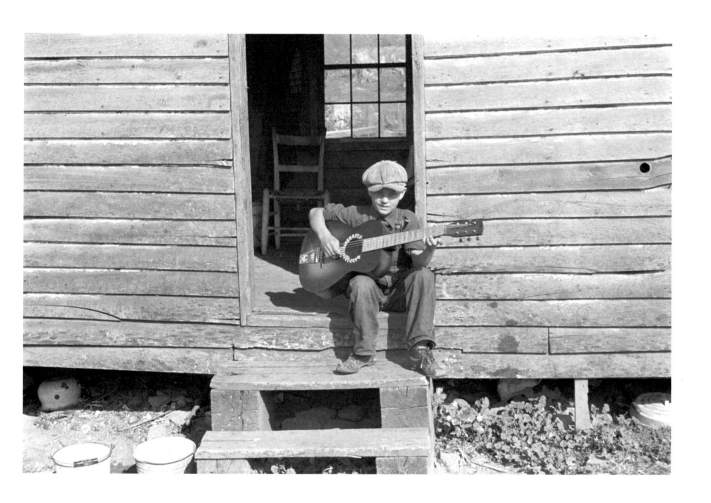

Son of a squatter. Shenandoah
National Park area, Virginia.
October 1935. Arthur Rothstein.

The family of Russell Tombs moving
out of their home, which is being taken
over by the army in Caroline County,
Virginia. June 1941. Jack Delano.

Aunt Samantha Baumgarner [*sic*],
fiddler, banjoist, guitarist, North
Carolina, Asheville. 1937. Ben Shahn.

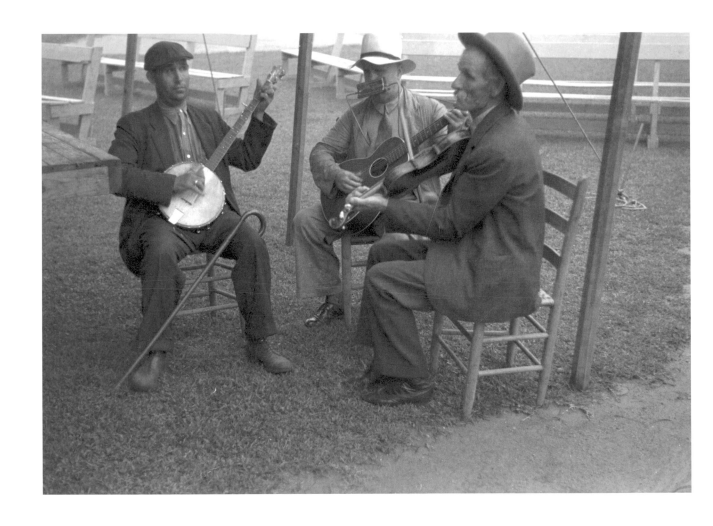

Jeeter Gentry, Elmer [*sic*] Thompson,
and Fiddlin' Bill Henseley [*sic*],
Asheville, North Carolina. 1937.
Ben Shahn.

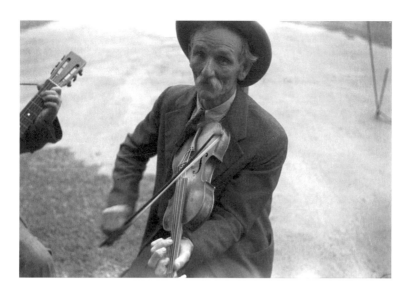

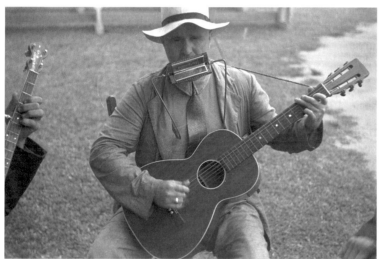

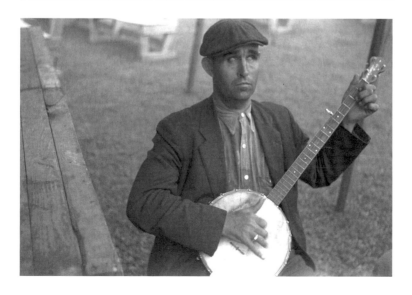

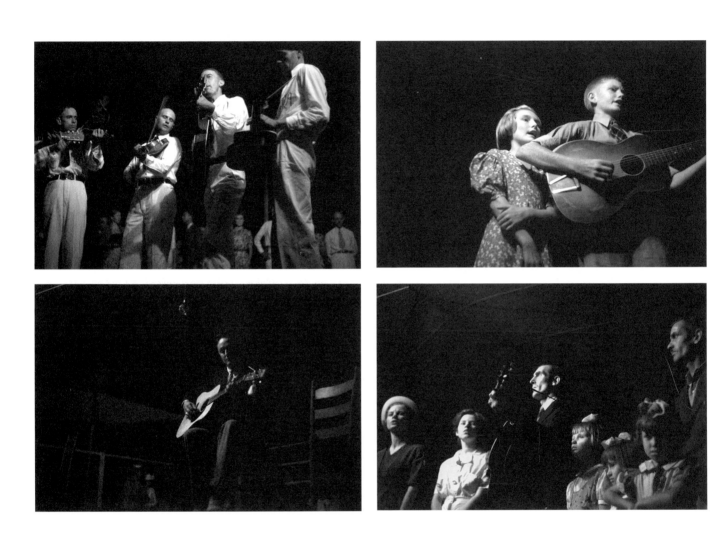

Asheville, North Carolina.
1937. Ben Shahn.

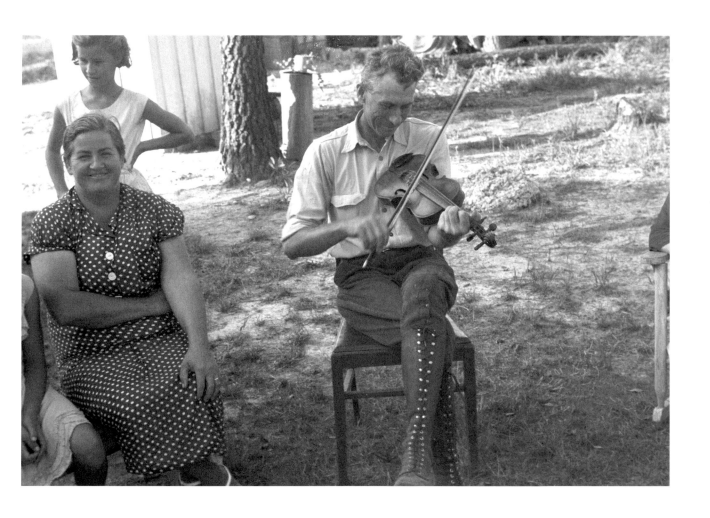

[Sunday at home, Penderlea
Homesteads, North Carolina.]
1937. Ben Shahn.

Traveling carnival at Old Trap, North Carolina. This troupe
follows the migrants around and stops where there is a large
settlement of them. A show generally consists of a band
concert and movie and vaudeville. July 1940. Ben Shahn.

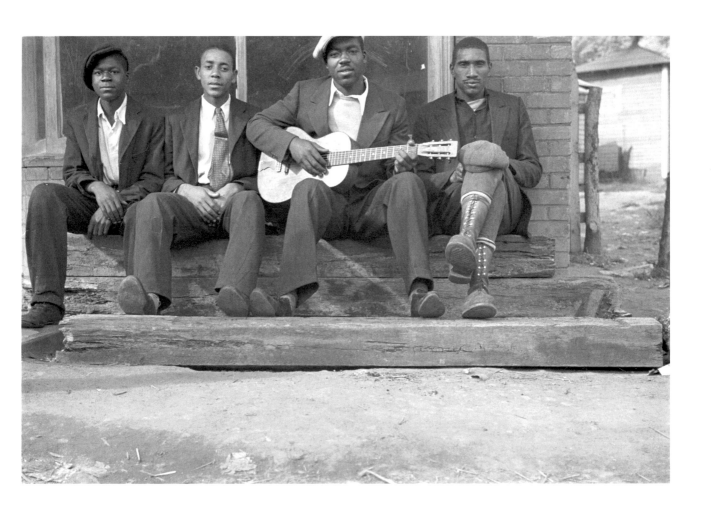

[Scott's Run, West Virginia.]
October 1935. Ben Shahn.

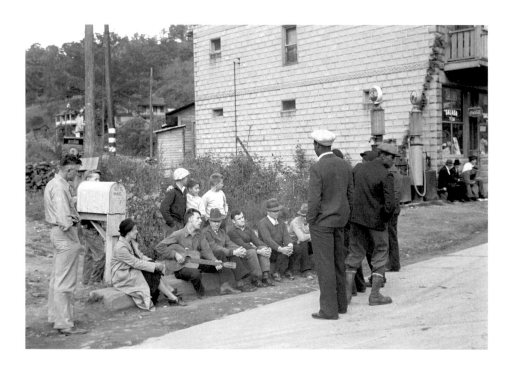

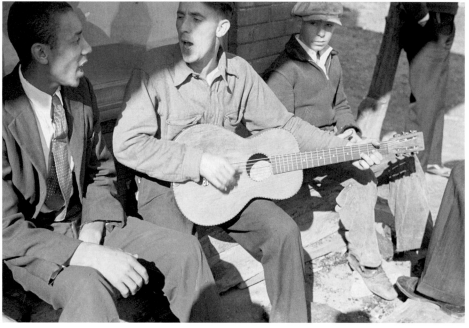

[Scott's Run, West Virginia.]
October 1935. Ben Shahn.

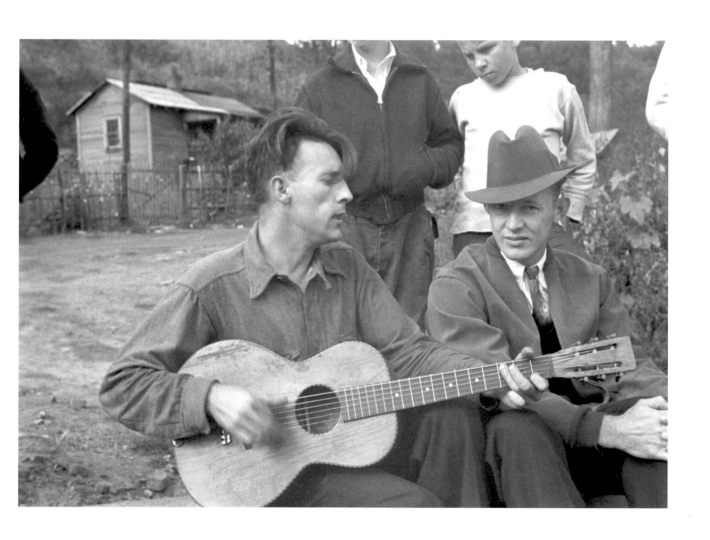

Doped singer, "Love oh, love, oh keerless love."
Scott's Run, West Virginia. Relief investigator
reported a number of dope cases at Scott's Run.
October 1935. Ben Shahn.

Leader of the Red House Band,
West Virginia. 1937. Ben Shahn.

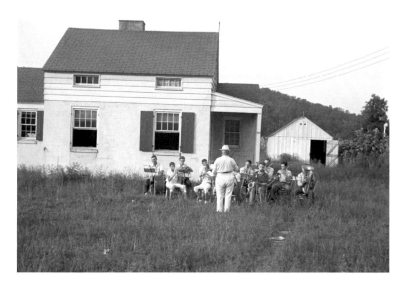

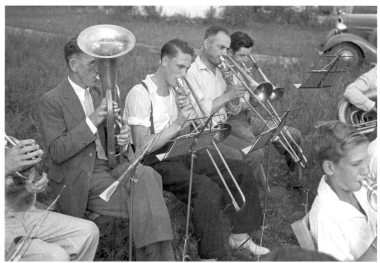

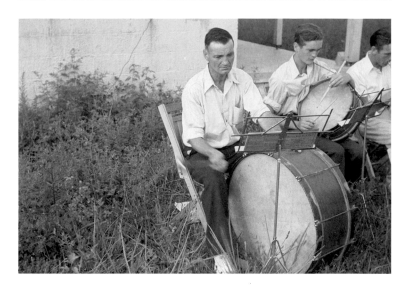

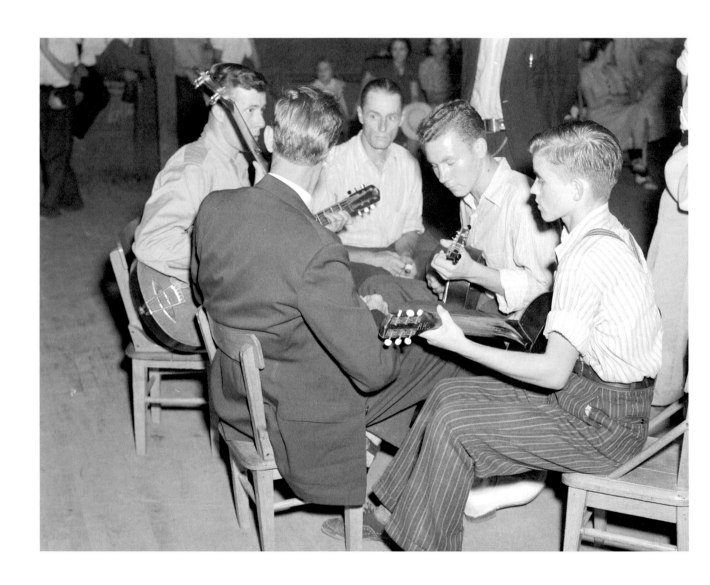

[Breathitt County, Kentucky.]
September 1940.
Marion Post Wolcott.

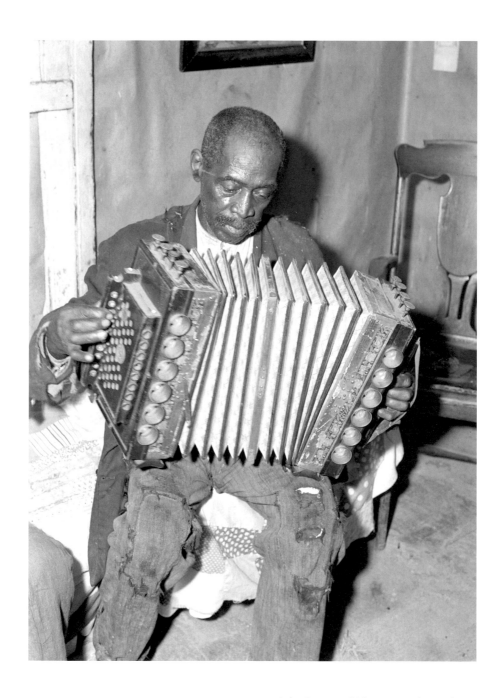

John Dyson, FSA borrower, playing the accordion. He was born into slavery over eighty years ago. Saint Mary's County, Maryland. September 1940. John Vachon.

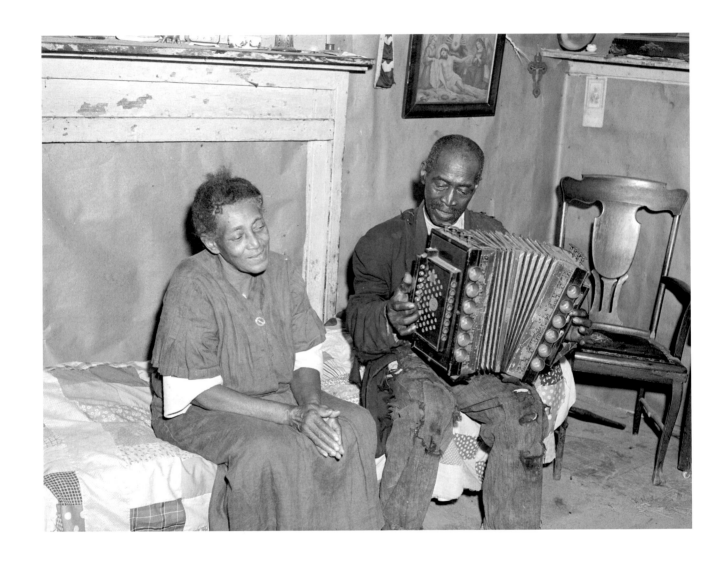

Mr. and Mrs. Dyson, aged FSA
borrowers, Sain[t] Mary's County,
Maryland. September 1940.
John Vachon.

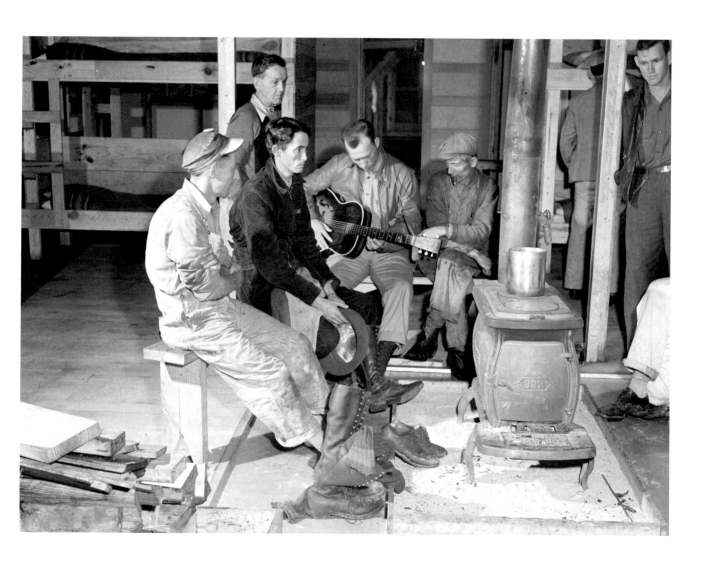

Construction workers around stove
after work in new craftsmen's
barracks, Camp Blanding, Florida.
December 1940. Marion Post Wolcott.

Singing hymns at evening service of
Helping Hand Mission, Portsmouth,
Virginia. March 1941. John Vachon.

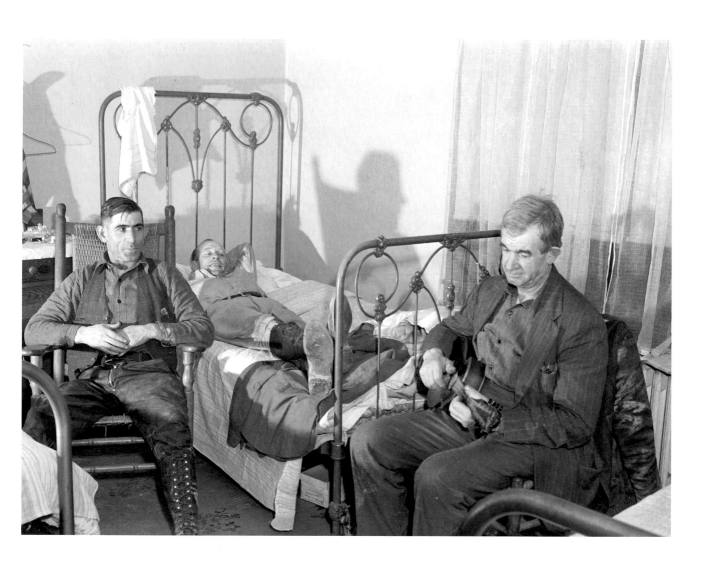

[Men living in room at Mrs. Jones's boardinghouse. Radford, Virginia.] December 1940. John Vachon.

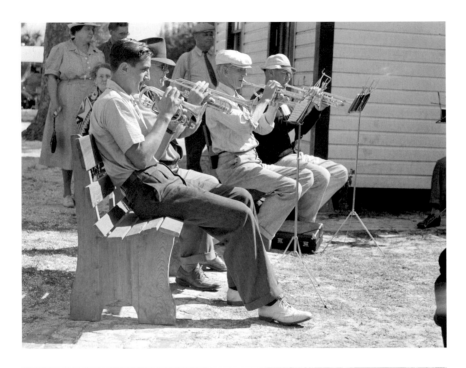

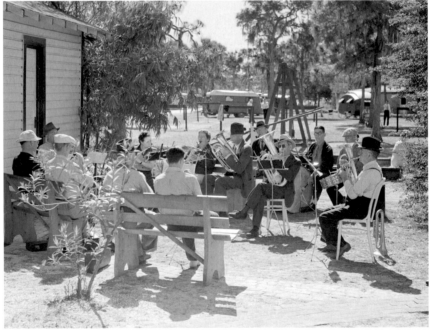

Band composed of guests of trailer
park. Sarasota, Florida. January 1941.
Marion Post Wolcott.

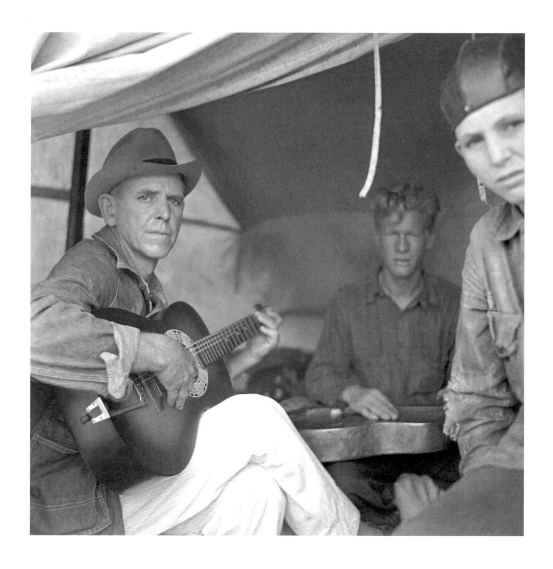

[Migrant packinghouse workers,
Deerfield, Florida.] January 1937.
Arthur Rothstein.

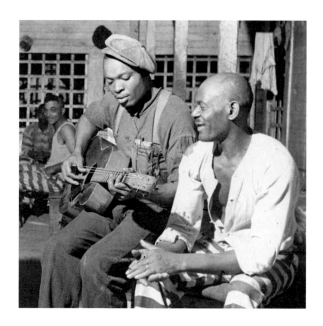

South

The Deep South Depression was the formative environment for many of the most prominent figures in country music, and the scenes depicted by the FSA would be familiar to them. Hank Williams met his musical influence Rufus "Tee Tot" Payne, an African American street singer, on the streets of Georgiana, Alabama. Johnny Cash grew up on an FSA farm in Dyess, Arkansas, an experience he would later describe as "[growing] up under socialism. Maybe a better word would be communalism." It was here that he was exposed to music in church, listened to the Grand Ol' Opry on the radio, and lived through seasons in the cotton fields as well as the 1937 flood that later would result in his song, "Five Feet High and Rising."[1]

Like the Southeast, the Deep South was high-yield territory for folklorists and commercial record labels, as well as photographers, because of the especially rich musical traditions. Perhaps the greatest of these is the archetypal bluesman playing to downtown crowds for change in a tin cup or an open instrument case.[2]

This image is central to our understanding of blues musicians, and yet very few people alive today have actually seen what this looks like. There is almost no visual representation of it. Marion Post Wolcott's shot of a guitar player (who looks like Mississippi John Hurt but almost certainly is not) in Belzoni, Mississippi (p. 33), is not a remarkable photograph—except that it is the best documentation in existence of this important phenomenon.

Ben Shahn's frames of the blind street singers (pp. 28, 29), who may be Blind Pete and George Ryan, give us a more intimate view of this. The song they were playing, according to Bernarda Shahn, Ben's widow who accompanied him on his shooting trips, was "River Stay Away from My Door."[3]

Much has been written about juke-joint murals, but Wolcott's photo (p. 44) may be the only photograph of one this early. And vintage instrument collectors have to wonder what was in that Beale Street (Memphis) pawn shop in November 1939 (p. 45).

Jack Delano's photographs of prisoners in their cells in Greene County, Georgia (p. 50), are very, very harsh, among the toughest in the file. The contrast to the shots of the convicts playing music and dancing is startling, and the result of a guard ordering the men to "dance for the photographer." Delano writes of this experience,

> I was so nervous and excited by the opportunity to get these pictures that I blocked out all my personal feelings. I had only one thought in my mind: I must not fail to get these pictures! I must not fail to get these pictures! I'll never have an opportunity like this again! It was only afterward, relaxing back in my hotel room, that the realization of what I had witnessed came upon me. The bitter irony of striped prison attire combined with song and dance seemed almost surrealistic. How humiliating it must have been for those men to be obliged to perform for me, as if they were trained animals! The idea that they had been ordered to put on a show for the photographer was abhorrent. Yet they did have a guitar, and I am sure they sometimes entertained themselves. After all, I reasoned, this is the sort of thing that produced the soulful music of the blues.[4]

Delano is right to recognize the connection with the blues. The guitarist he photographed was the great Piedmont-style musician Buddy Moss, nearing the end of his six-year prison term for murder.[5]

In many respects, the Skyline Farms Dancers were the best success of Charles Seeger's program. Bascomb Lamar Lunsford was hired to work with them, building a program of traditional music and square dancing. The RA Music Division made recordings of them, and in 1939 they were invited to the White House to perform for the Roosevelts and King George VI and then-Princess Elizabeth.

We know from Herbert Halpert's 1939 recordings of Chester Allen (p. 39, white shirt), that his repertoire at the time included "Salty Dog," "Old Hen Cackle," "Rattler," "Cincinnati Blues," and "John Henry." Other musicians in the photos are Hub Green (p. 38, left), Ruben Rousseau (p. 38, right), and Walter Holt (p. 39, wearing cap).

Other songs collected at Skyline include "The Miller," "One of Us," "Cumberland Mountain Blues," "Green Coffee Grows on a White Oak Stump," "Roll On Buddy," and "Cotton Mill Colic." Seeger's intention of the residents creating their own music based on the communal experience appears to have borne some fruit in "These Old Cumberland Mountain Farms" and "Skyline Jubilee."

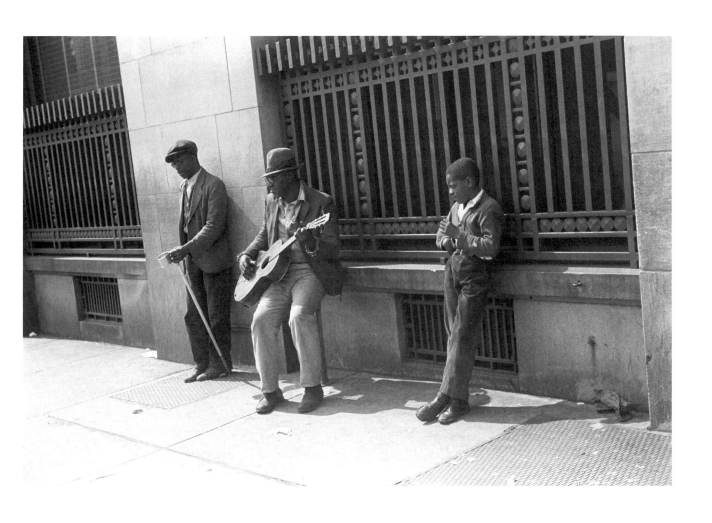

Beggars on main street corner,
Montgomery, Alabama. Spring 1939.
Marion Post Wolcott.

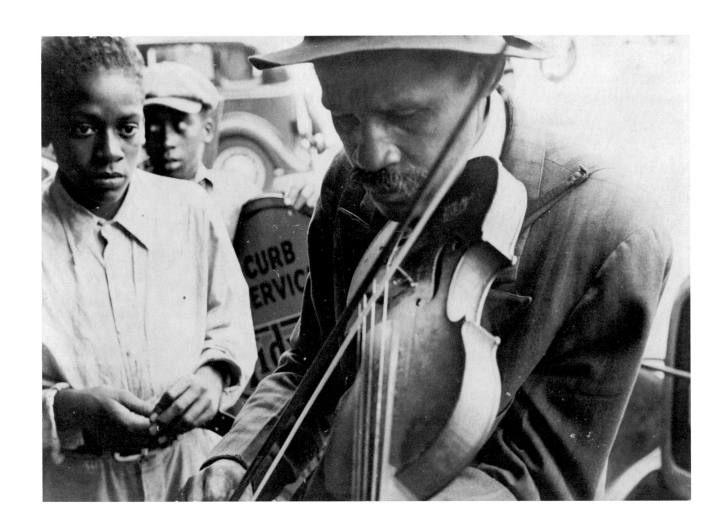

Blind street musician, West Memphis,
Arkansas. October 1935. Ben Shahn.

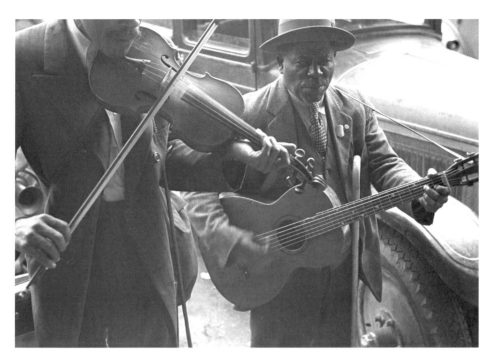

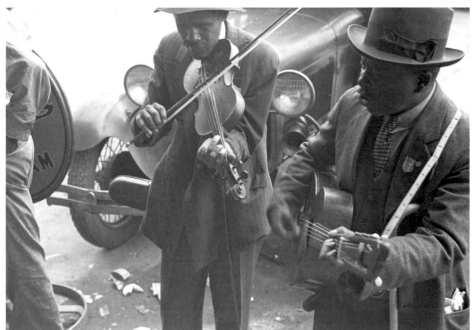

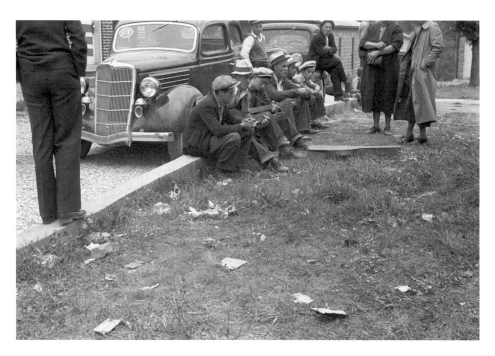

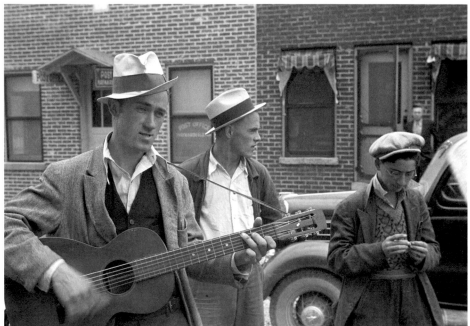

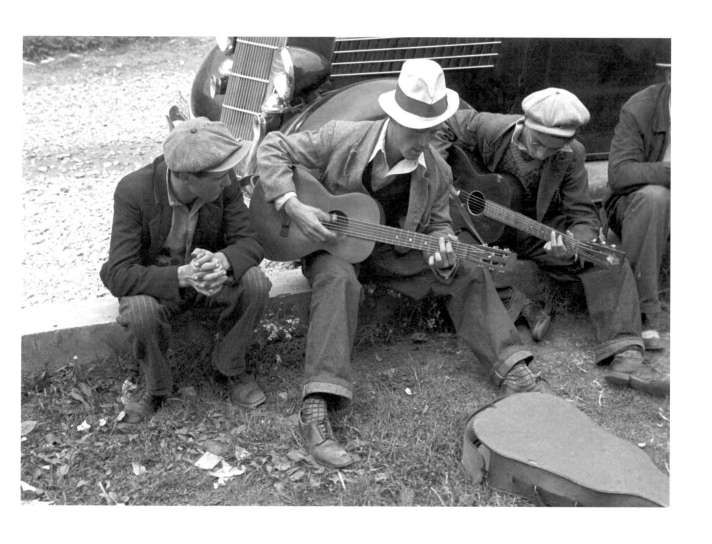

Street musicians, Maynardville,
Tennessee. October 1935. Ben Shahn.

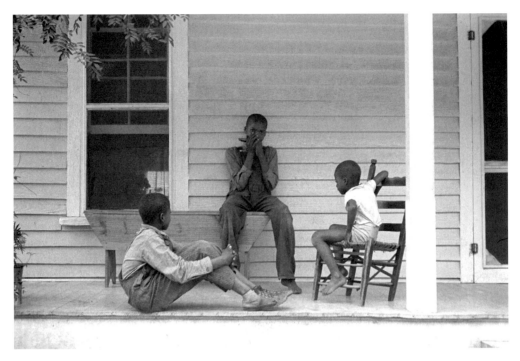

Sharecropper's Children.
September 1935.
Arthur Rothstein.

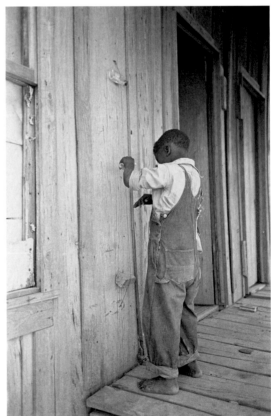

Child of former sharecropper, playing
primitive musical instrument made
by stretching wire from one nail to
another, creating [a] sort of violin.
Southeast Missouri Farms. May 1938.
Russell Lee.

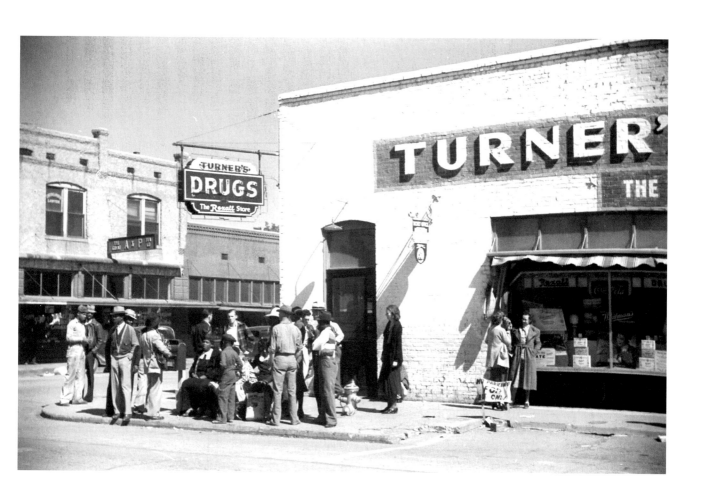

Main Street on Saturday afternoon,
Belzoni, Mississippi Delta, Mississippi.
October 1939. Marion Post Wolcott.

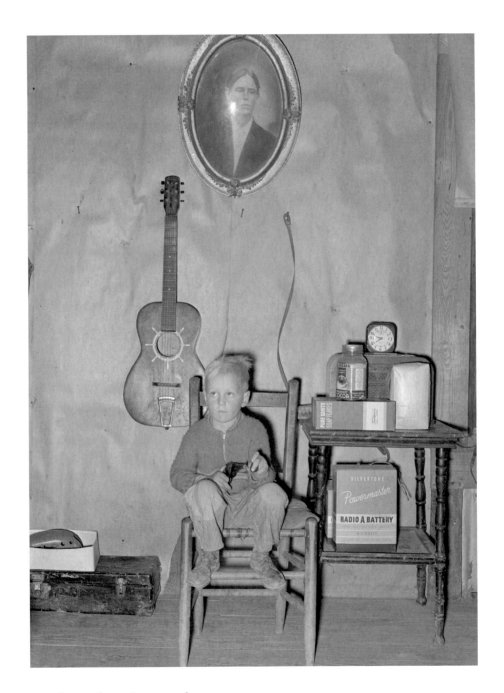

Son of tenant farmer in corner of living room. Pace, Mississippi. Background photo, Sunflower Plantation. January 1939. Russell Lee.

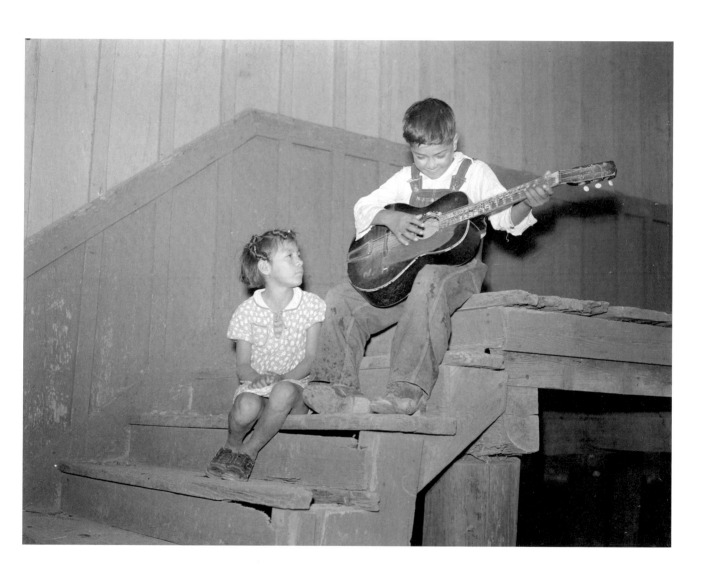

Two Mexican children on steps of railway station where they live during the cotton picking season on Knowlton Plantation, Perthshire [Mississippi]. This transient labor is contracted for and brought in trucks from Texas each season. October 1939. Marion Post Wolcott.

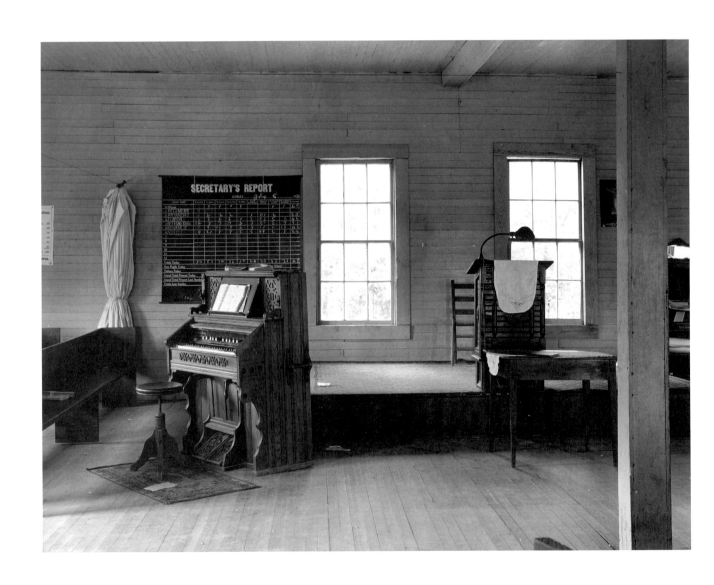

Church interior. Alabama or Tennessee.
1936. Walker Evans.

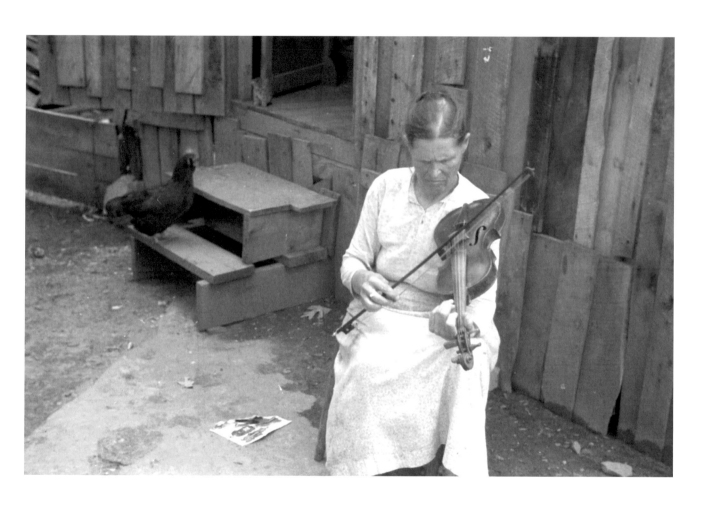

[Mrs. Mary McLean, Skyline Farms,
Alabama. 1937.] Ben Shahn.

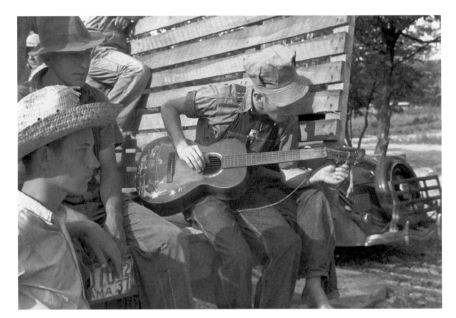

Young musician at
Skyline Farms, Alabama.
1937. Ben Shahn.

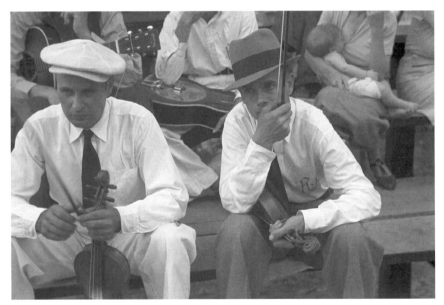

[Square dance, Skyline
Farms, Alabama. 1937.]
Ben Shahn.

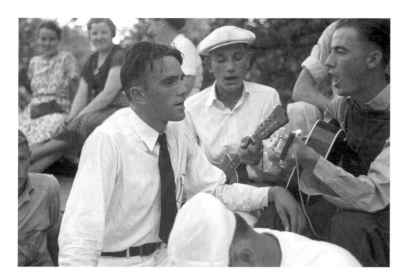

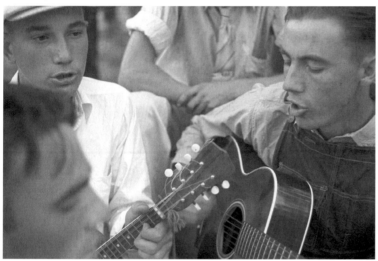

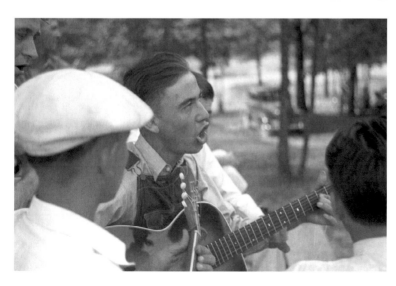

Music for square dance,
Skyline Farms, Alabama. 1937.
Ben Shahn.

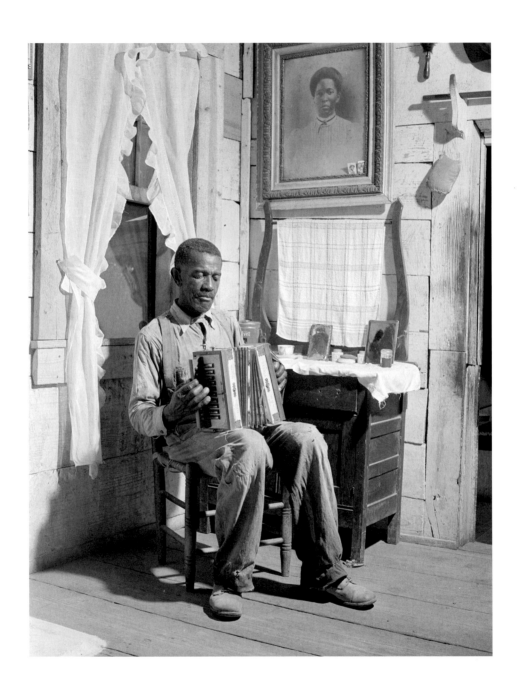

Mr. Cicero Ward, Negro FSA client.
Southern Greene County, Georgia.
June 1941. Jack Delano.

School choir led by Robert Pierce, school principal. They won state championship. Gee's Bend, Alabama. May 1939. Marion Post Wolcott.

[May Day pageant, Siloam.
Greene Co., Georgia. May 1941.]
Jack Delano.

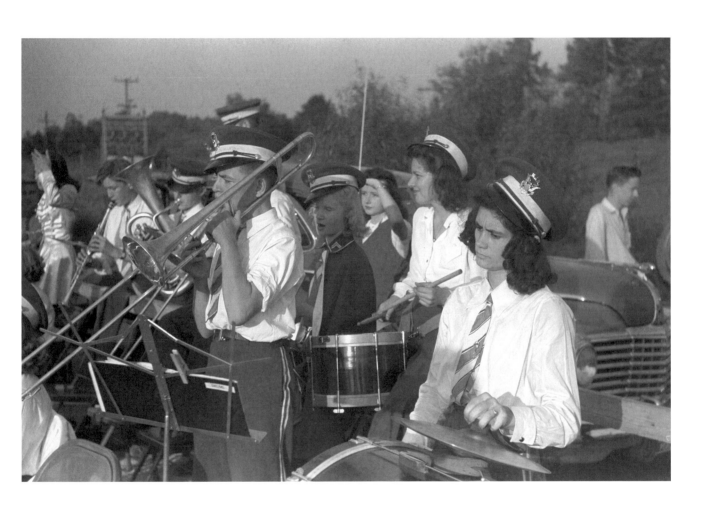

Greensboro, Greene County, Georgia.
Band at a football game. Fall 1941.
Jack Delano.

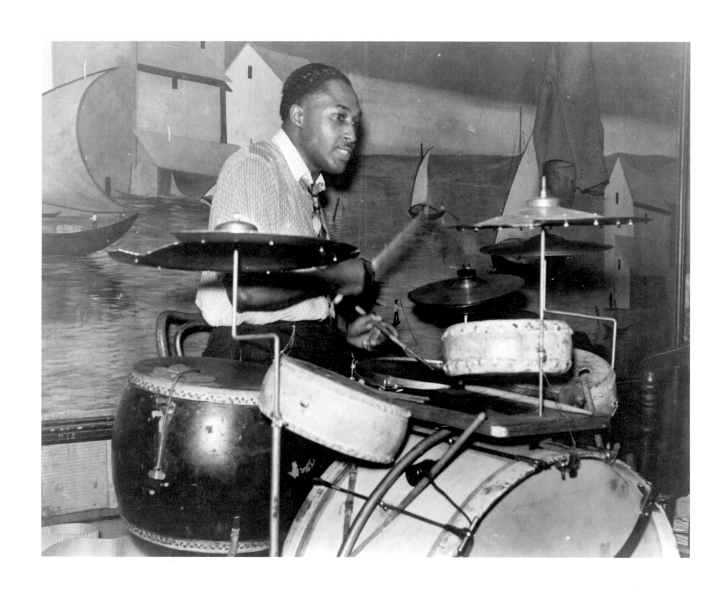

Drummer in orchestra in Memphis
juke joint, Tennessee. October 1939.
Marion Post Wolcott.

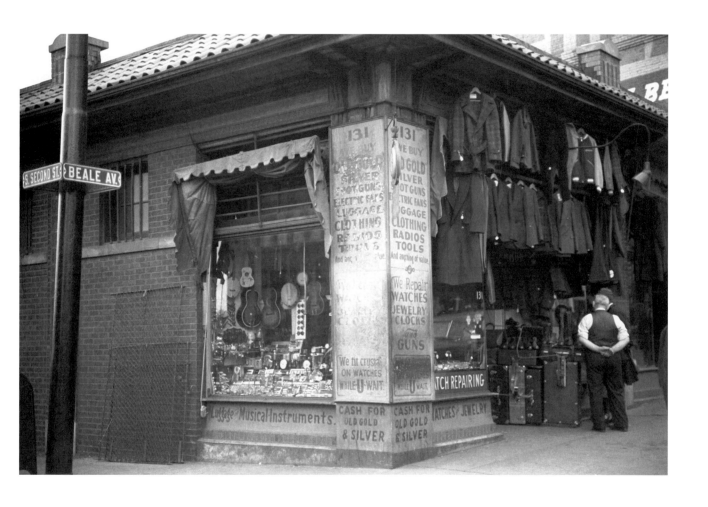

Pawn shop and secondhand clothing
store on Beale Street, Memphis,
Tennessee. November 1939.
Marion Post Wolcott.

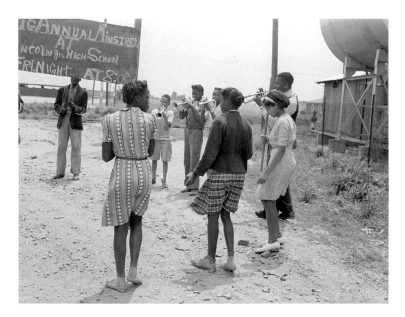

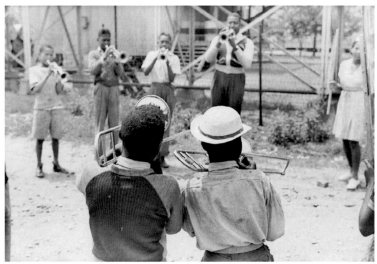

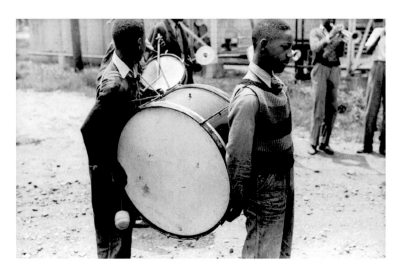

High school jazz band. Sikeston,
Missouri. May 1940. John Vachon.

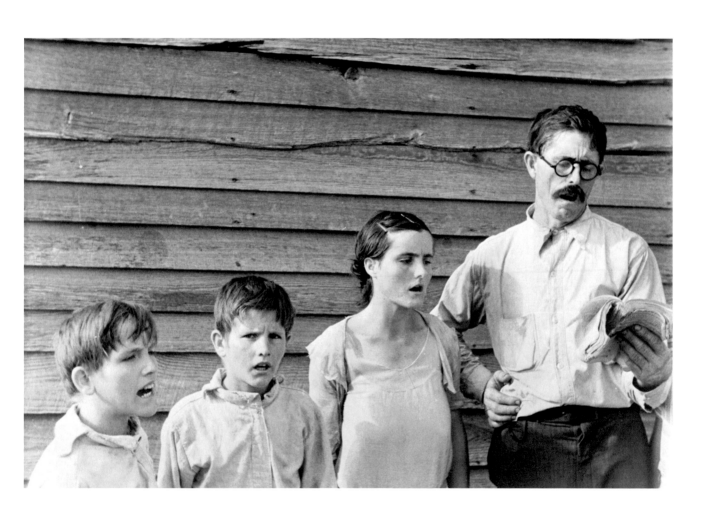

Frank Tengle's family. Hale County,
Alabama. 1936. Walker Evans.

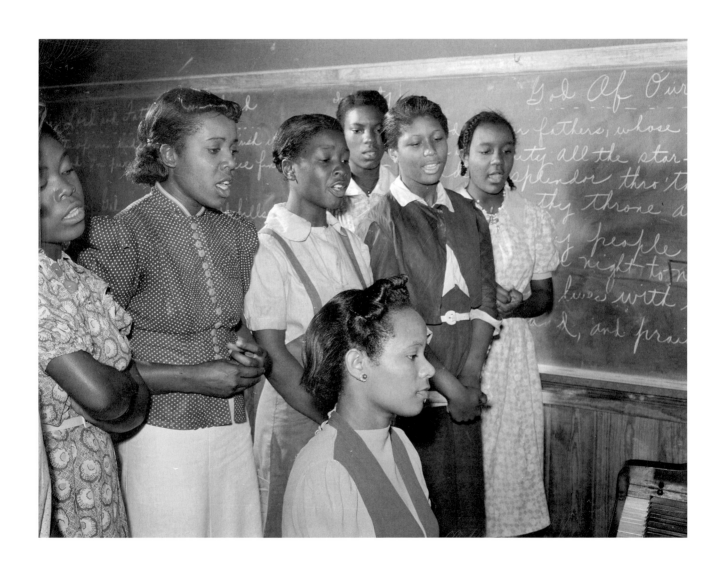

Music class practicing songs for May Day–
Health Day festivities. Flint River Farms,
Georgia. May 1939. Marion Post Wolcott.

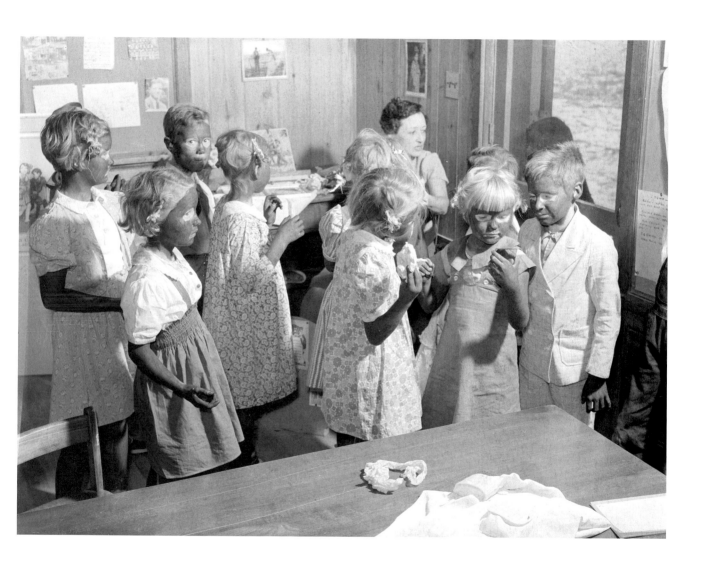

Second and third grade children being made
up for their Negro song and dance at May
Day–Health Day festivities. Ashwood Plantations,
South Carolina. May 1939. Marion Post Wolcott.

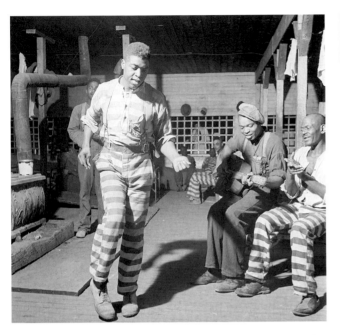

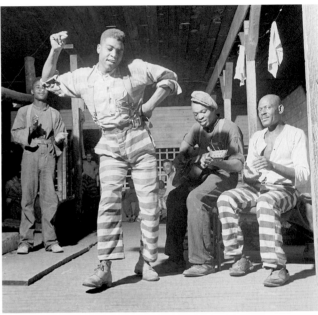

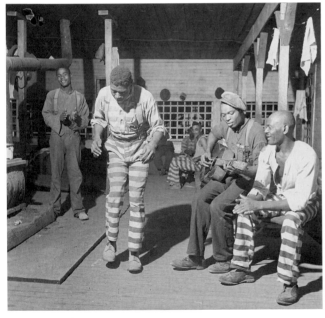

In the convict camp in Greene County,
Georgia. May 1941. Jack Delano.

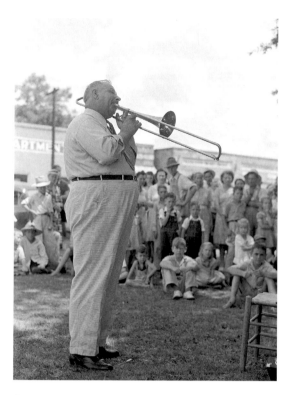

Local band leader leads with "An Old Southern Melody" and everybody cheered. Home guard passes through Enterprise, Coffee County, Alabama. August 1941. John Collier.

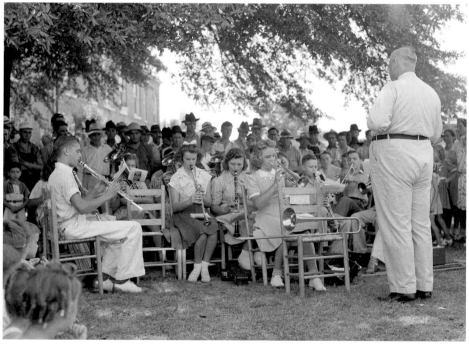

The high school band had been practicing up for weeks. Home guard passes through Enterprise, Coffee County, Alabama. August 1941. John Collier.

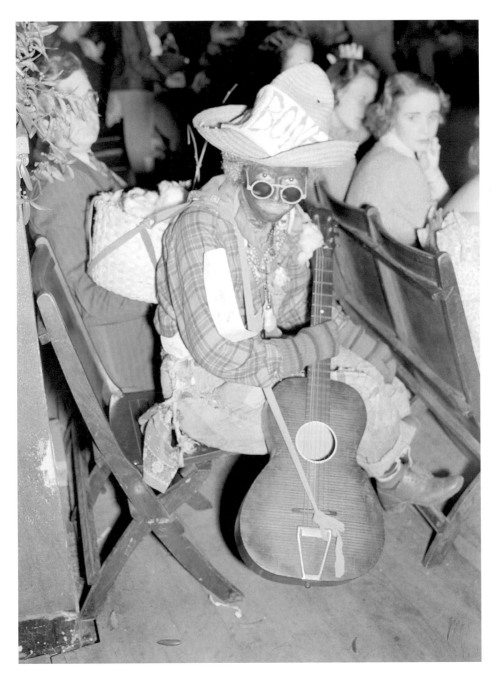

[Celebrant at cotton carnival ball.
Memphis, Tennessee. May 1940.]
Marion Post Wolcott.

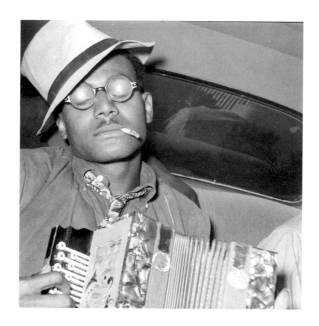

Louisiana

Russell Lee's coverage of the National Rice Festival in Crowley is one of the few instances where an FSA photographer sought out music specifically. After finishing an assignment for Public Health in New Orleans, he wrote to Roy Stryker about the upcoming Rice Festival, "This really sounds like something. Cajun dances, Cajun bands, balls and all sorts of ceremonies, big parades and floats. Please do not commit me for any work from October 3 to October 6, because I certainly want to attend this."[1] Stryker accommodated his request, and the resulting coverage of the festival provides, visually, an unequalled look at Cajun music from the time, from the traditional dance parties, the *fais-dodo,* to contests, to the early adoption of electric instruments.

The Federal Writers' Project state guide for Louisiana provides a compact description of the *fais-dodo:*

> A country dance is generally known today among the Cajuns as a *fais-dodo* (literally, go to sleep); possibly because the dancers stay up all night and sometimes fall asleep while still dancing; possibly because the mothers sing *fais-dodos* (lullabies) to put the younger children to sleep so that they themselves can leave the *parc aux petits* for the dance floor . . .

Swing bands, radios, and automatic phonographs have penetrated the Cajun country, but at the genuine *fais-dodo* the music of the fiddle, the accordion, and the triangle (sometimes called the "ting-a-ling") is always featured; for the Acadian retains his love for these instruments and often possesses rare skill in playing them. A full orchestra includes also the guitar and harmonica.[2]

Generally speaking, though, accordions were out of fashion in the late 1930s. The oil boom brought with it the sound and style of Hank Williams, Bob Wills, and such commercial Cajun string bands as the Hackberry Ramblers, the Rayne-Bo Ramblers, and Harry Choates. Twin fiddles featured prominently, and the FSA photos reflect the inclusion of saxophones, banjos, and electric instruments.

The accordion remained in fashion in Afro-French Creole music, traditionally played along with a washboard for rhythm. The washboard pictured here (p. 68) is a regular washboard, before the style of a wearable piece of corrugated metal was developed. The identities of these two musicians is one of the great mysteries of the FSA photos.

Some other identities we do know. Born Jules Angelle Lamparez, Papa Cairo (p. 55) was the premiere steel guitarist in Cajun music. After World War II (some of which he spent as a German prisoner of war), he had a successful career playing with Leo Soileau and Harry Choates as well as in the bands of a number of country and western swing artists, including Chuck Guillory (where he sang on the hit, "Big Texas"), Ernest Tubb, and Doug Kershaw. Papa Cairo led his own band in Port Arthur, Texas, where, for a brief while, his lead singer was George Jones.[3]

Leo Soileau (p. 63) was one of the great traditional Cajun fiddlers and a pioneering Cajun recording artist. By the 1930s, he was no longer playing duets with accordion players but leading one of the earliest Cajun string bands, Leo Soileau and his Three Aces. By 1938 he was deeply into a career that encompassed not only traditional music but popular repertoire as well. "There was a big dancehall near Crowley. The crowd didn't like accordion bands or orchestras. They only liked local string bands because they performed both French and popular music. We played all the popular tunes, gave them what they wanted." He retired from music as a profession in the 1950s, later working in oil refineries and after that as a janitor.[4]

There are also reminders that even outside New Orleans the musical scene in Louisiana was more varied than just traditional Cajun music. The "specialty number" (p. 64) speaks to the presence of jazz elsewhere in the state. The bands and drum corps (pp. 58–59) are typical and not unique to Louisiana.

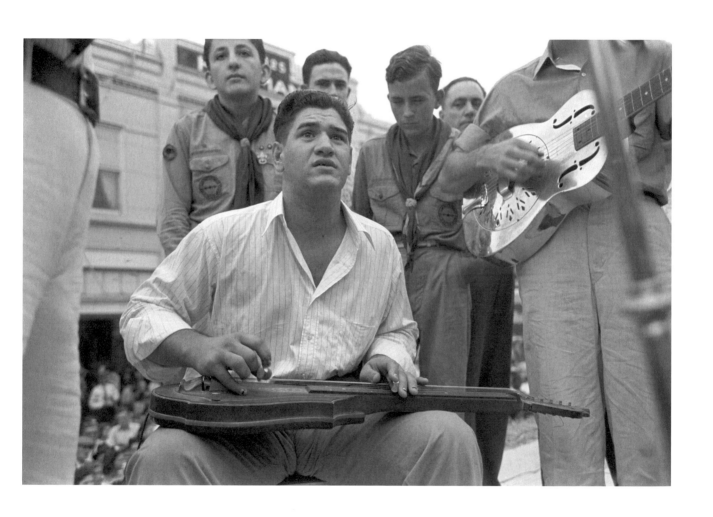

Cajun Hawaiian guitar player, National
Rice Festival, Crowley, Louisiana.
October 1938. Russell Lee.

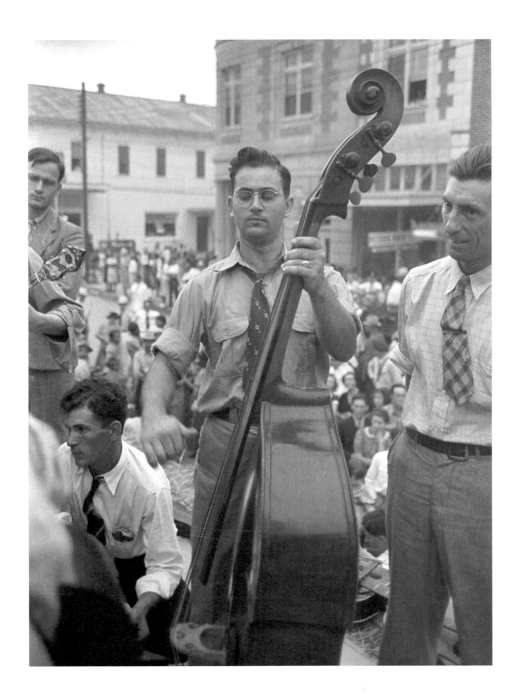

Bass viol player, Cajun band contest,
National Rice Festival, Crowley,
Louisiana. October 1938. Russell Lee.

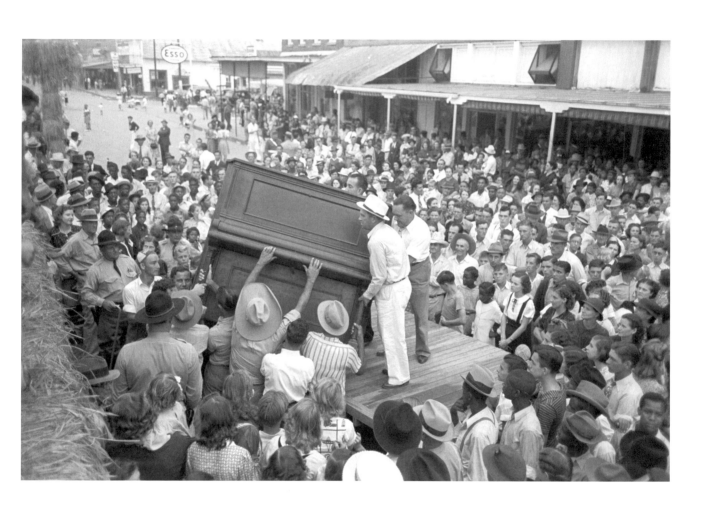

Raising piano from truck to elevated
platform for Cajun band contest,
National Rice Festival, Crowley,
Louisiana. October 1938. Russell Lee.

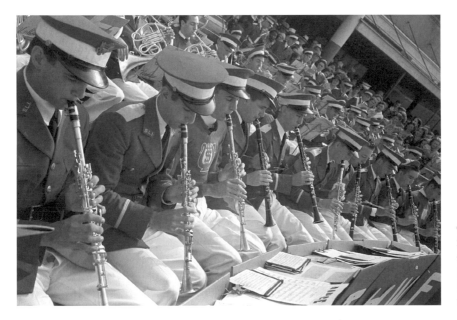

Clarinet players, Southwestern University band, National Rice Festival, Crowley, Louisiana. October 1938. Russell Lee.

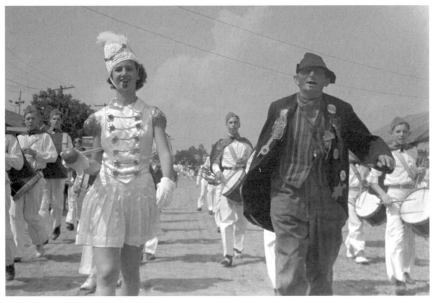

Drum majorette with clown, leading parade of the drum corps, state fair, Donaldson, Louisiana. November 1938. Russell Lee.

Leader of the band,
National Rice Festival,
Crowley, Louisiana.
October 1938.
Russell Lee.

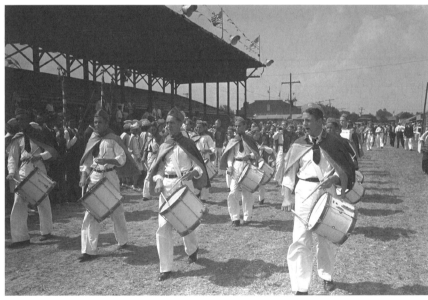

Parade of the drum
corps, Donaldsonville,
Louisiana, state fair.
November 1938.
Russell Lee.

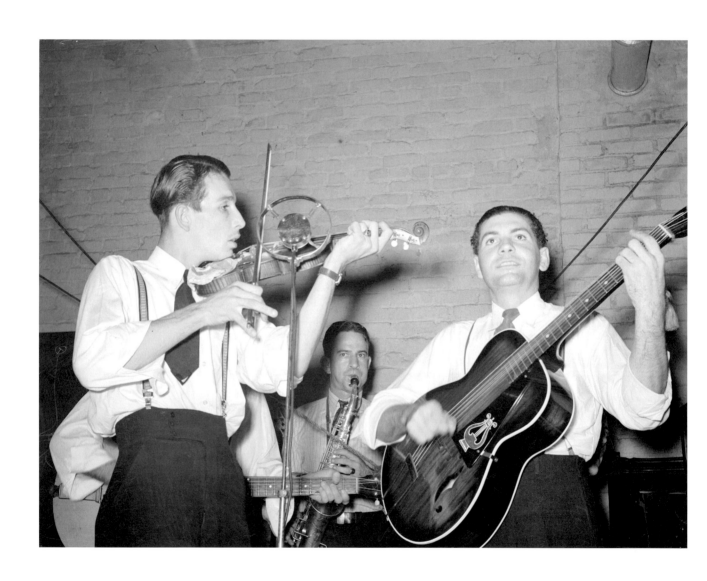

Cajun musicians at *fais-do-do* at
National Rice Festival, Crowley,
Louisiana. October 1938. Russell Lee.

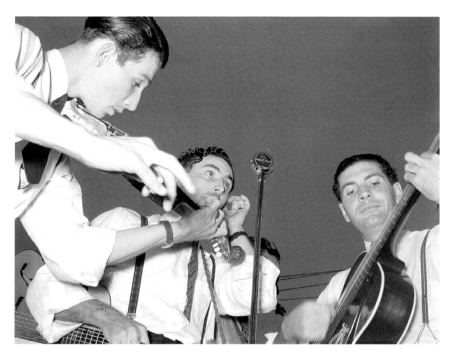

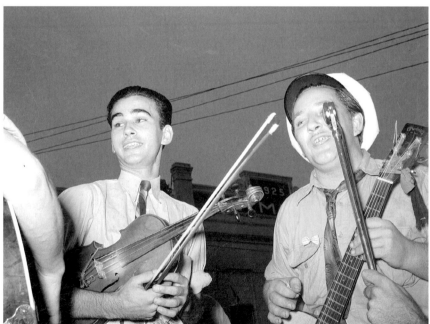

Musicians in cajun [*sic*] band contest
at National Rice Festival, Crowley,
Louisiana. October 1938. Russell Lee.

Pianist in cajun [*sic*] band contest.
National Rice Festival, Crowley,
Louisiana. October 1938. Russell Lee.

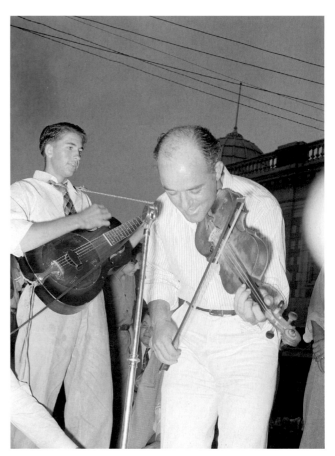

Musicians in Cajun band contest,
National Rice Festival, Crowley,
Louisiana. Most of the music was
of the folk variety, accompanied by
singing. October 1938. Russell Lee.

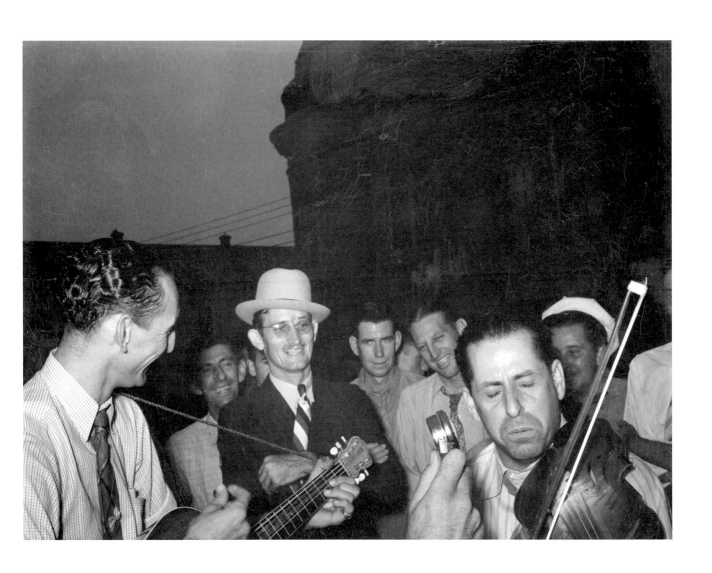

[National Rice Festival, Crowley,
Louisiana. October 1938.] Russell Lee.

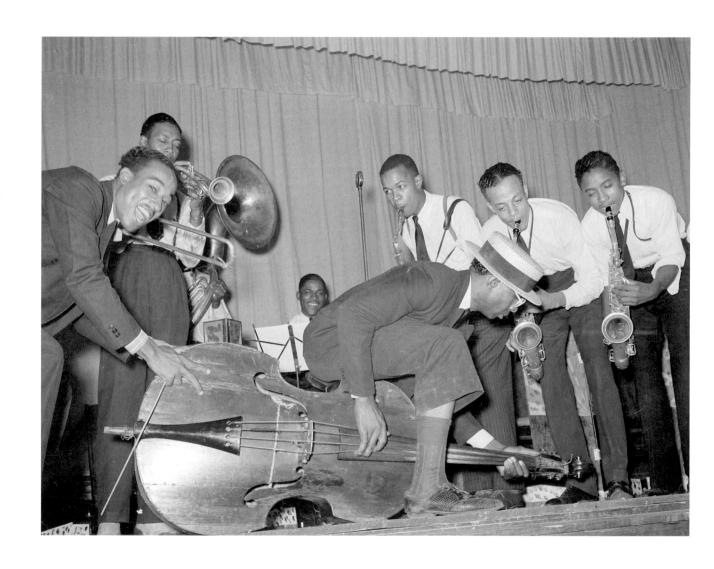

Specialty number of orchestra at
the National Rice Festival, Crowley,
Louisiana. October 1938. Russell Lee.

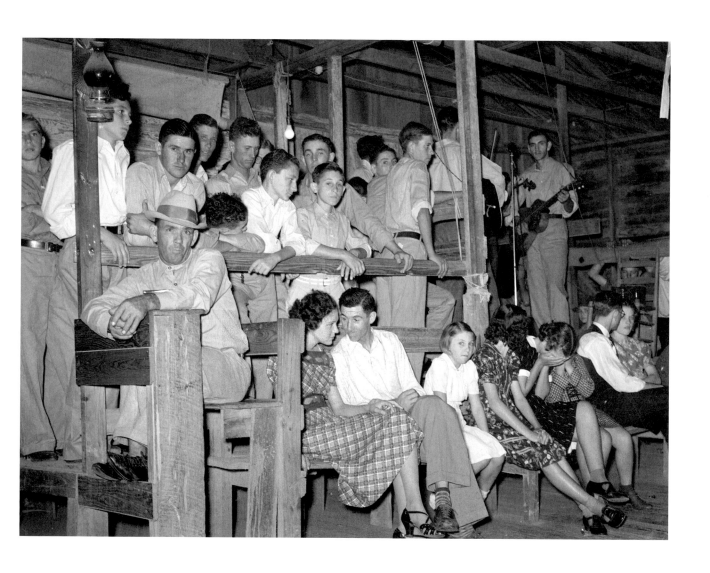

Men's section at *fais-do-do* near
Crowley, Louisiana. Note ticket taker.
October 1938. Russell Lee.

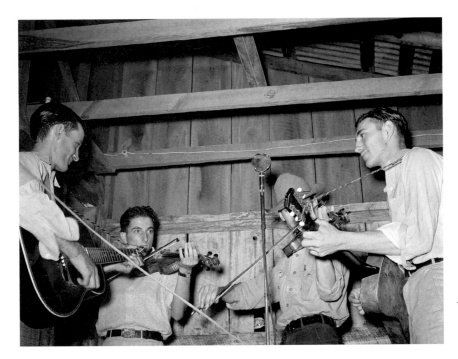

Cajun orchestra at *fais-do-do* dance near Crowley, Louisiana. October 1938. Russell Lee.

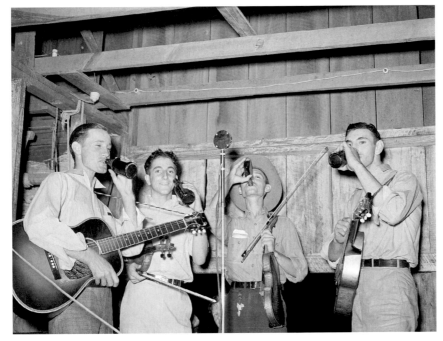

Cajun orchestra for *fais-do-do* near Crowley, Louisiana. Having intermission with drinks. October 1938. Russell Lee.

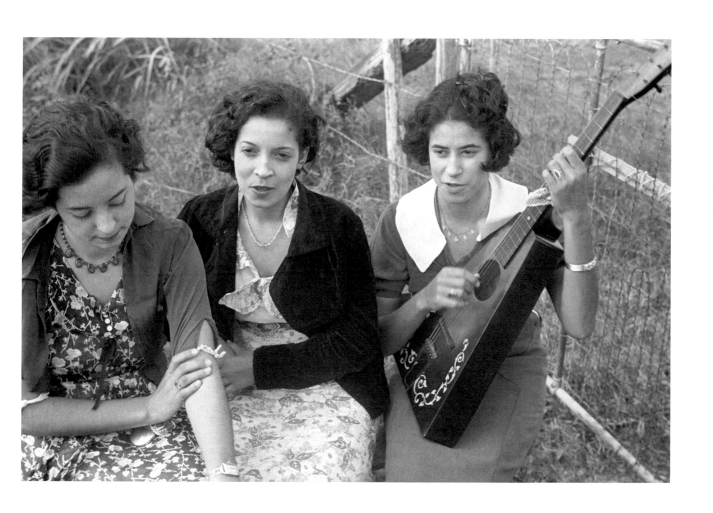

Creole Girls, Plaquemines Parish,
Louisiana. October 1935. Ben Shahn.

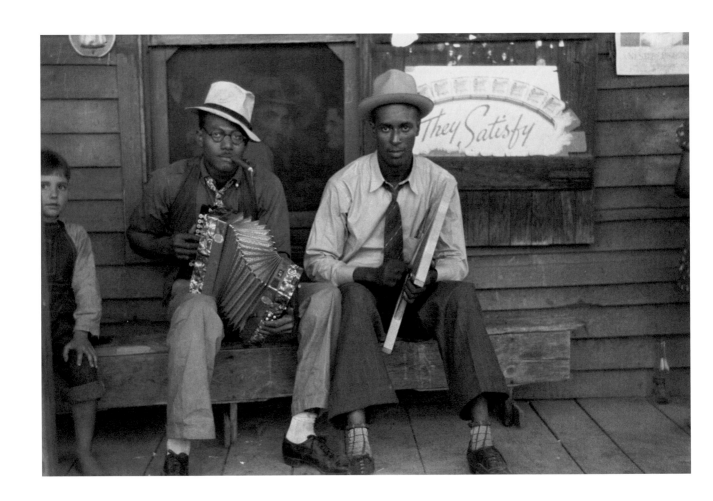

Negro musicians playing accordion
and washboard in front of store, near
New Iberia, Louisiana. November
1938. Russell Lee.

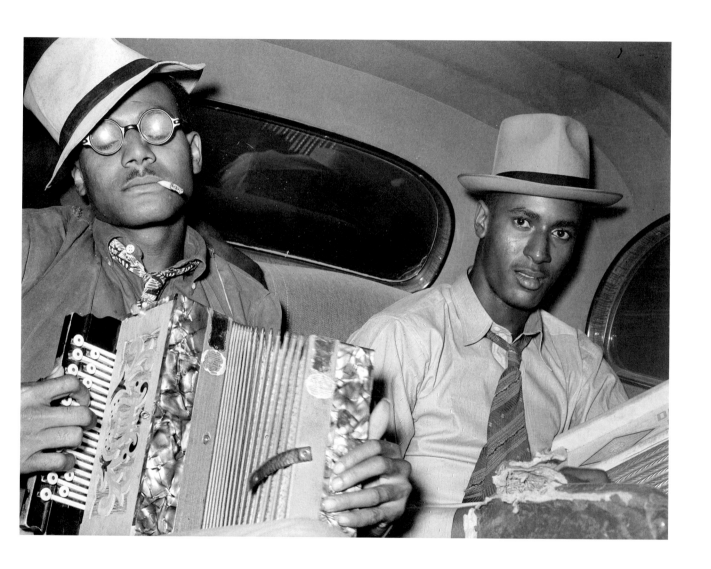

Negro musicians playing accordion
and washboard in automobile. Near
New Iberia, Louisiana. November
1938. Russell Lee.

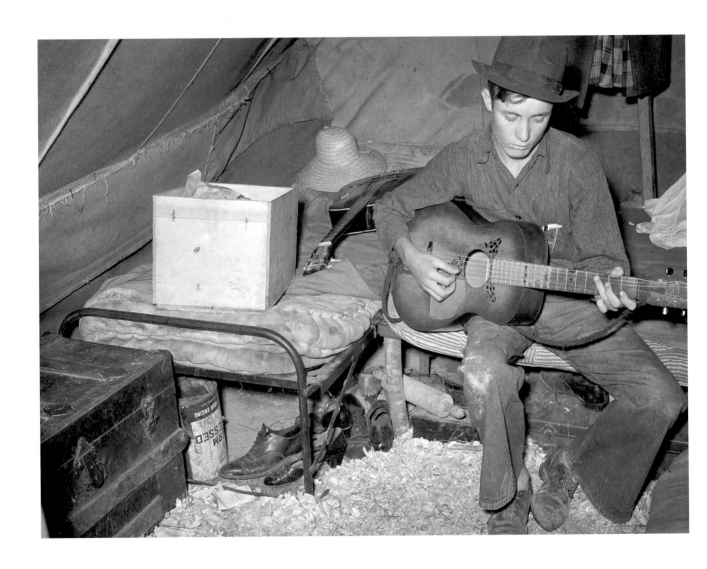

White migrant strawberry picker play-
ing guitar in his tent near Hammond,
Louisiana. April 1939. Russell Lee.

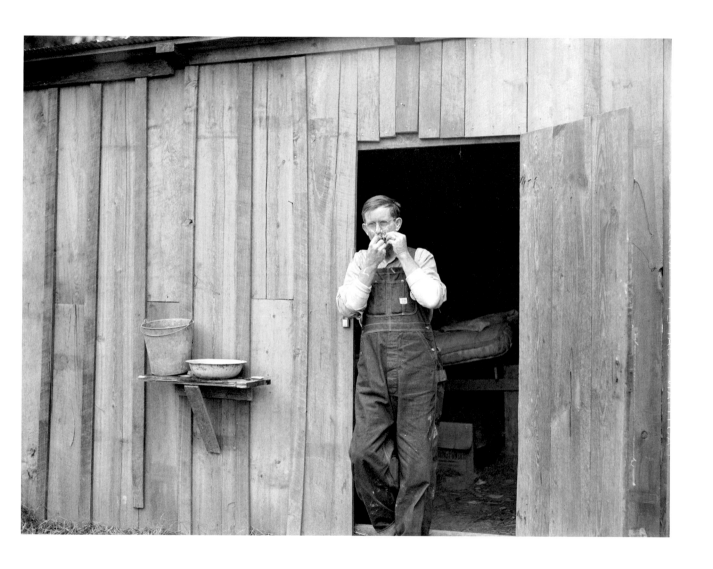

[Camp Livingstone, Alexandria,
Louisiana. December 1940.]
Marion Post Wolcott.

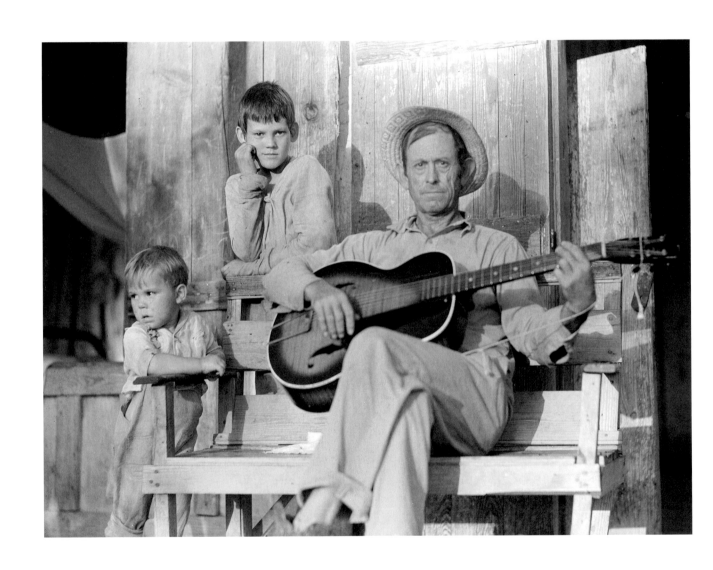

Natchitoches, Louisiana. June 1940.
Marion Post Wolcott.

Southwest

L ionized in John Steinbeck's novels, Woody Guthrie's songs, and Pare Lorentz's films, the Southwest is at the narrative core of the Great Depression. As the home of the Dust Bowl and the exodus it brought about, it speaks to the parts of the American psyche that love survivors and the connection with the land that comes from living by the sweat of the brow.

While including this imagery, the FSA photographers tell a less distilled story, one where the Okies (who were, after all, relative newcomers to the area) share a world with the Hispanic population, evangelical revivalists (whose theology undoubtedly differed from Preacher Casey's), and people who prospered in the oil boom.

The accordion player at the United Cannery, Agricultural, Packing, and Allied Workers of America meeting (p. 93, top) is Agnes "Sis" Cunningham. Her father played the fiddle, and through her involvement with the Southern Tenants Farmers' Union she learned such radical labor songs as John Handcox's "Mean Things Happening in This Land." She taught Wobbly songs to the children of packinghouse workers and at one point met Pete Seeger and Woody Guthrie on one of their trips through Oklahoma. Performing with the Red Dust Players, a troupe of political activists that used music and theater to organize farmers and other rural workers, she would follow short plays with musical solos of Joe Hill, Boll Weevil, or political songs she wrote or adapted.[1]

She described an evening similar to the one pictured here (p. 93) by writing,

> The piano in the school was fine, and I played the accordion only to accompany myself when doing my solo (my own song "Sundown" on this occasion). The audience was all black, mostly young people, and the students had organized a quartette that sang during intermission. It wasn't just intermission—it was the show that night, as far as *we* were concerned. Their singing made ours sound thin and pale. Several times at our back-country performances (as distinguished from those in the towns), we had audiences that were mostly black. In some localities the folks had not seen a movie or a show of any kind.[2]

As a member of the Communist Party in an increasingly hostile environment, Cunningham fled to New York City in 1941. There she joined Seeger and Guthrie as a member of the Almanac Singers and later founded *Broadsides* magazine.

Russell and Jean Lee discovered Pie Town, populated by displaced farmers from Oklahoma and Texas, on a trip through New Mexico and were impressed with its qualities of frontier community and self-reliance. Among other virtues, Pie Town held weekly square dances, and the extensiveness of the coverage of the Community Sing, held at the Baptist church, speaks to their connection with the place.[3]

According to Nancy Wood, the four men in Lee's well-known image from the event (p. 108) are, from left, Fred Hamilton, Lawrence Brown, Oscar Nicholson, and Jack Whinery. The fiddler at Bill Stagg's all-night square dance (p. 111) is Oley "Monk" McKee, a former Texas sharecropper.[4]

Jean Lee wrote the general captions on their travels. In Muskogee County, Oklahoma, she recorded that children at a pie supper (a fund-raiser for a piano at the school, p. 82) sang "Sucking Cider Through a Straw," and described the singing teacher's workload as including four or five schools and being "responsible for the programs at various local entertainments, keeping the sings going during winter months, and playing for church on Sunday morning as well as funerals and weddings."[5]

In McIntosh County, she described a play party (p. 83, bottom). "As I neared the house I heard a guitar going and voices singing. In one small room, about ten by twelve feet, some twenty people were gathered. . . . They played "swing and sing games" which were much the same as square dances except that there was no caller and everyone sang and danced at the same time."[6]

The Fiesta honors the two patron saints of Taos, New Mexico: Santa Ana and Santiago. Although there had been a Spanish American and mestizo population in the area since before the Pilgrims landed, there was an influx of Hispanic immigrants to New Mexico following the assassination of Maximilian, bringing music of the Austro-Hungarian Empire with them.[7]

"New Mexico–style" waltzes—faster, shorter steps with more of an up-and-down movement, as opposed to the long strides of a Viennese waltz—were played for street dances, as were polkas, schottisches, tangos, *varsovianas* (derived from the Spanish word for Warsaw), and popular and traditional music. Waltzes were also the standard fare for the merry-go-round, or *tio vivo*.[8]

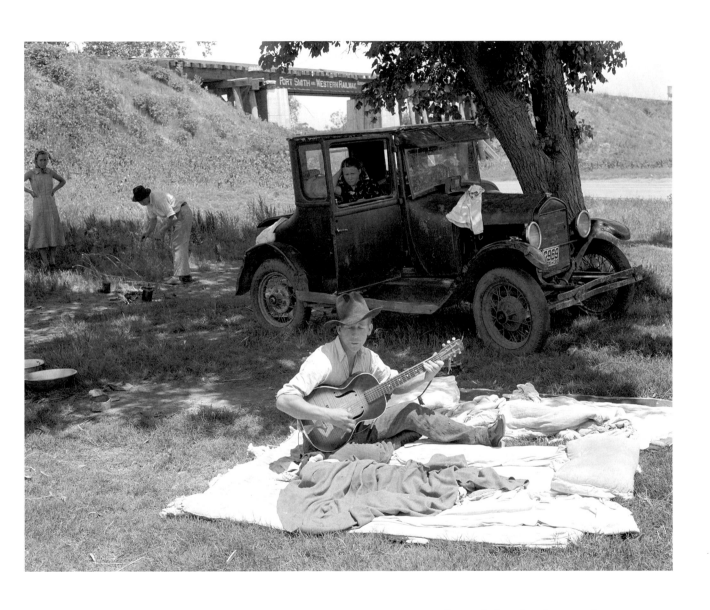

Camp of migrant workers near Prague,
Oklahoma. Lincoln County. June 1939.
Russell Lee.

Migrant boy removing guitar before
they leave for California. At old home-
stead near Muskogee, Oklahoma.
July 1939. Russell Lee.

Second-hand goods displayed for
sale, market square, Waco, Texas.
November 1939. Russell Lee.

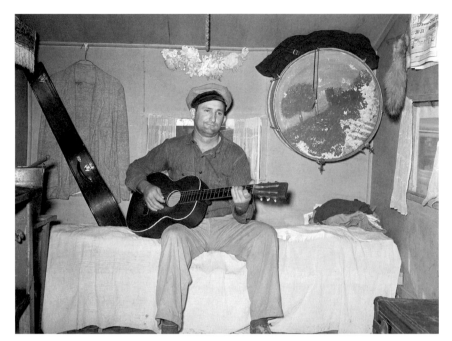

White migrant playing guitar in trailer home. Weslaco, Texas. February 1939. Russell Lee.

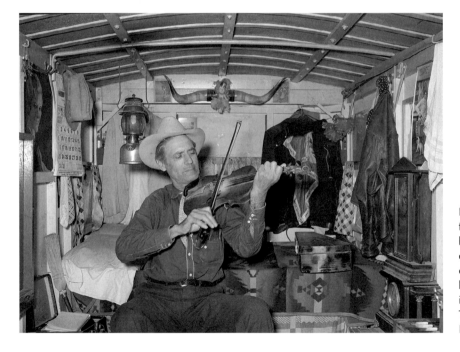

Mr. Bias playing the fiddle in his trailer home. He is a former cowboy who travels over the country. He has a small private income. Weslaco, Texas. February 1939. Russell Lee.

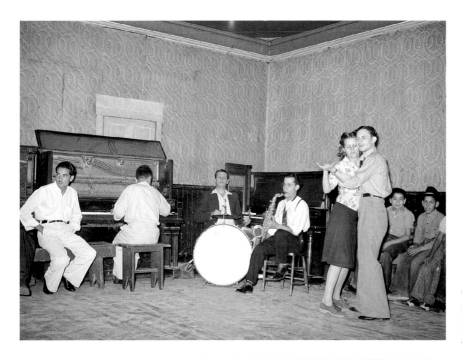

Orchestra and dancers
at payday dance.
Mogollon, New Mexico.
June 1940. Russell Lee.

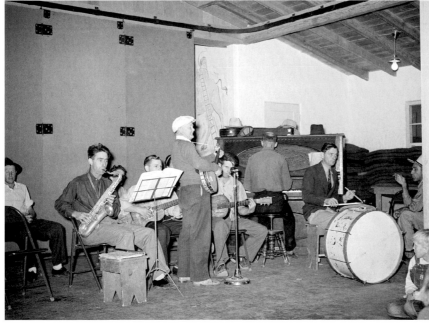

Camp orchestra at
dance on Saturday
night at the Agua Fria
migratory labor camp.
Arizona. May 1940.
Russell Lee.

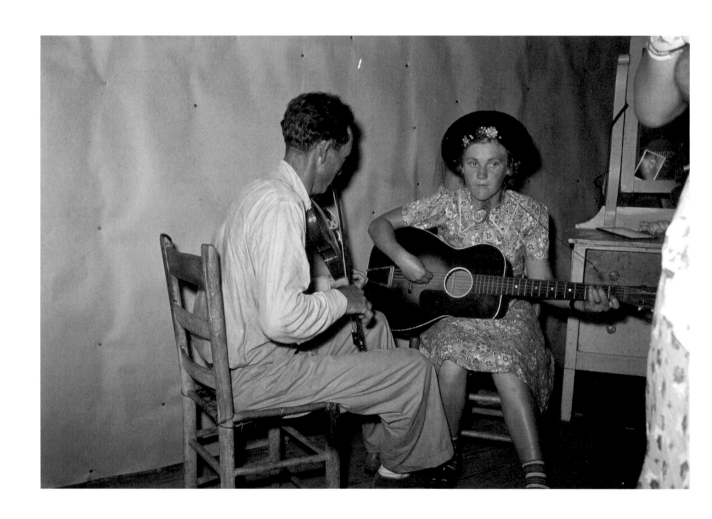

Orchestra at square dance in
McIntosh County, Oklahoma. 1939 or
1940. Russell Lee [original in color].

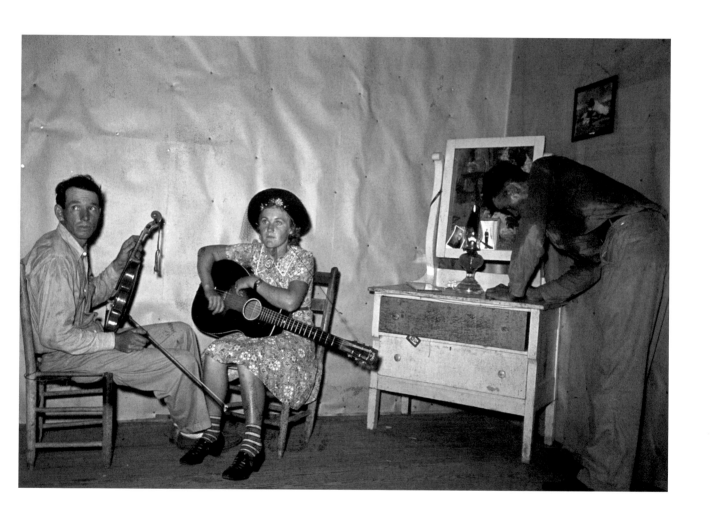

Orchestra during intermission at square dance; notice sweated shirt of host, McIntosh County, Oklahoma. 1939 or 1940. Russell Lee [original in color].

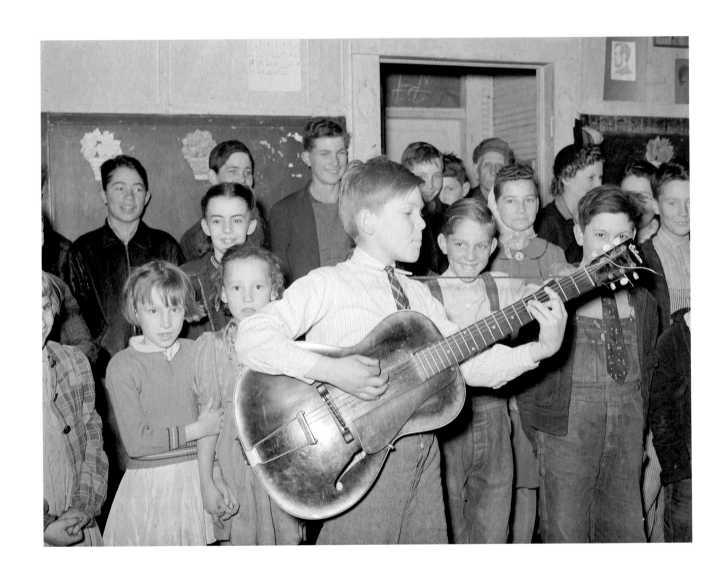

Boy playing and singing "Sipping
cider through a straw" at a pie supper
in Muskogee County, Oklahoma.
February 1940. Russell Lee.

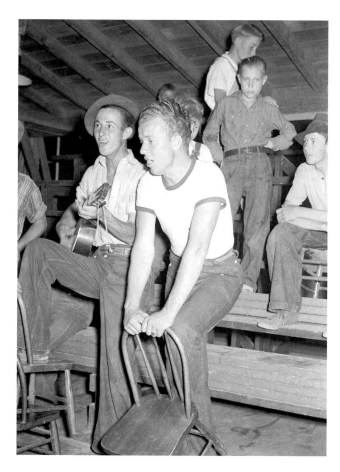

Young migratory agricultural workers singing at the Saturday night dance at the Agua Fria migratory labor camp, Arizona. May 1940. Russell Lee.

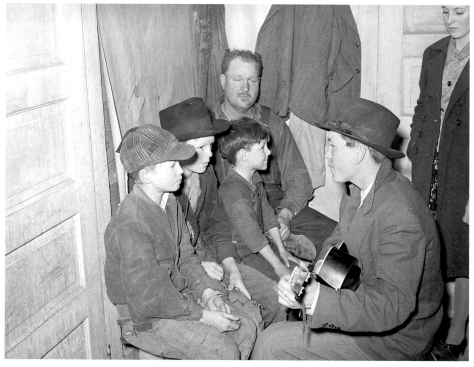

Guitar player and singers at play party in McIntosh County, Oklahoma. February 1940. Russell Lee.

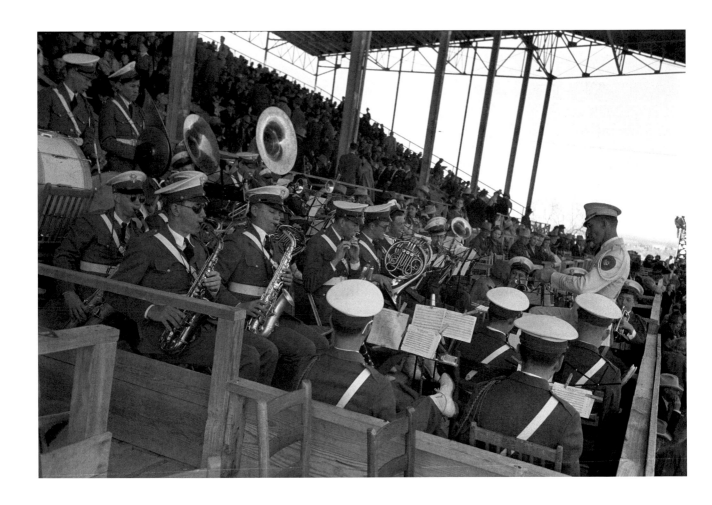

The band at the rodeo of the San
Angelo Fat Stock Show, San Angelo,
Texas. March 1940. Russell Lee.

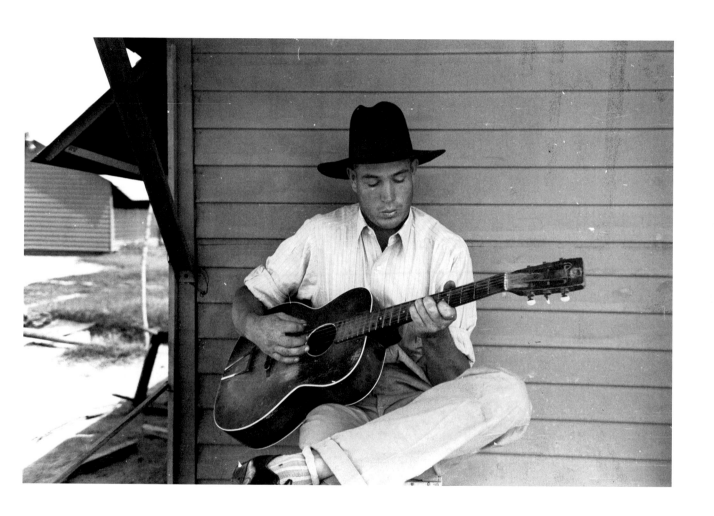

Migratory worker playing guitar on
front porch of his metal shelter in
the Agua Fria Labor Camp, Arizona.
May 1940. Russell Lee.

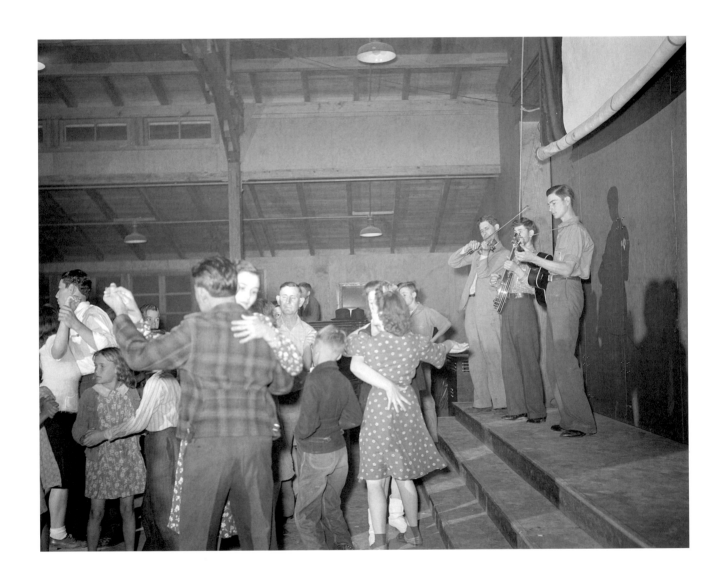

[Drake family playing for a Saturday
night dance. Weslaco, Texas.
February 1942.] Arthur Rothstein.

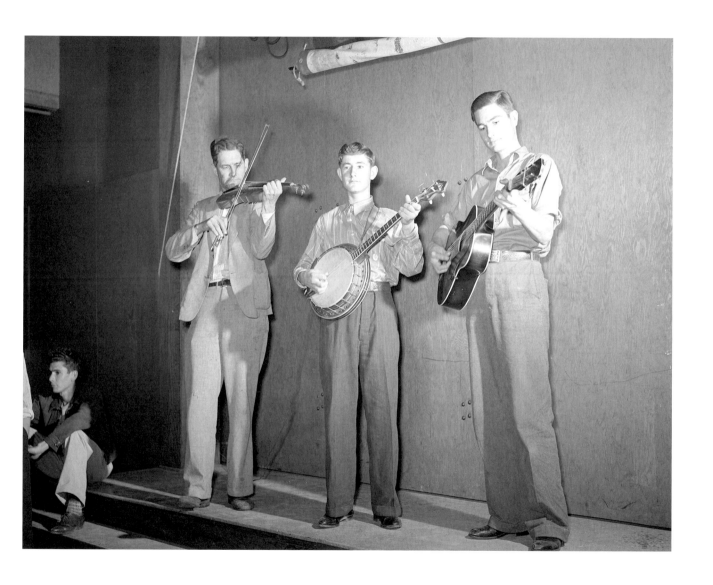

Weslaco, Texas. FSA camp. Drake family
playing for a Saturday night dance.
February 1942. Arthur Rothstein.

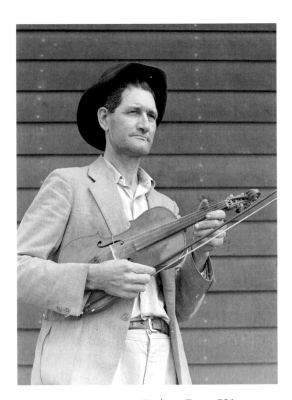

Weslaco, Texas. FSA camp.
Jasper Drake. February 1942.
Arthur Rothstein.

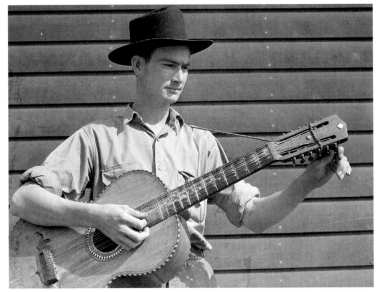

Weslaco, Texas. FSA camp.
Boy musician. [Member of
Drake family.] February 1942.
Arthur Rothstein.

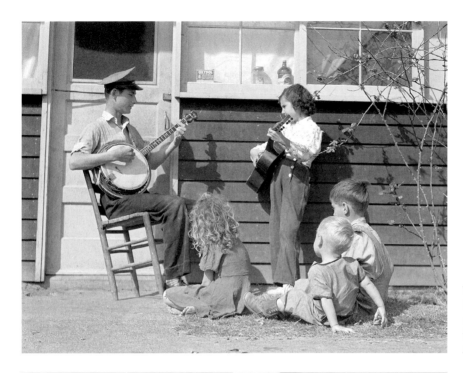

Weslaco, Texas.
FSA camp. Younger
members of Drake
family. February 1942.
Arthur Rothstein.

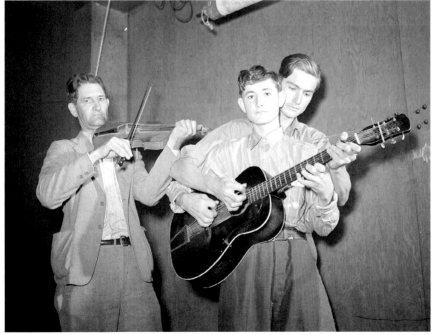

[Weslaco, Texas. Drake
family. February 1942.]
Arthur Rothstein.

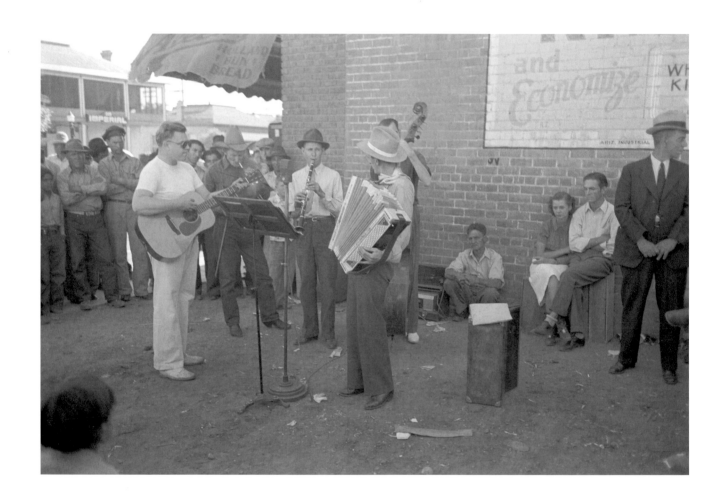

Orchestra playing outside a grocery store
on Saturday afternoon, which is designed
to attract customers to the store, Phoenix,
Arizona. March–May, 1940. Russell Lee.

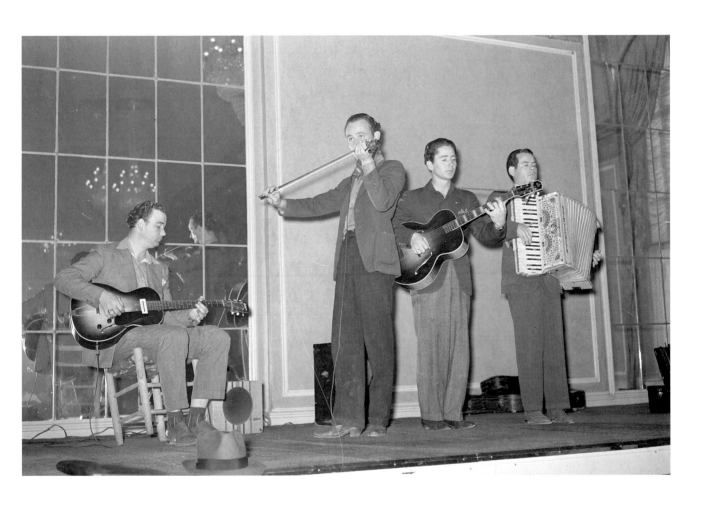

Orchestra playing at Chamber of
Commerce luncheon, San Angelo,
Texas. March 1940. Russell Lee.

Band and clowns at
Labor Day celebration,
Silverton, Colorado.
September 1940.
Russell Lee.

High school band at
the miners' Labor Day
celebration, Silverton,
Colorado. September
1940. Russell Lee.

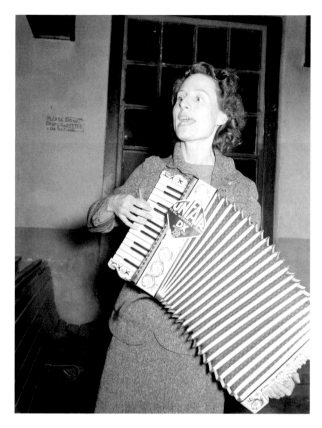

"For the union makes us strong." UCAPAWA (United Cannery, Agricultural, Packing, and Allied Workers of America) meeting. Bristow, Oklahoma. February 1940. Russell Lee.

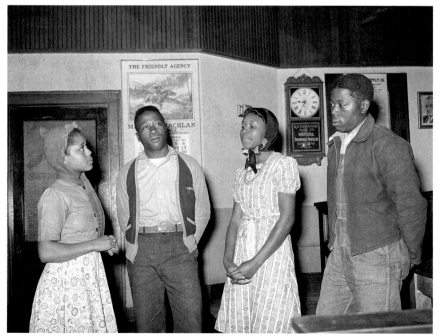

Negro boys and girls humming spiritual at UCAPAWA (United Cannery, Agricultural, Packing, and Allied Workers of America) meeting, Bristow, Oklahoma. The union meeting has become a main social gathering in these sections and has taken on some of the spirit of the old time revival. Spirituals vie with the union songs for popularity. February 1940. Russell Lee.

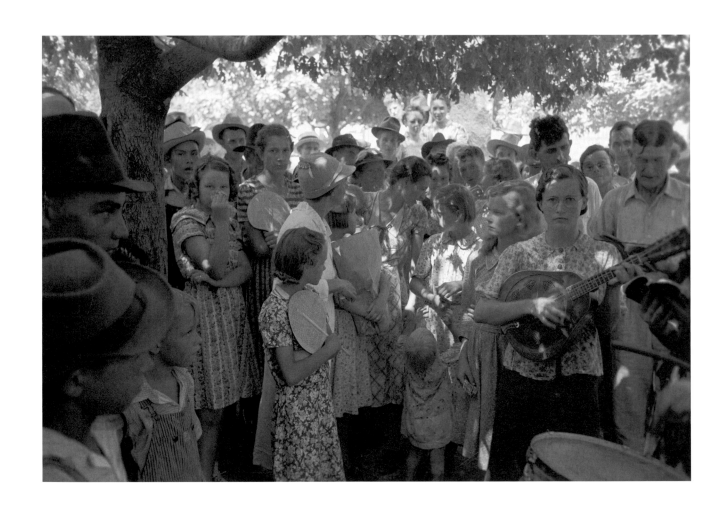

Group of people assembled under a
tree to listen to revival rally on Satur-
day afternoon. Tahlequah, Oklahoma.
July 1939. Russell Lee.

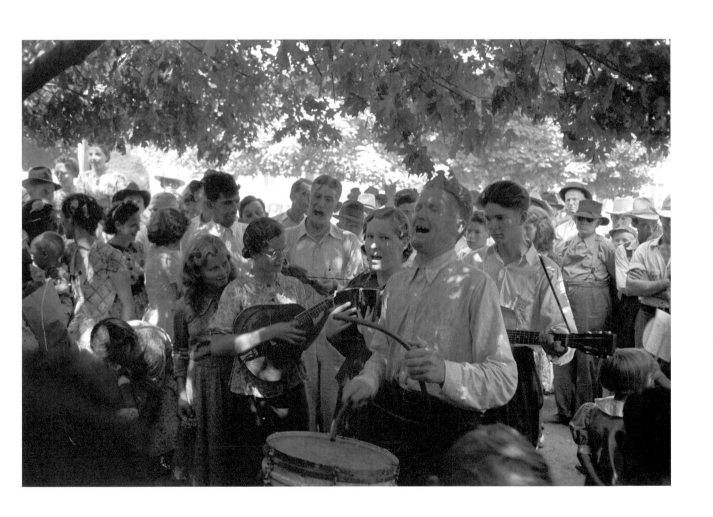

Revivalist rally under tree in square,
Saturday afternoon, Tahlequah,
Oklahoma. July 1939. Russell Lee.

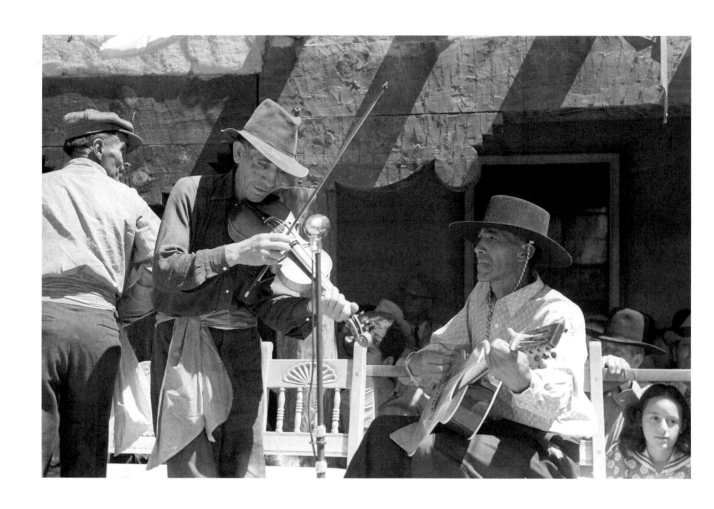

Spanish-American musicians playing
at the fiesta at Taos, New Mexico. July
1940. Russell Lee.

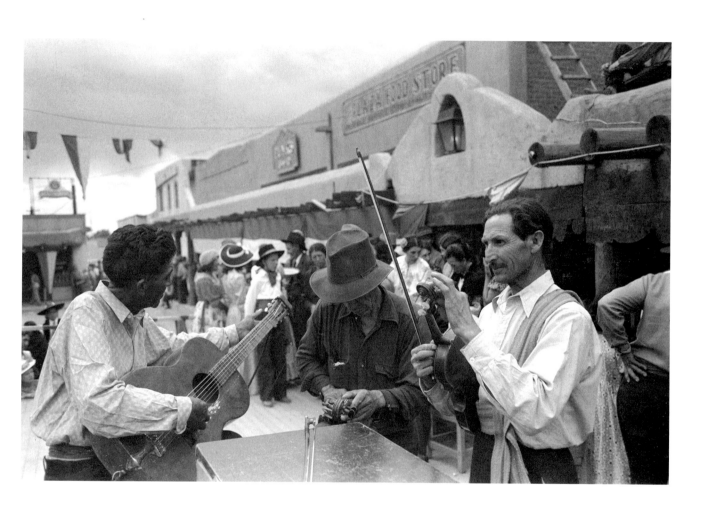

[Spanish-American musicians playing
at the fiesta at Taos, New Mexico.
July 1940.] Russell Lee.

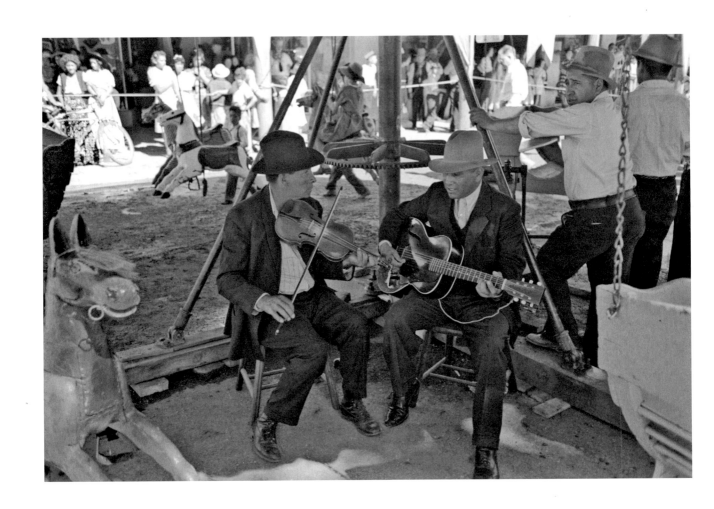

The music for the merry-go-round.
Fiesta, Taos, New Mexico. July 1940.
Russell Lee.

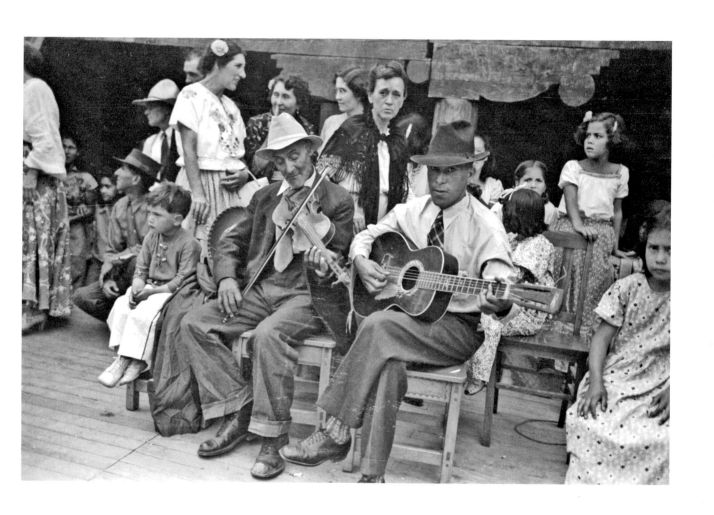

[Spanish-American musicians at
fiesta, Taos, New Mexico. July 1940.]
Russell Lee.

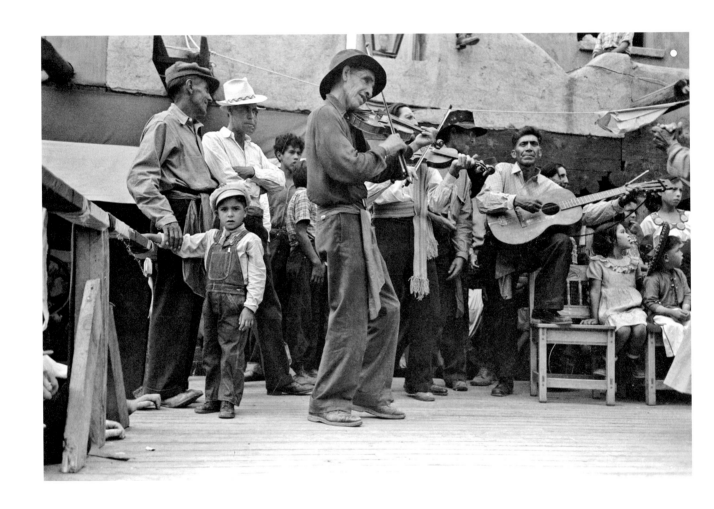

[Spanish-American musicians at
fiesta, Taos, New Mexico. July 1940.]
Russell Lee.

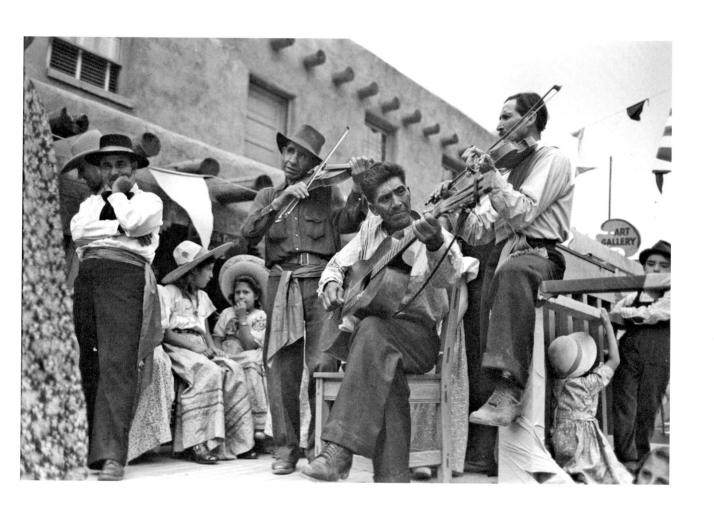

Spanish-American musicians at fiesta,
Taos, New Mexico. July 1940.
Russell Lee.

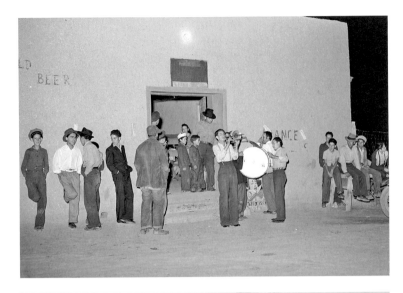

Orchestra with traveling show (Spanish-American). Penasco, New Mexico. July 1940. Russell Lee.

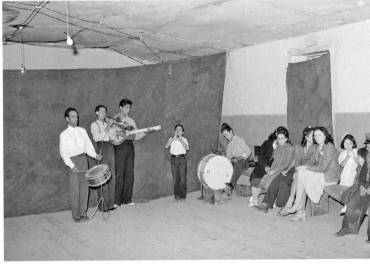

Orchestra and audience at Spanish-American traveling show. Penasco, New Mexico. July 1940. Russell Lee.

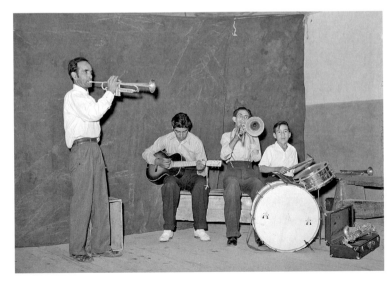

Orchestra with traveling show (Spanish-American). Penasco, New Mexico. July 1940. Russell Lee.

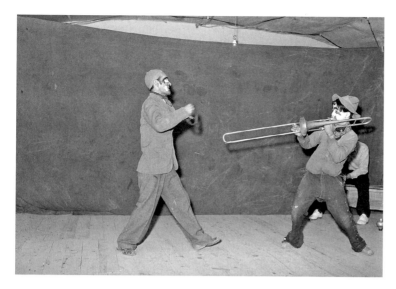

Penasco, New Mexico. Spanish-American clowns at a traveling show. July 1940. Russell Lee.

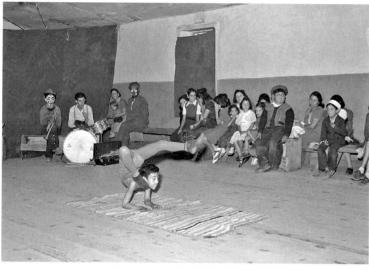

Acrobat and audience at Spanish-American traveling show. Penasco, New Mexico. July 1940. Russell Lee.

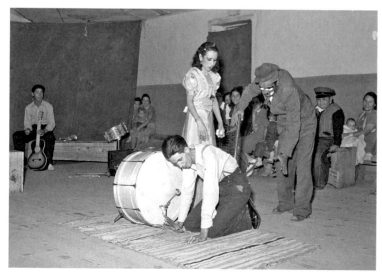

Players of Spanish-American show. Penasco, New Mexico. July 1940. Russell Lee.

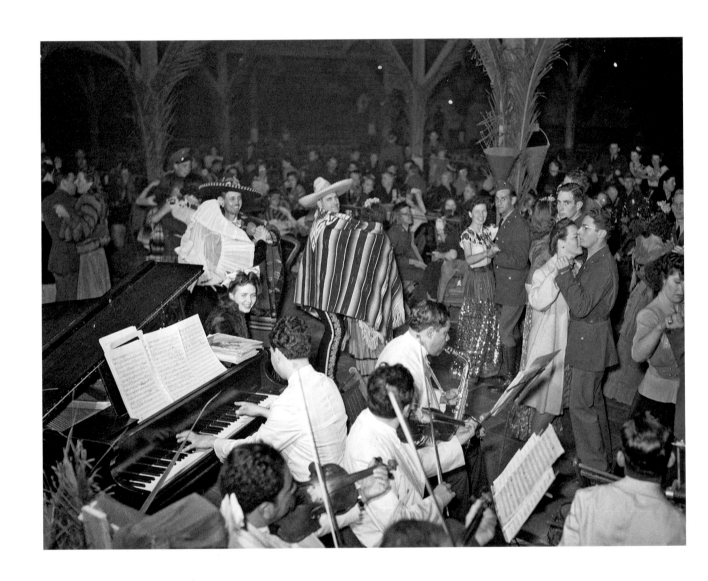

Brownsville, Texas. Charro Days
fiesta. Dance at El Rancho Grande.
February 1942. Arthur Rothstein.

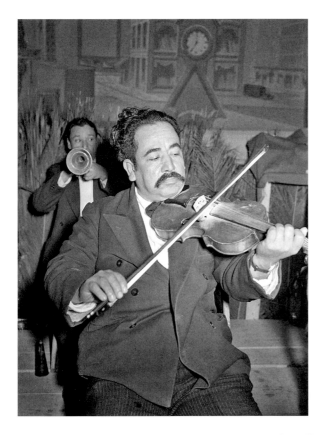

Brownsville, Texas. Charro Days fiesta. Member of Mexican orchestra at El Rancho Grande. February 1942. Arthur Rothstein.

Mexican boy playing guitar in room or corral, Robstown, Texas. February 1939. Russell Lee.

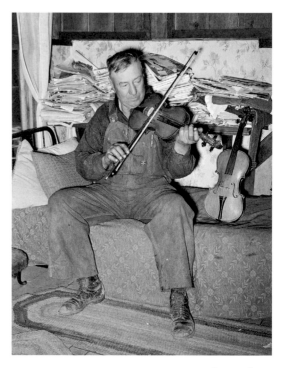

Farm boy playing guitar in front of the filling station and garage, Pie Town, New Mexico. July 1940. Russell Lee.

George Hutton, farmer from Maud, Oklahoma, playing his violin, which he made. July 1940. Russell Lee.

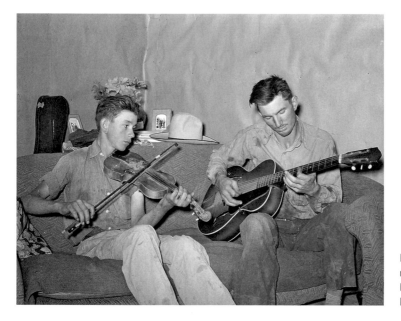

Farmer and his brother making music. Pie Town, New Mexico. July 1940. Russell Lee.

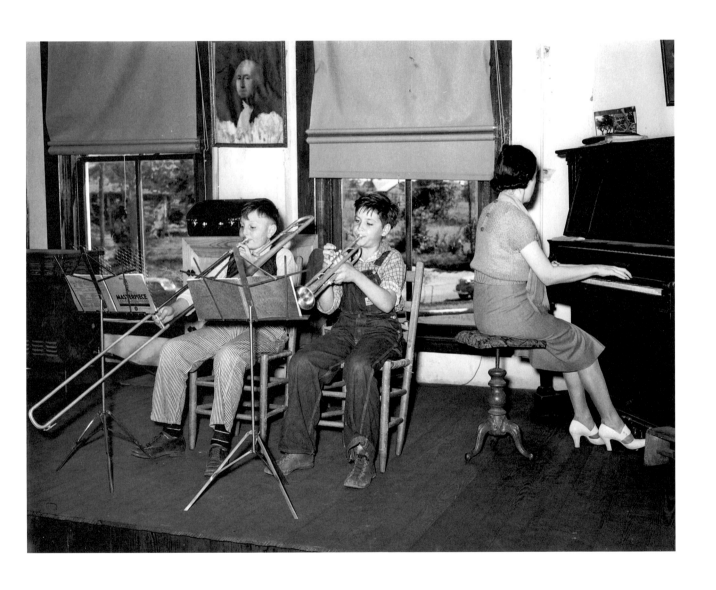

Music lesson. Grade school,
San Augustine, Texas. April 1939.
Russell Lee.

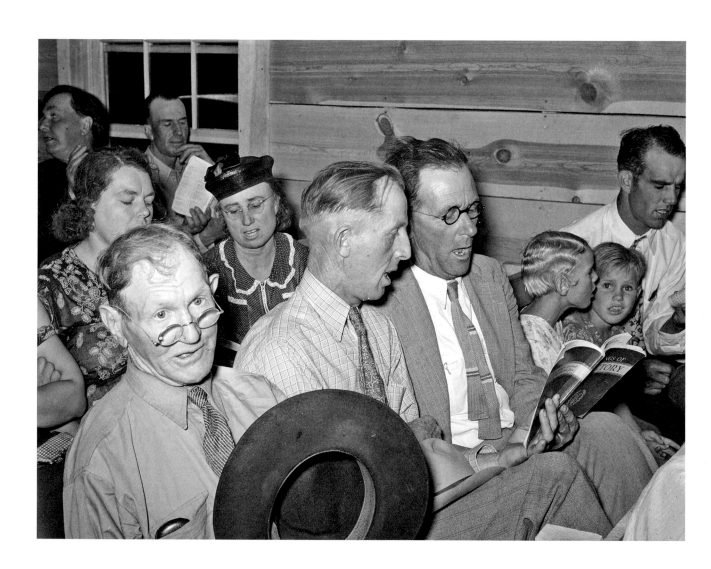

At the community sing. Pie Town,
New Mexico. June 1940. Russell Lee.

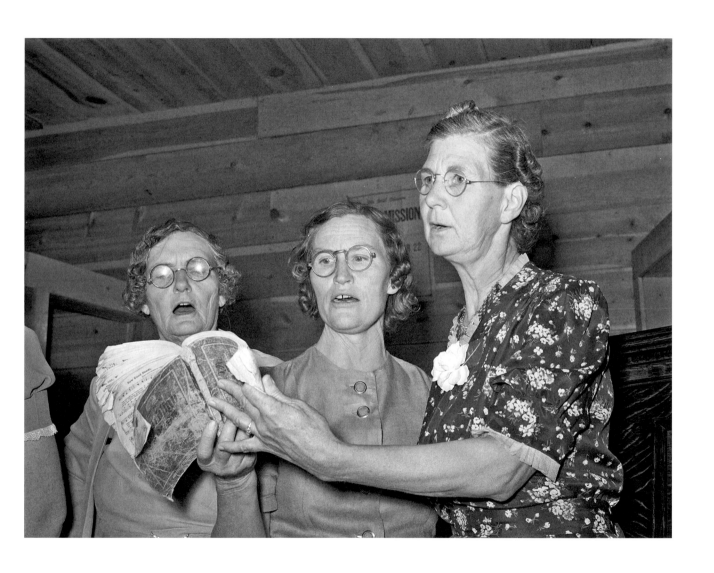

Three members of ladies' quintette at community sing. Pie Town, New Mexico. June 1940. Russell Lee.

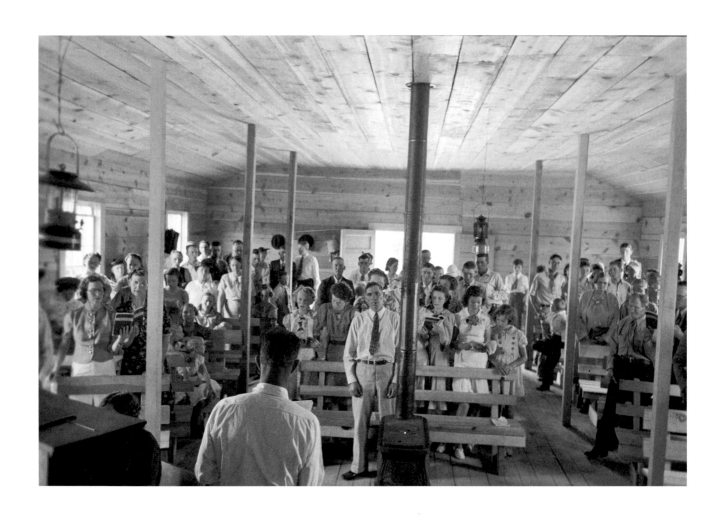

All day community sing, Pie Town,
New Mexico. June 1940. Russell Lee.

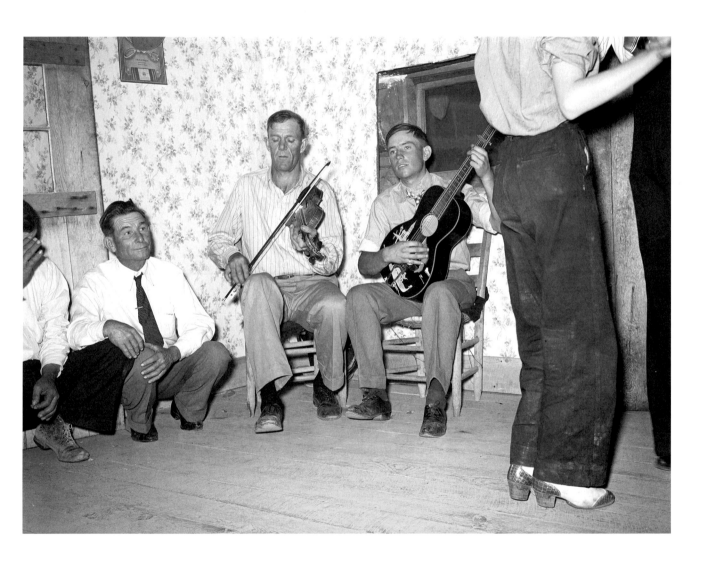

Musicians at the square dance.
Pie Town, New Mexico. June 1940.
Russell Lee.

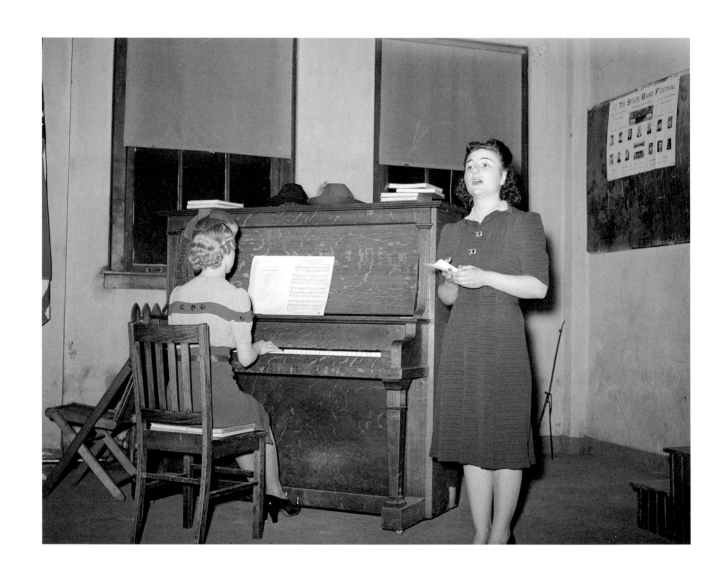

Young lady from nearby college sing-
ing at the Jaycee buffet supper and
party. Eufaula, Oklahoma. February
1940. Russell Lee.

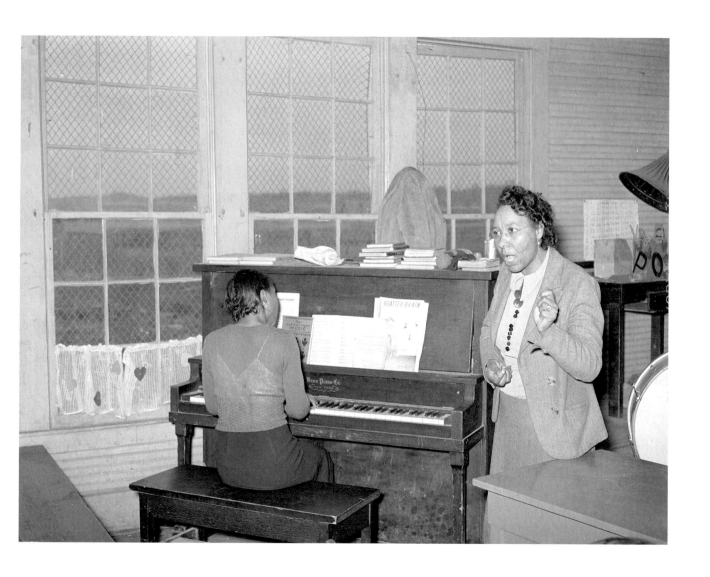

Song director conducting singing of
Negro spiritual at soil conservation
meeting at Vernon, Oklahoma.
February 1940. Russell Lee.

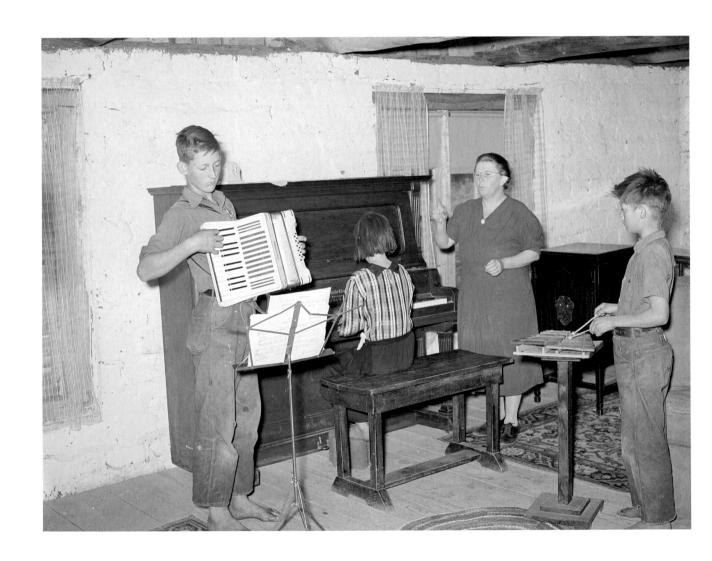

Wife of a homesteader with her WPA music
class. These children walk eight miles for
their music lessons. Pie Town, New Mexico.
June 1940. Russell Lee.

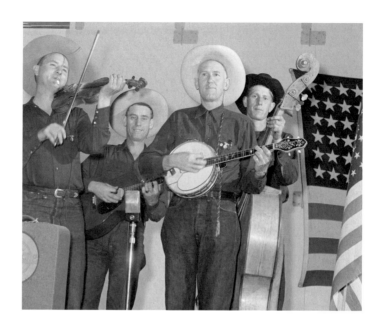

California

California also plays a key role in the migrant story; it's where the Joads ended up and most of the Dust Bowl refugee experience, as we know it, took place. Amid the hard-bitten faces that we have come to recognize as the look of the era's migrant workers, there are a few things that did not make it into John Steinbeck's novels or Woody Guthrie's songs, such as blackface performance and religious conversion.

The state was also the location of two important folk music–collecting projects. Sidney Robertson Cowell, who began her fieldwork as one of Charles Seeger's RA folklorists, conducted the Works Projects Administration's California Folk Music Project, while Charles L. Todd and Robert Sonkin documented the lives of residents in Farm Security Administration migrant workers' camps.[1]

Informants for Todd's and Sonkin's collection, the King family (p. 117) are emblematic of the migrant experience. In 2004, I managed to locate the mandolin player, Charlie "Babe" King, and asked him whether he remembered meeting or being photographed by Dorothea Lange. "No," he said. "We had our picture taken in tents a lot back then."

Charlie King was born in 1928 in Ft. Smith, Arkansas, where his father worked in a furniture factory and later owned a store and service station in Midway. In Ft. Smith, the family band—including Charlie's brother, Harlen (guitar, behind towel in photo), sister Julia (or "Tootie," violin, on bed in photo), brother John (drums), brother Bill (bass),

and their father (banjo—four-string in the band and five-string for "specialty tunes")—played once a week on radio station KWXY. Sponsored by a local clothing store, the show featured the band playing requests that listeners had written in. Their instruments were second-hand, fixed up by their father, and the band's repertoire included "country tunes and old-time religious tunes," including "Give Me That Old Time Religion."

When their father lost the store in Midway, the family worked around Arkansas and Mississippi for a while and in 1938 decided to go to California. They traveled in a used Lincoln Family Car, built a rack on top for the instruments, and pulled a hard-tired trailer behind. In Buckeye, Arizona, the family ran out of money. They found work picking cotton and got a job playing in a local movie theater during reel changes. They stayed for a month, then left for California. Once there they followed the crops, sometimes in government camps, sometimes in company ones: pea picking at Point Conception, fruit at Thornton. In most places, Charlie's father and older brother played at local taverns for extra money.

At the FSA camp at Arvin, the family played for dances on Saturday nights. There were other bands in the camps, and they held regular jam sessions, playing "Red River Valley" and "Coming Round the Mountain," songs they would soon play in the barn dance scene at the end of Twentieth Century-Fox's *The Grapes of Wrath*. The Kings were paid for their work, "but not that much," according to Charlie. When filming was completed they returned to Arvin to pick fruit.

Charlie was never all that interested in playing music. His dad was, and it was a good way to earn extra money during hard times. Charlie played clarinet in high school band, and as an adult he called square dances. Today he occasionally plays mandolin and clarinet for his own pleasure.[2]

Much has been written about Dorothea Lange's sequence of Salvation Army photos, but never from a musicological perspective. By the 1930s, most Salvation Army bands, especially in the larger corps, emphasized brass bands as a means of drawing attention and gathering a crowd before preaching. Smaller corps often used guitars and concertinas or accordions. ("Scandinavian bands" were often comprised of guitars, banjos, violins, and accordions.) Their repertoire favored traditional hymns, such as "The Old Rugged Cross," that the men on skid row would recognize and perhaps be comforted by, as well as "street tunes," secular songs reworked with religious lyrics.

The accordion player in Lange's series is Adjutant Bill Nock and the guitarist his wife, Lydia. (The guitar she is playing appears to be a 1934 or later Gibson L-7.) Both were born in England in the 1880s. He worked as a nail maker and she as a domestic before becoming Salvation Army officers. The couple moved to the United States in 1925 to accept their first appointment at San Francisco's Third Street Corps.

According to Lt. Col. Don McDougal, who knew the couple when they were older, Bill was a respected musician who was involved in Salvation Army vocal groups. In the 1950s, then a major, he led the Los Angeles Tabernacle Songsters and played sousaphone in the Los Angeles Congress Band. Lydia is remembered as more of a "background figure," and little is known about her musical life.[3]

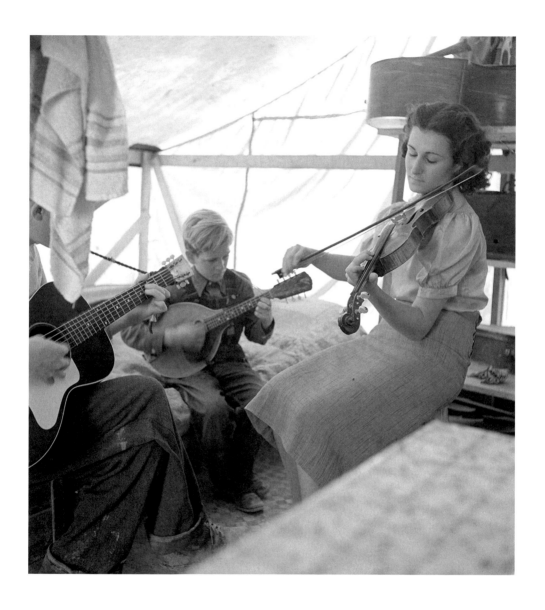

Migrant family from Arkansas playing
hill-billy songs. Farm Security Administra-
tion emergency migrant camp. Calipatria,
California. February 1939. Dorothea Lange.

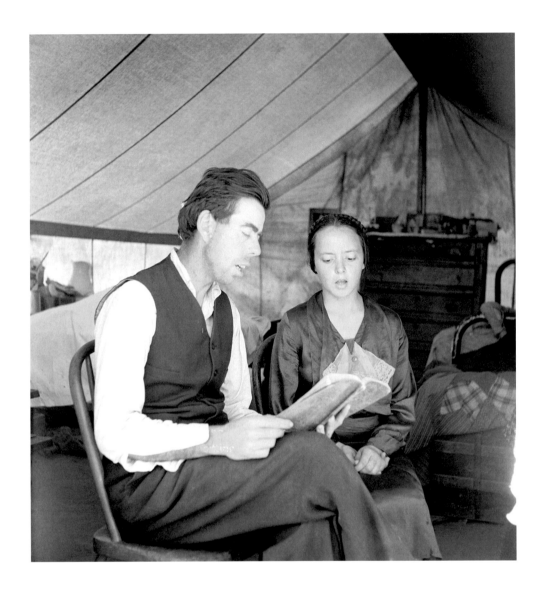

The Great Reaping Day. Hymn singing, Sunday
afternoon. The woman had been "saved" the
week before. Oklahoma potato pickers. Kern
County, California. March 1937. Dorothea Lange.

Singing hymns before opening of meeting
of Mothers' Club at Arvin Farm Security
Administration camp for migrants, California.
November 1938. Dorothea Lange.

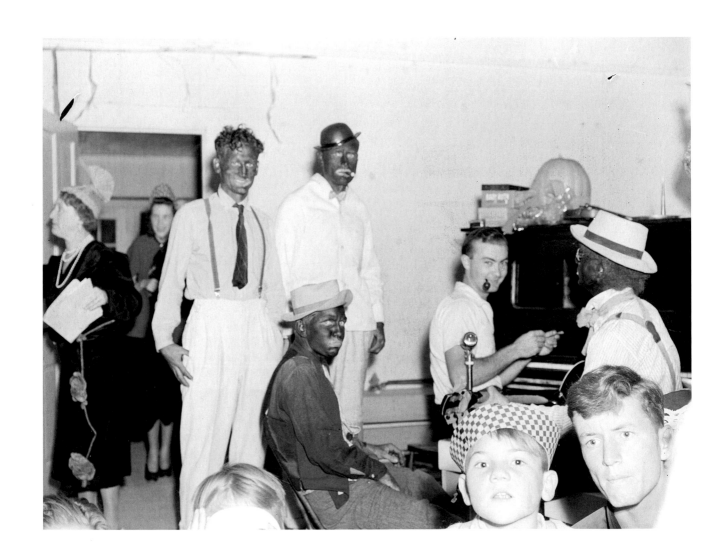

[Halloween party, Shafter camp for
migrants, California. November 1938.]
Dorothea Lange.

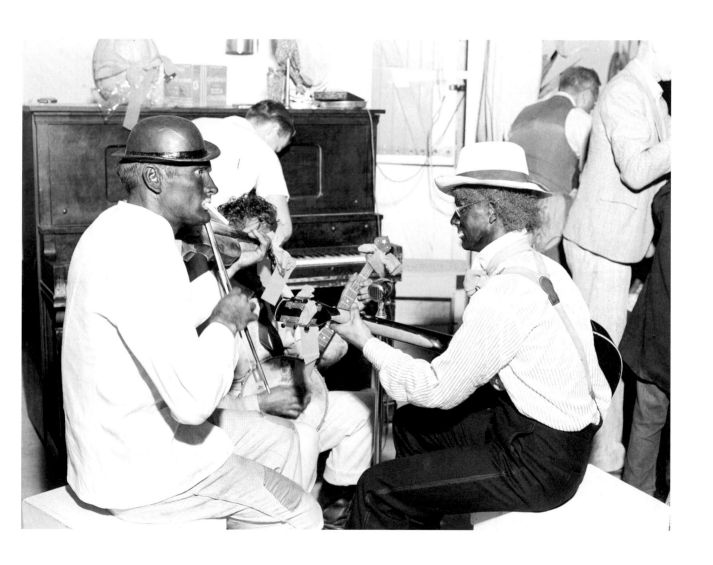

Camp talent provides music for
dancing at Shafter camp for migrants.
Halloween party, Shafter, California.
November 1938. Dorothea Lange.

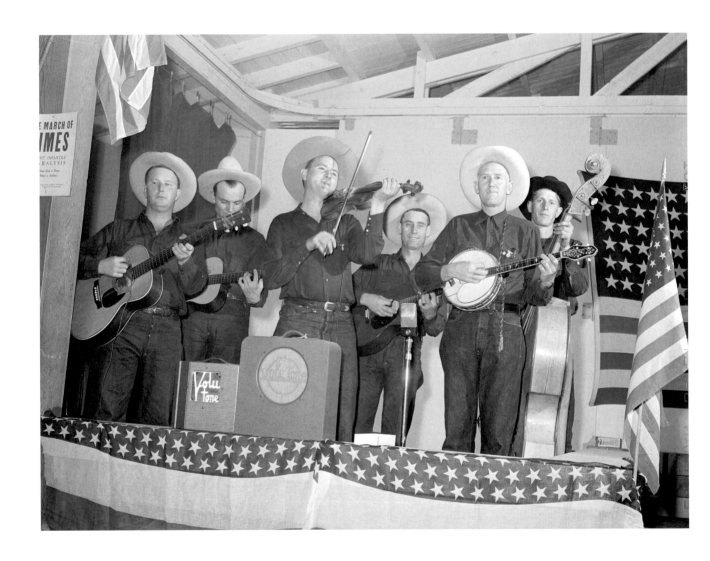

Tulare County, California. FSA farm
workers' camp. Hired orchestra which
played at the President's birthday ball.
February 1942. Russell Lee.

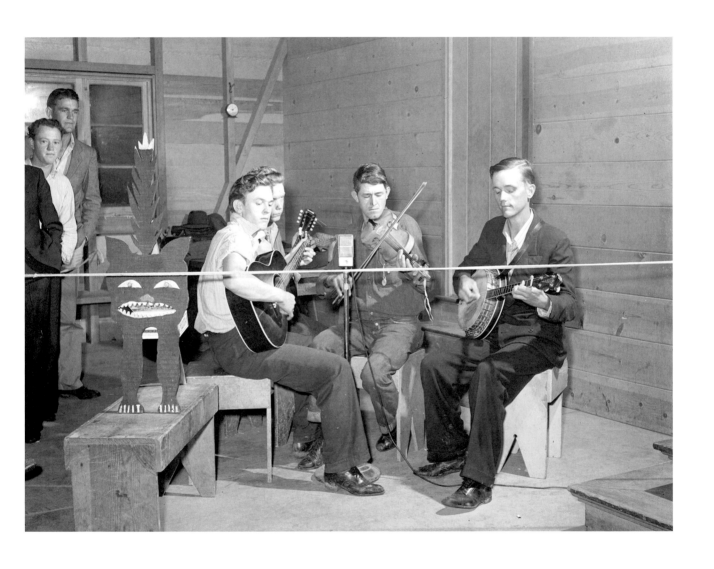

Band playing at Saturday night dance.
Tulare migrant camp. Visalia, California.
March 1940. Arthur Rothstein.

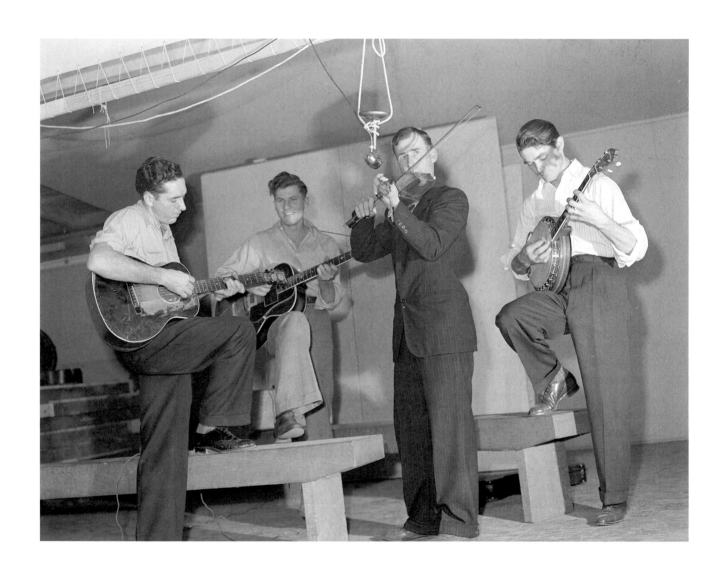

Woodville, California. FSA farm workers'
community. Musicians at the Saturday
night dance. January 1942. Russell Lee.

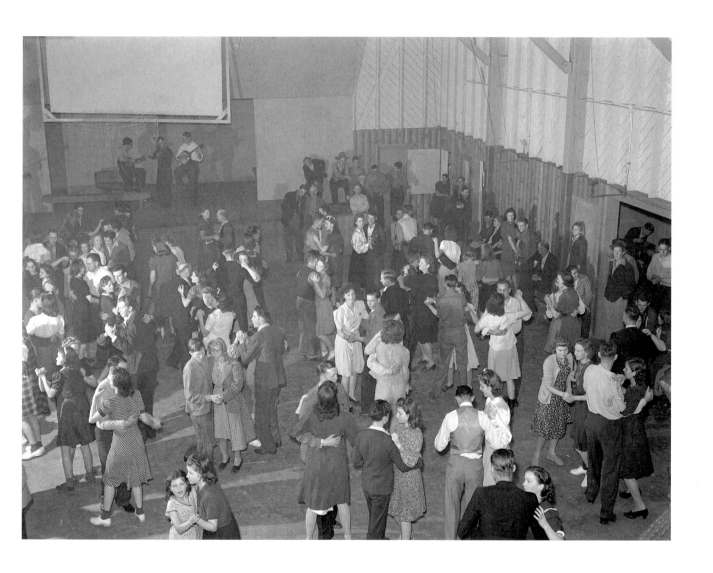

Woodville, California. FSA farm workers'
community. Saturday night dance in the
auditorium of the community house.
January 1942. Russell Lee.

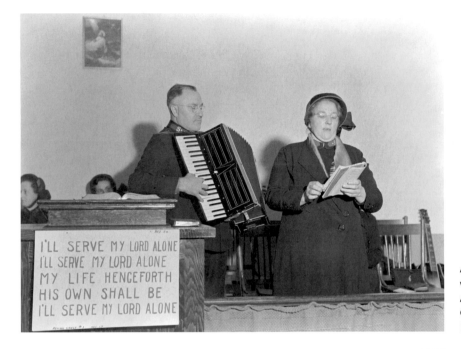

Adjutant and his wife sing. Salvation Army. San Francisco, California. April 1939. Dorothea Lange.

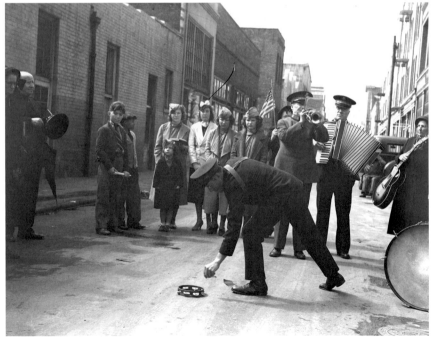

Salvation Army, San Francisco, California. Army contributes first to the tambourine (two dollars), outside contribution about seventy-five cents, all from drunks and the like. April 1939. Dorothea Lange.

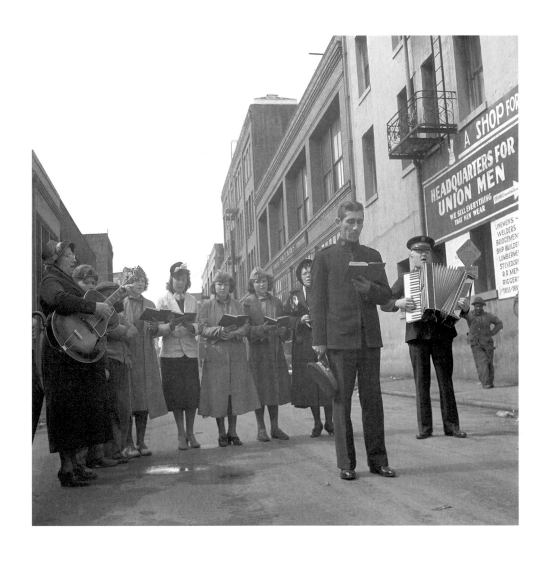

At Minna Street the army forms
a semi-circle and sings to attract
a crowd. Salvation Army, San
Francisco, California. April 1939.
Dorothea Lange.

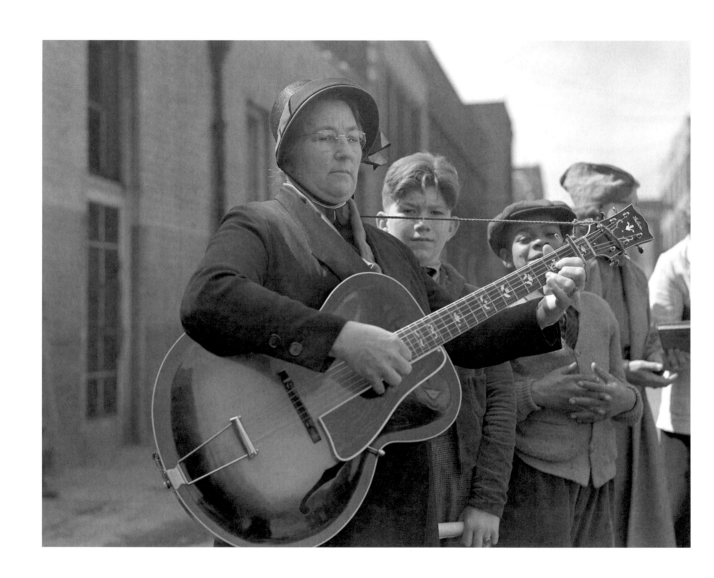

Solo. Salvation Army, San Francisco,
California. April 1939. Dorothea Lange.

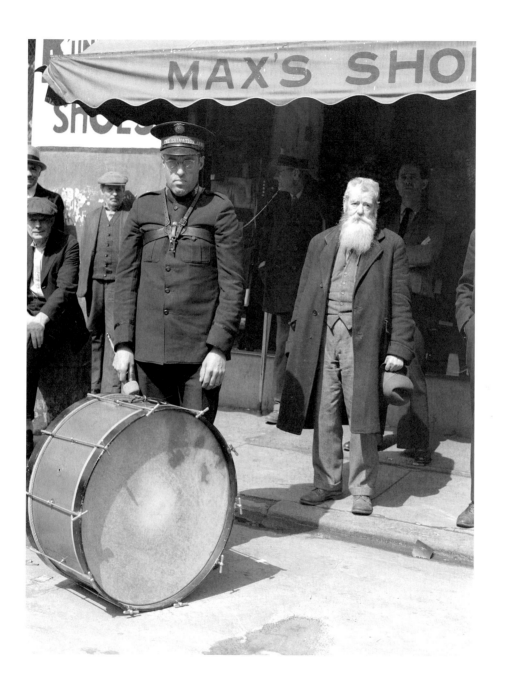

Salvation Army, San Francisco, California.
Soldier: "I go panhandling every night at bars
and places. You wouldn't want a picture of that,
it's just beggin." April 1939. Dorothea Lange.

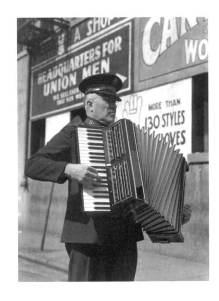

Solo.

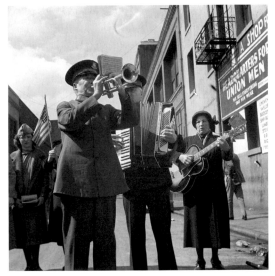

Trio.

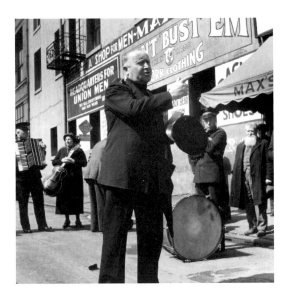

"Power of the Lord" preaching by a
"soldier" saved twelve years before,
and with the army ever since. All
Salvation Army, San Francisco,
California. April 1939. Dorothea Lange.

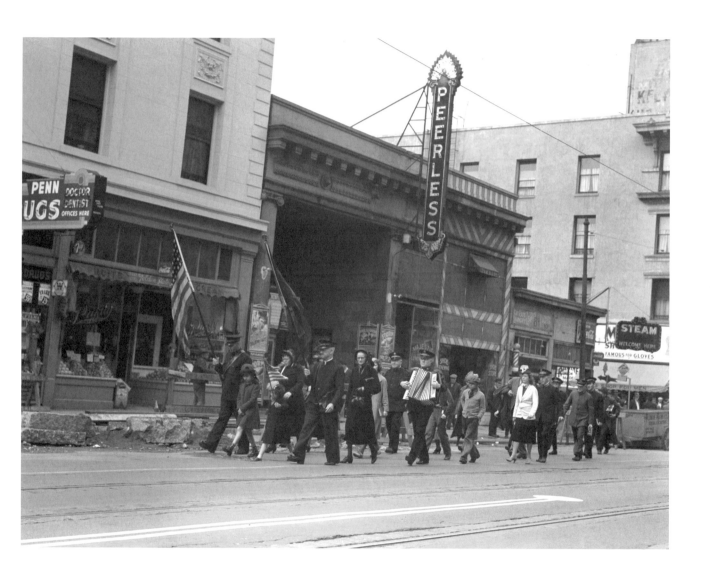

Salvation Army, San Francisco,
California. Returning to headquarters;
no recruits to audience from street.
April 1939. Dorothea Lange.

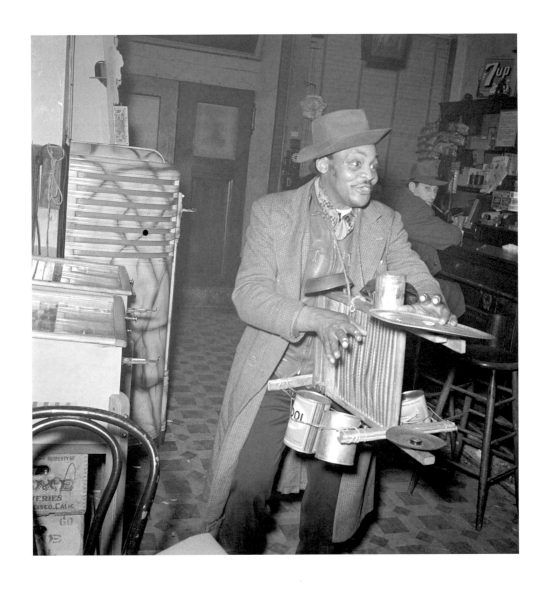

One man tin can band during
blackout. San Francisco, California.
December 1941. John Collier.

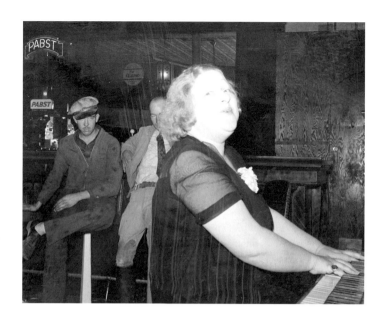

Northwest and High Plains

Of the FSA photographers, John Vachon was the most enthusiastic about music. Although he didn't play, himself, he was an ardent fan of quite a few jazz players, citing as his favorites Louis Armstrong, Jimmy Noone, Jelly Roll Morton, Jimmy Dorsey, and George Gershwin. While on assignment he would write home to his wife, Penny, about hearing Noone, Baby Dodds, and local bands he encountered while on the road.[1] Vachon's letters offer the most candid look into the musical tastes and sensibilities of any of the FSA photographers.

In North Platte, Nebraska, in October 1938, he wrote both to Penny and to Roy Stryker about photographing saloon piano player Mildred Irwin, a former Omaha prostitute. The two letters are similar, the one to Penny offering more in the way of musical detail:

> At the piano was a big huge large fat blonde woman of 45 to 50 yrs. With beautiful smeary red make up on her puss, and huge mammy type bosoms. And her voice, O that you could hear her voice. She has Sophie Tucker in the waste basket. Her piano was good honky tonk, back and forth stuff like I could never seem to make you do. The customers feed her kitty, and requested nasty songs that she knew.—one called "I wish I was a Fascinatin' Bitch" all about a girl who wanted to be a prostitute. And another about her man—pretty double entendre and dirty. All the others were legitimate—"Some of These Days," "After You've Gone," "Blue Skies," etc.[2]

Four years later, Vachon wrote to Penny from Lincoln, telling her the details of a photo project on students at the University of Nebraska. One of his subjects, Jesse Younger, earned money by working in a band:

I had a really wonderful time last night—from 10 till 1. I went to the Elks to photograph Jesse playing his sax. I took him and a few others of the band, but most of the time I just sat in with the boys, quashing my urge to take a chorus. My Goodness I love to be there. I am going to become a band hanger on. I learned a lot, saw how they work, etc. It's five pieces, Jesse just plays the sax, tenor sax. The leader doubles on sax and clarinet. Really 1st rate sweet pure free jazzy trumpet. Piano (girl) and drums. They have arrangements for all numbers—some the regular commercial ones you buy, others look local, written down, but I don't think they're home made. During many numbers however each of the 3 boys who blow stand up for out of their head choruses, and while they're doing it the others often make up real swell stuff to go with it. Jesse is definitely the least inspired of the players, except the piano which is strictly from hunger. Jesse plays very intelligently, stylistically. I can clearly see his classical training when he does an extempore chorus on Exactly Like You, let us say. He isn't corny, he fits in well, with something all his own. He just doesn't move very far out. Now the leader, playing clarinet, probably comes closer to corny. He grates once in a while. But every time he stood up, let out those first familiar notes of a clarinet about to take off, I would get it in the spine. He uses an awful lot of stuff from other people. But that trumpet is really good. Some one should hear him. He would do one with Sweet Georgia Brown, swell, and then surprise everyone by going right into another one with Sweet Georgia Brown, really flying, all the boys riding. He sounded very much like Beiderbecke, really. Except a little sweeter tone. The drum boy I guess was good. He sounded good to me. But I never seem to hear a drummer to my dissatisfaction. He looked the part very much, goofy gesticulations, dopey face like a coke fiend. He was very young, the others were all "college men" types. He thought I was a talent scout I guess. Every time he would hit some extra fancy licks he'd look to see if I was watching him. He liked awfully having his picture took. Why can't I go all over the country sitting on band stands with my camera? It's sure wonderful to be so close to it. I've got to learn to play something. Get my clarinet fixed and buy a trombone. That's for sure.[3]

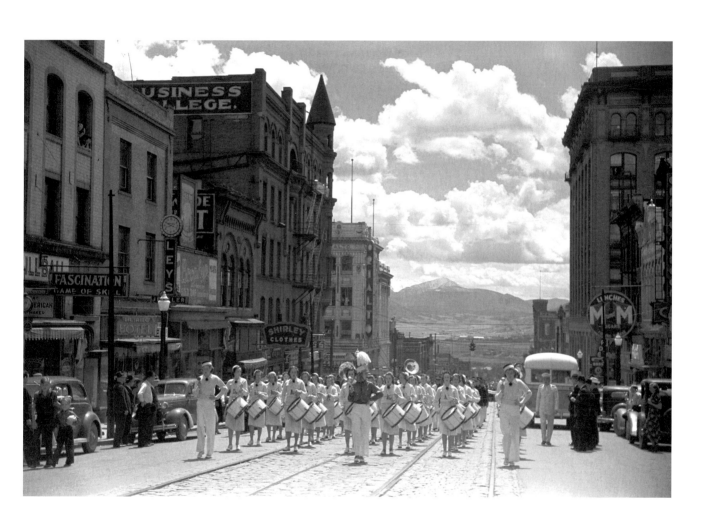

High school band parading up
Montana Street, Butte, Montana.
Summer 1939. Arthur Rothstein.

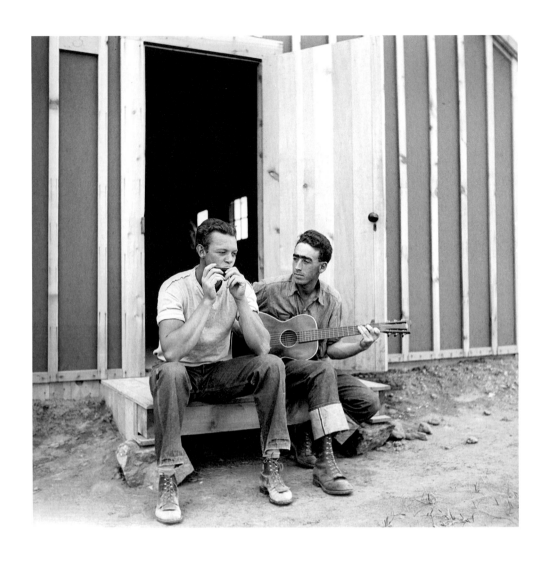

Resettlement Administration workers.
Rimrock Camp. Madras, Oregon.
July 1936. Arthur Rothstein.

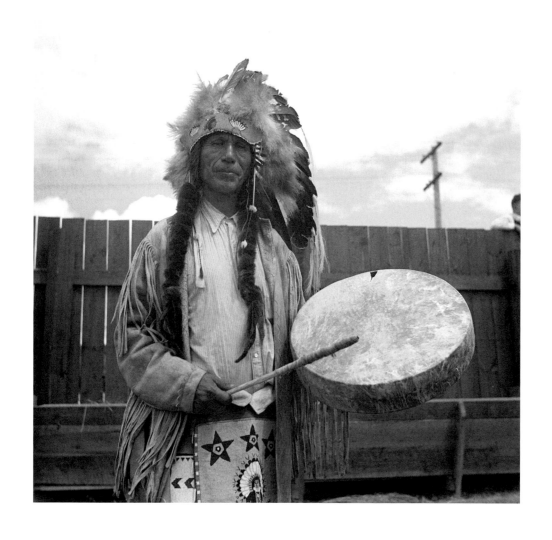

Warm Springs Indian. Molalla,
Oregon. July 1936. Arthur Rothstein.

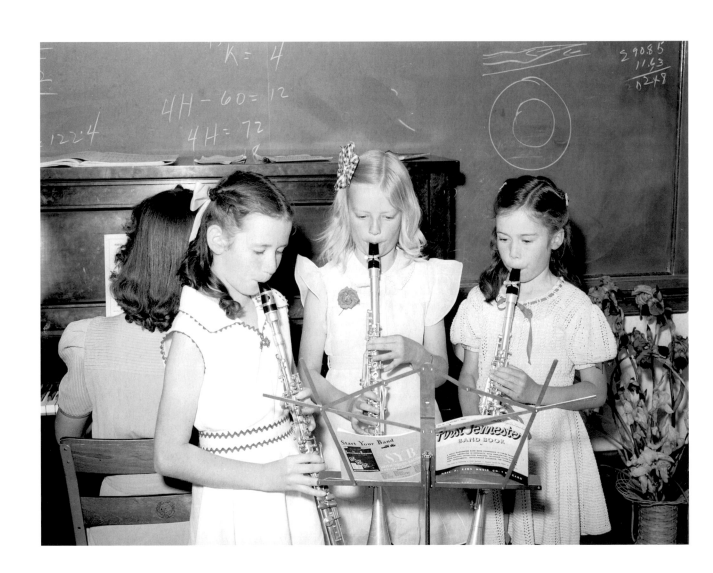

Schoolgirls give a musical number
at the 4-H Club Spring fair. Adrian,
Oregon. May 1941. Russell Lee.

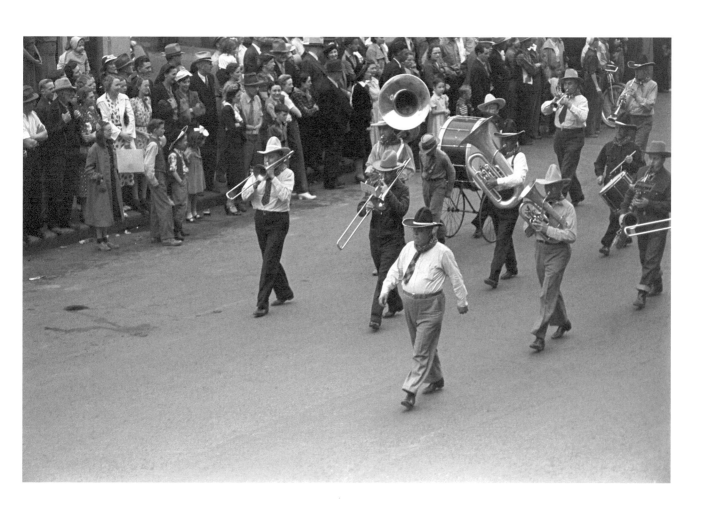

Cowboy band in Go Western parade,
Billings, Montana. Summer 1939.
Arthur Rothstein.

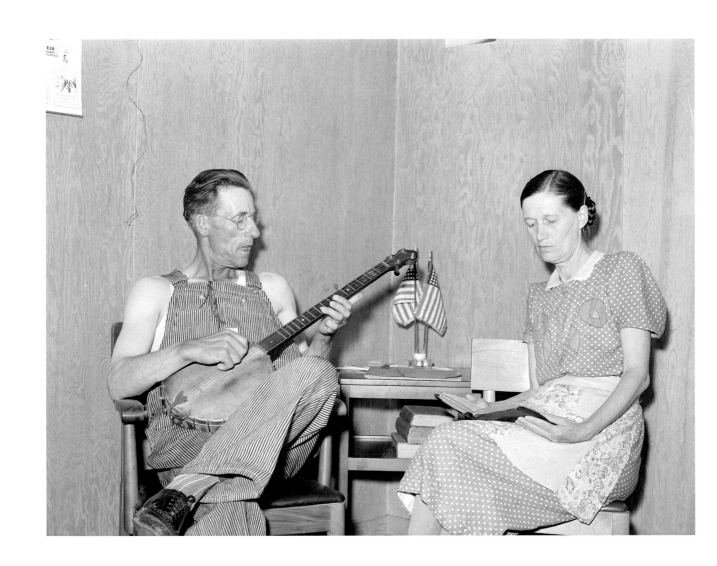

Farm worker and his wife in their
cottage home at the FSA labor
camp. Caldwell, Idaho. June 1941.
Russell Lee.

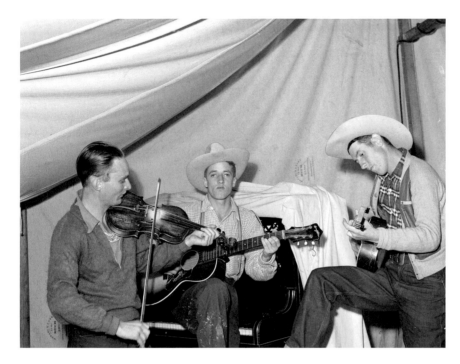

[Singing cowboy songs at entertainment at the FSA mobile camp for migratory farm workers. Odell, Oregon. September 1941.] Russell Lee.

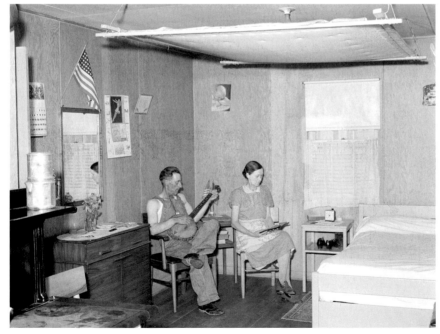

Farm worker and his wife in their cottage at the FSA labor camp. Caldwell, Idaho. Notice the quilt on frame near the ceiling. June 1941. Russell Lee.

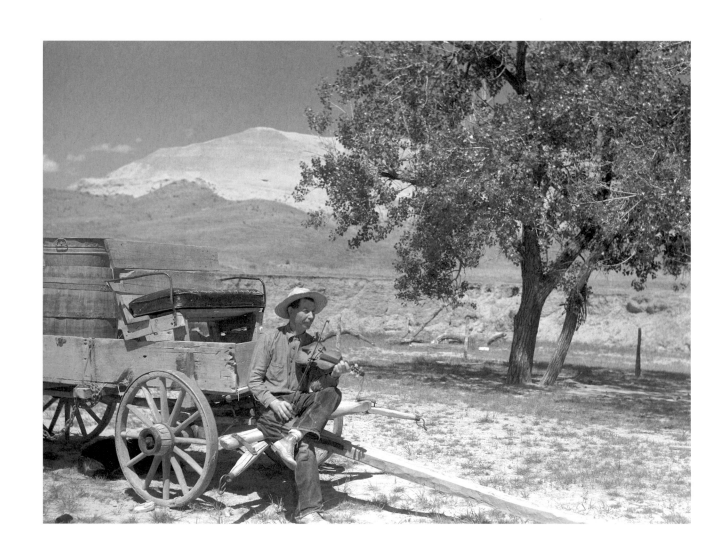

Homesteader in the land development
area. Pennington County, South
Dakota. May 1936. Arthur Rothstein.

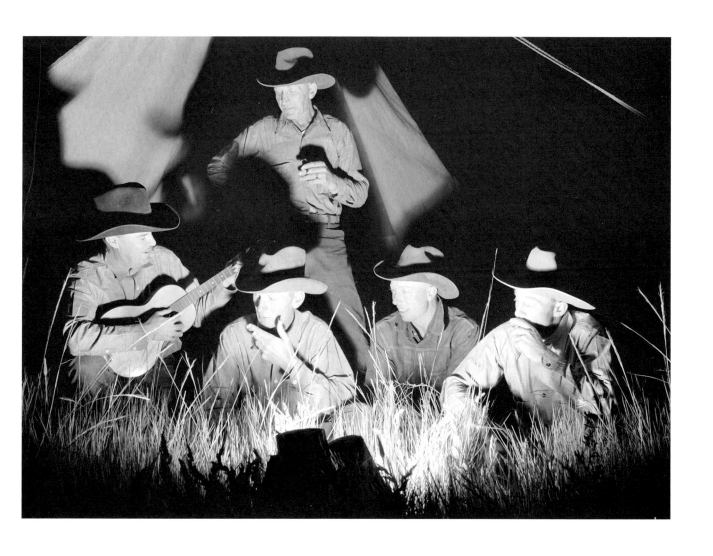

Cowhands singing after a day's work.
Quarter Circle "U" Ranch roundup.
Big Horn County, Montana. June 1939.
Arthur Rothstein.

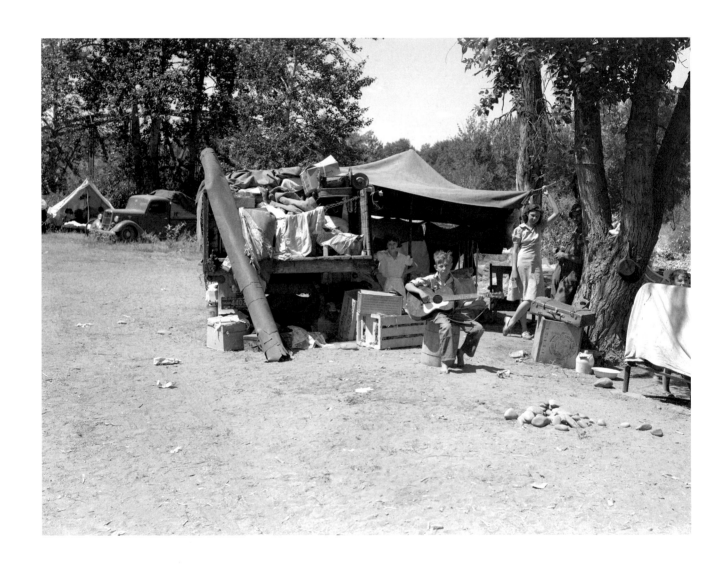

Camp of family with nine children who
have been on the road for three years.
Washington, Yakima Valley. August 1939.
Dorothea Lange.

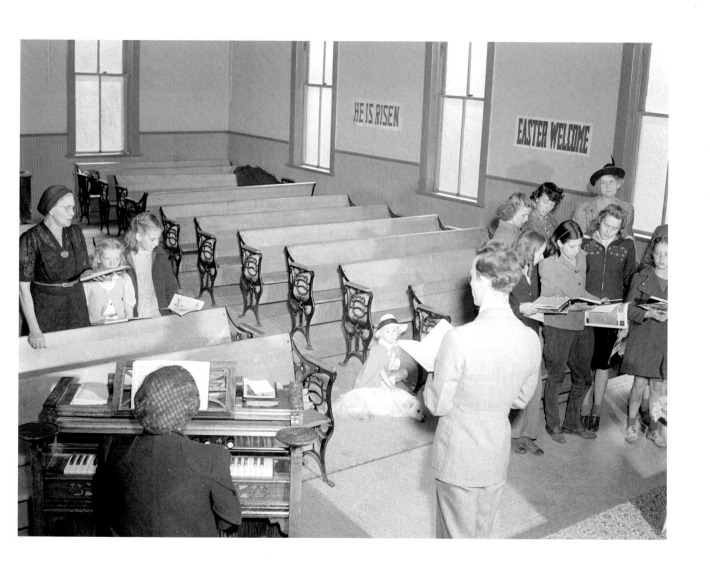

Wisdom, Montana. Singing hymns
at Sunday school. April 1942.
John Vachon.

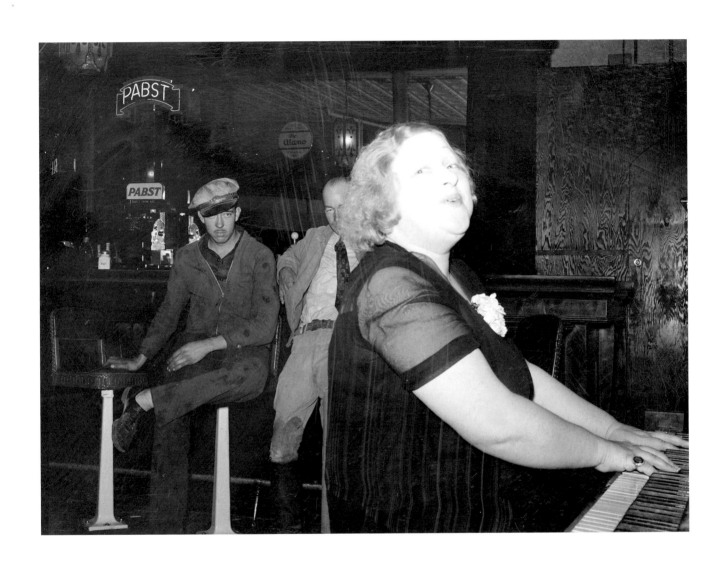

Mildred Irwin, entertainer in saloon at
North Platte, Nebraska. She entertained for
twenty years in Omaha before coming to
North Platte. October 1938. John Vachon.

[Jesse Younger playing the saxophone in small band for a Saturday night dance. He has defrayed part of his college expenses this way for four years.] Lincoln, Nebraska. May 1942. John Vachon.

Dudes harmonizing in back room
of beer parlor. Birney, Montana.
June 1939. Arthur Rothstein.

Midwest

I n the Midwest we find a disappointing possible answer to the question of what was in the pawn shops: maybe a few decent pieces but mostly a bunch of cheap, mass-produced instruments (p. 161). There were an awful lot of unremarkable musical instruments in circulation during the Depression.

By the mid-1930s, most guitar manufacturers had reached a peak in terms of structure and ornamentation. Gibson had introduced its Super 400, and C. F. Martin its flattop dreadnought models. These were landmarks in instrument design and production, but the economic realities of the Depression simply could not support instruments of that quality, and manufacturers had to find other ways to keep their doors open.

Kay, Harmony, Stella, and Regal specialized in affordable low-end models, and Gibson launched their budget division, Kalamazoo. They also produced cheap guitars for other distributors' labels. Gibson even supplemented instrument sales with a line of wooden toys, while Martin considered the idea of rosewood jewelry.[1] How any of these instruments ended up in pawn shops, or at foreclosure auctions, such as the Greene County, Indiana, sale (p. 163), in the latter days of the Depression needs little explanation.

Band instruments made their way to the pawn shops in the same way, but there might have been another factor at work. John Philip Sousa's death in 1932 marks the end of the old era of band music, one where it was not only a popular form of entertainment

but the dominant one. It had been an era when commercial, military, and community bands were ubiquitous, often prestigious and commercially successful.

By the 1930s, the focus had shifted to school bands, with the primary emphasis on education rather than entertainment. No longer was a "celebrated cornet soloist" the hottest guy on the scene. Still, the community bands held on. They played for local functions and gave concerts on town squares, sometimes with the older style of instrumentation and seating arrangements.[2]

The FSA photographers, like most people, tended to see the community band as a cultural marker that indicated traditional small-town life, volunteer participation, and American values. As Jason Michael Hartz notes, bands and their inclusive nature "exemplify the egalitarian spirit of America—they are neither pretentious nor vulgar."[3] From Charles Ives to the *Andy Griffith Show,* the local band has been used to invoke a sense of the virtues of the American character.

Band concert in park. Kellogg,
Minnesota. July 1941. John Vachon.

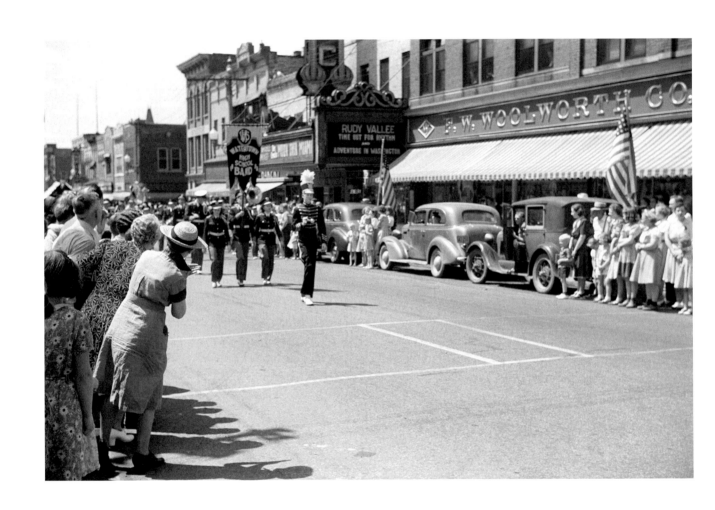

Fourth of July parade, Watertown,
Wisconsin. July 1941. John Vachon.

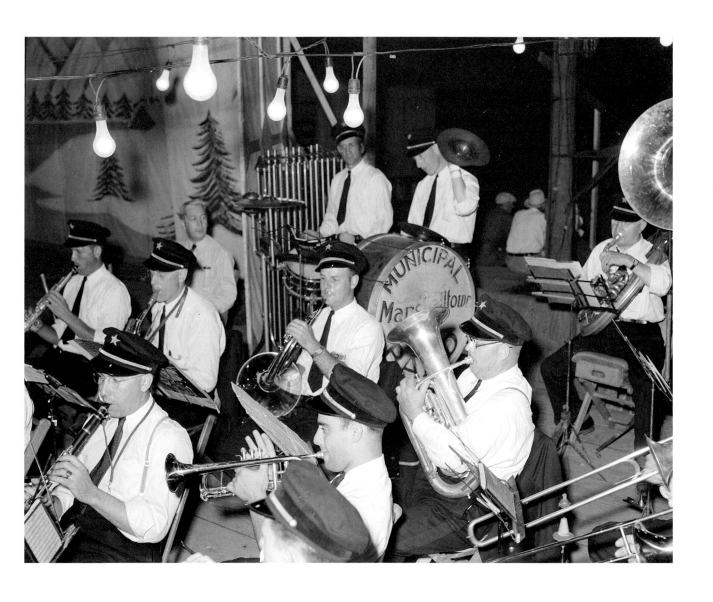

Municipal band at the Central Iowa Fair. Marshalltown, Iowa. September 1939. Arthur Rothstein.

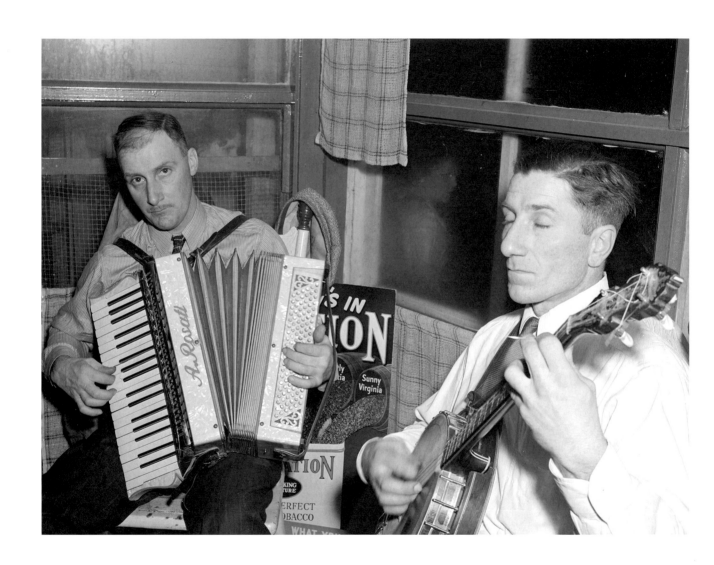

Meeker County, Minnesota. Music
supplied by two Meeker County
farmers for dance at crossroads store.
February 1942. John Vachon.

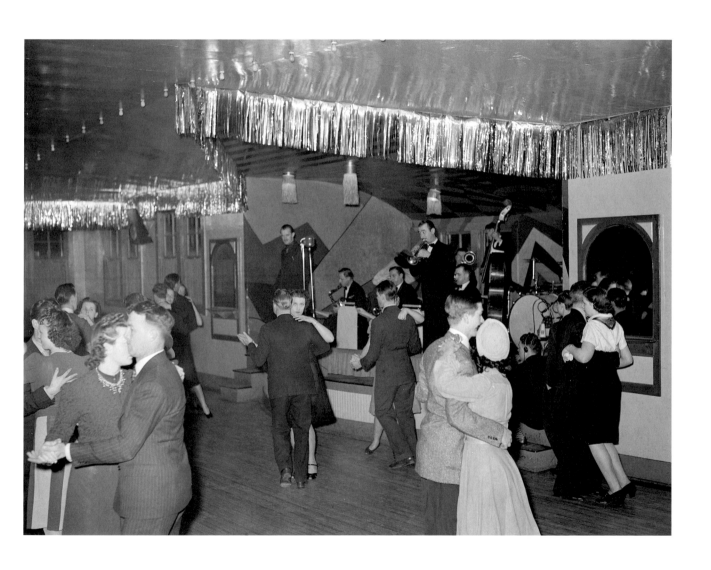

Dance hall, Saturday night.
Marshalltown, Iowa. February 1940.
Arthur Rothstein.

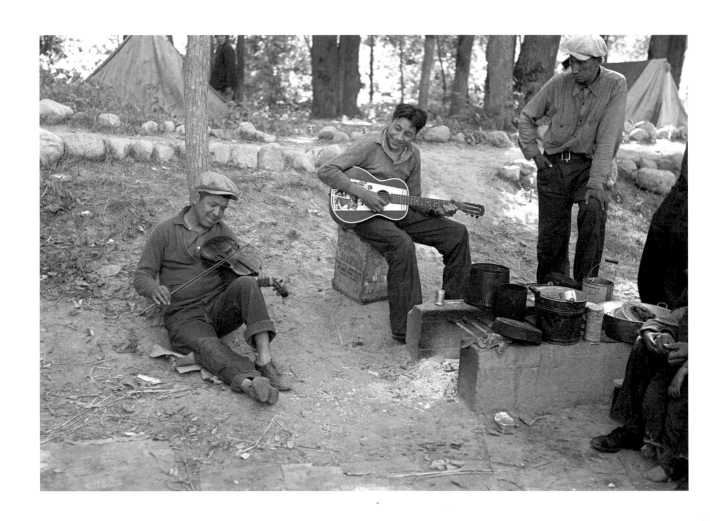

Indian boys playing guitar and violin
in blueberry camp near Little Fork,
Minnesota. September 1937.
Russell Lee.

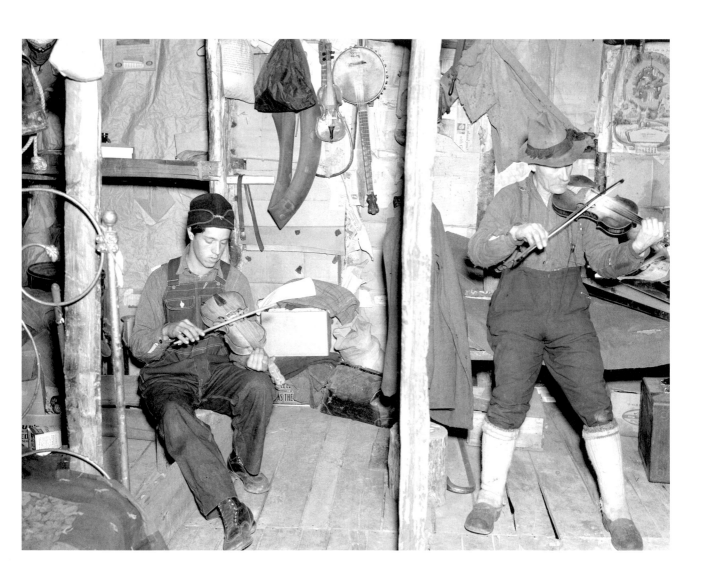

Lon Allen and his son playing their fiddles to the tune of "The Arkansas Traveler." The fiddle played by the son was made by him. Near Iron River, Michigan. May 1937. Russell Lee.

An organ deposited by the flood on
a farm near Mount Vernon, Indiana.
February 1937. Russell Lee.

Wonder bar, hot spot in Circleville,
Ohio. Summer 1938. Ben Shahn.

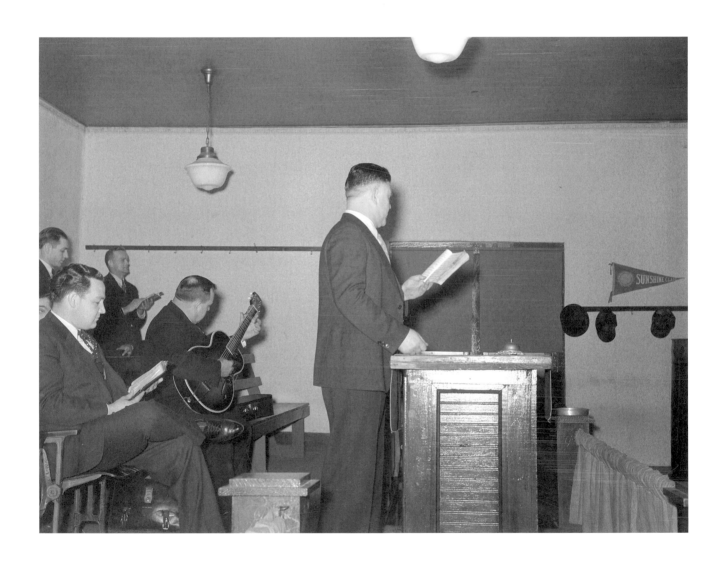

Preacher conducting hymn singing.
Pentecostal church, Cambria, Illinois.
January 1939. Arthur Rothstein.

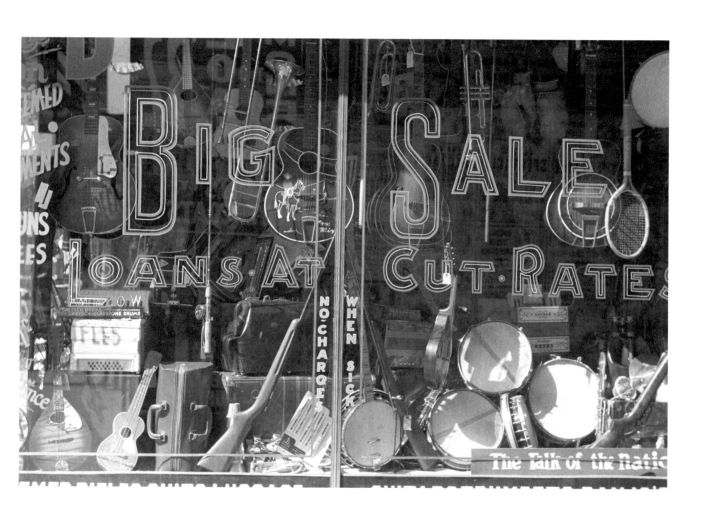

Pawnshop in Gateway District,
Minneapolis, Minnesota.
September 1939. John Vachon.

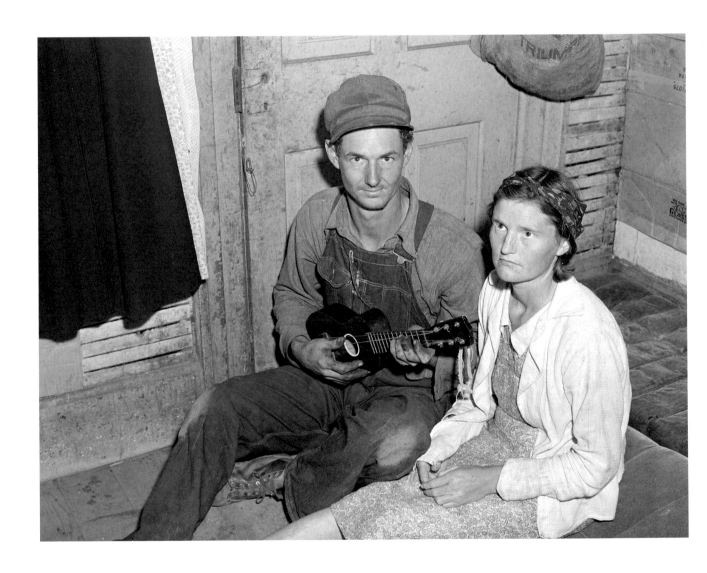

Parents of five children, migratory
fruit workers from Arkansas. Berrien,
Michigan. July 1940. John Vachon.

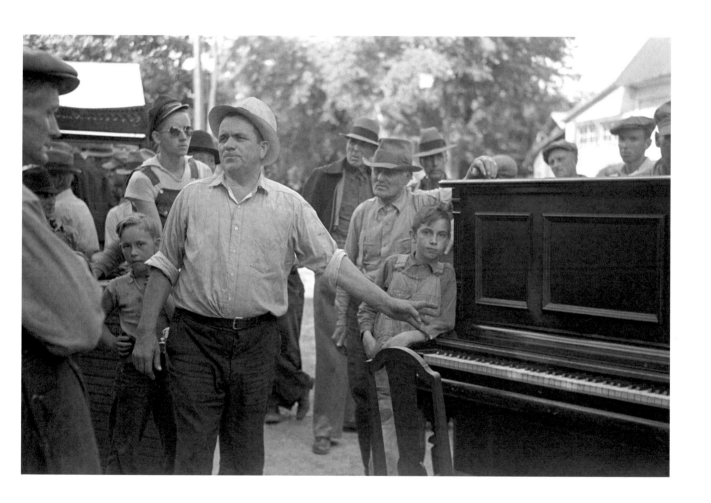

Auction sales in Greene County are frequent because
as farm conditions became worse, families move into
smaller houses and sell excess furniture. Owensburg,
Indiana. May 1938. Arthur Rothstein.

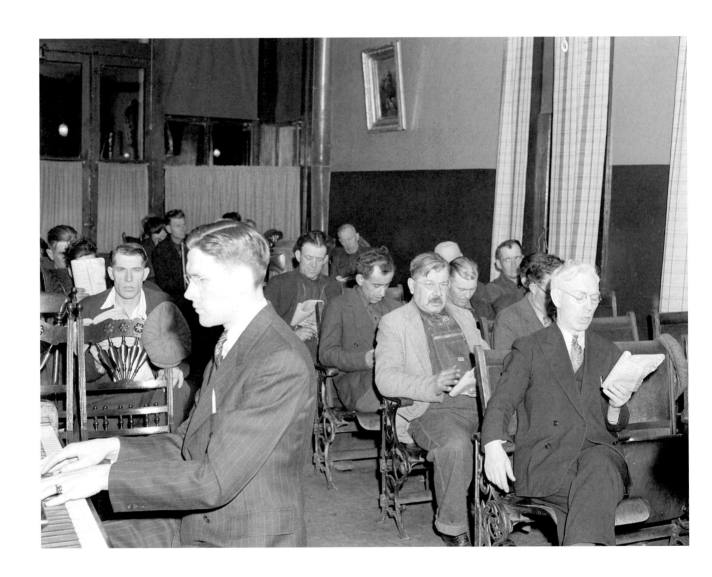

Hymn singing during evening
services at city mission for homeless
men. Dubuque, Iowa. April 1940.
John Vachon.

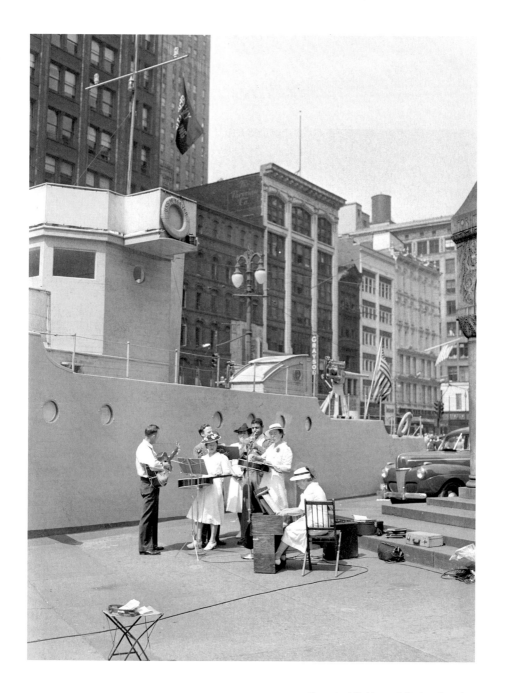

Detroit, Michigan. Mission band
playing. August 1942. John Vachon.

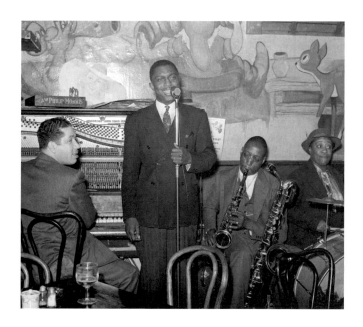

Chicago

Russell Lee and Edwin Rosskam's coverage of Chicago's South Side was a departure for the FSA, and these photos provide a look into a different part of the musical landscape, as do Jack Delano's photos of the following year. Chicago was the principal migration destination for African Americans leaving the South. In response to increasing war production and the impact of Richard Wright's *Native Son,* the FSA covered Chicago's Bronzeville neighborhood at a time when its unemployment rate had improved from 50 percent to 35 percent, and Bronzeville was saddled with a population density twice that of surrounding white neighborhoods, high disease and death rates, and pathetic housing.[1]

Amid all this was a music scene so hot and vibrant that it is hard to fathom today. At the heart of it, at 47th and Parkway,[2] was the Savoy Ballroom. The Savoy, with a half-acre of dance floor, as well as bowling alleys, billiard rooms, and a roller-skating rink, featured battles of the bands that lasted all night and drew audiences in the thousands. About a mile and a half from the Savoy, at 55th and State, was the legendary Club DeLisa.

The photographers were present for an interesting moment in time. The personnel working the Chicago clubs in the early 1940s represent a bridge between Louis Armstrong's New Orleans and 1950s R&B. These are undoubtedly the only union musicians in the collection, and by and large, they are considerably more famous.

Count Basie and Chicago had a mutual affinity, and he played at the Savoy often. The shot of his orchestra (p. 175, bottom) features Don Byas (foreground), who had replaced Lester Young as Basie's featured tenor sax player a few months earlier. Boyd Atkins (p. 169), who had played in early bands with Louis Armstrong and wrote the Hot Five's first commercial hit, "Heebie Jeebies," was working as a bandleader in the Midwest, mainly in Chicago and Peoria.

As part of a longer picture story on African American professionals, Jack Delano created two photo sequences on Chicago drummers Red Saunders and Oliver Coleman.[3] Theodore "Red" Saunders (p. 171) began at the Club DeLisa in Albert Ammons' band. By the time of Delano's photograph, he was leading the house band. Saunders continued at the DeLisa for years, working at the same time in recording sessions for a number of R&B artists.

Having worked with bands ranging from Earl Hines to Little Miss Cornshucks, Oliver Coleman (p. 171, top) was a top drummer in the city. Like Saunders, he survived into the R&B era, working as a session drummer for Chess Records. He was also highly regarded as a teacher.

Lonnie Johnson (pp. 172, 173, slotted-head guitar) was an enormously popular and important musician in the 1920s. In 1941, the great singer and innovative guitarist was on an upswing portion of a long, highly fluctuating career. It remains unclear whether Russell Lee knew who he was when he photographed him along with the rest of his trio, Dan Dixon and Andrew Harris. Lawrence Cohn identifies this venue as Squares Boulevard Lounge.[4]

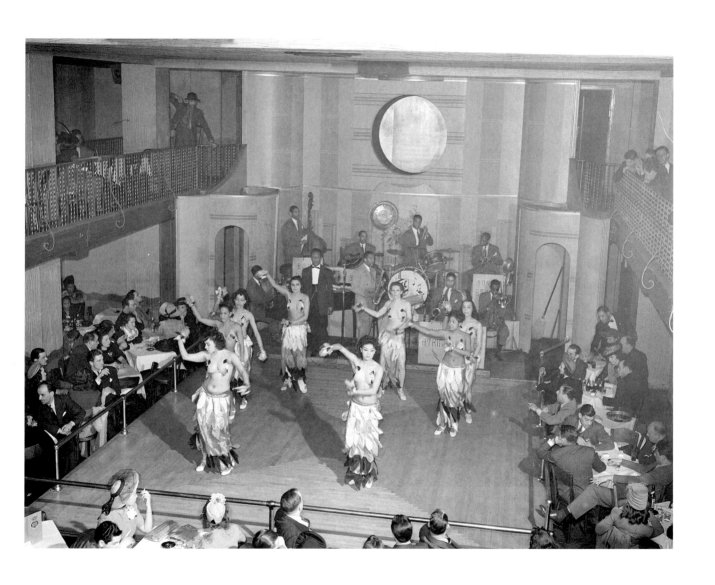

Negro Cabaret. Chicago, Illinois.
April 1941. Russell Lee.

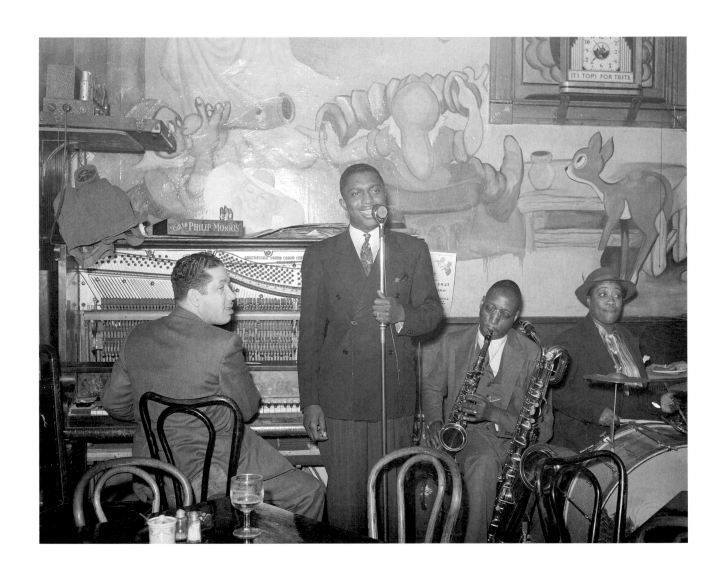

Tavern on southside of Chicago,
Illinois. April 1941. Russell Lee.

Oliver Coleman playing in a nightclub on 55th Street in Chicago, Illinois. April 1942. Jack Delano.

Dancing to the music of "Red" Sounders [*sic*] and his band at the Club DeLisa, Chicago, Illinois. April 1942. Jack Delano.

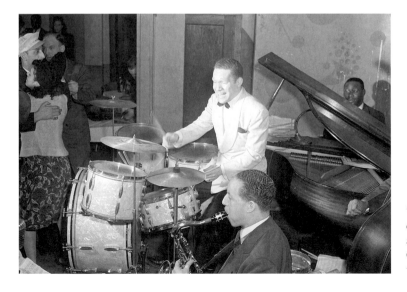

"Red" Sounders [*sic*], drummer, and his band, at the Club DeLisa, Chicago, Illinois. April 1942. Jack Delano.

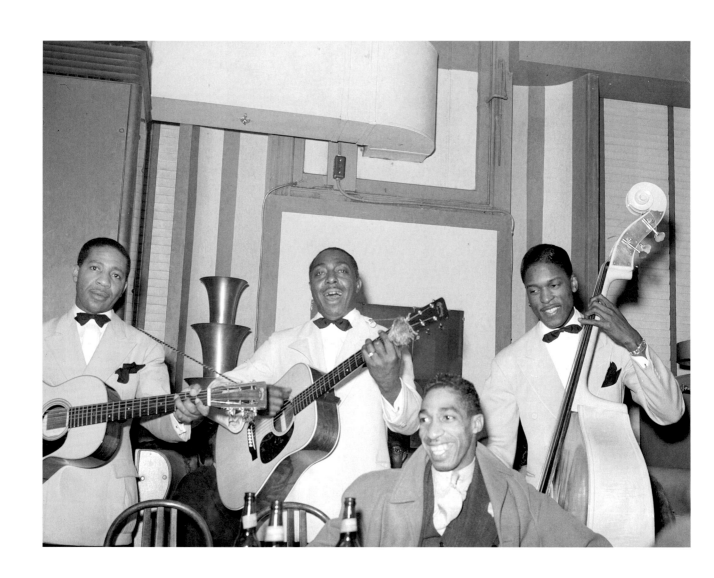

Entertainers at Negro tavern. Chicago,
Illinois. April 1941. Russell Lee.

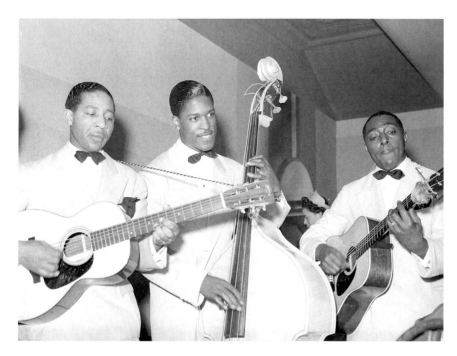

Entertainers at Negro tavern. Chicago, Illinois. April 1941. Russell Lee.

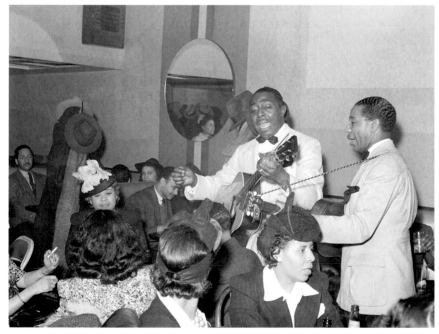

Tavern on southside of Chicago, Illinois. April 1941. Russell Lee.

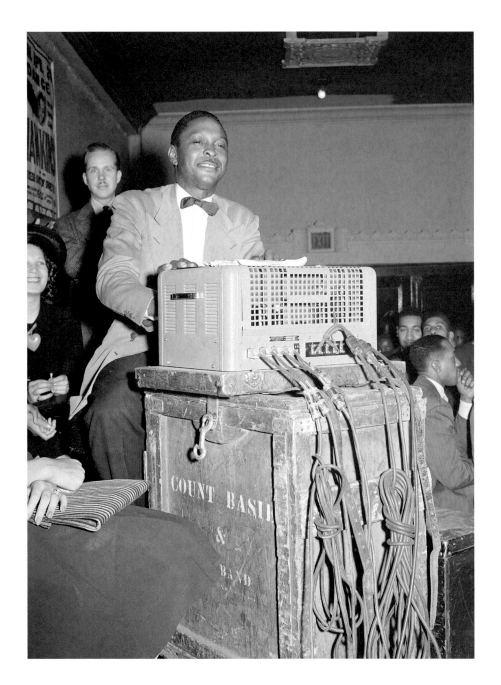

Sound effects man of orchestra at
Savoy Ball Room. Chicago, Illinois.
April 1941. Russell Lee.

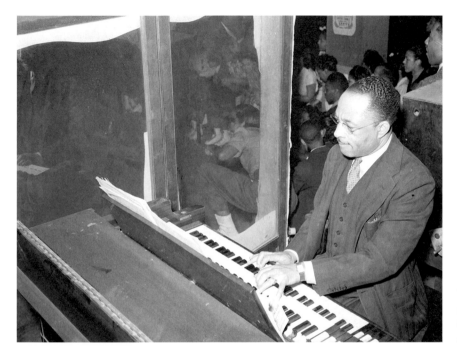

The organist at Negro
rollerskating rink.
Chicago, Illinois.
April 1941. Russell Lee.

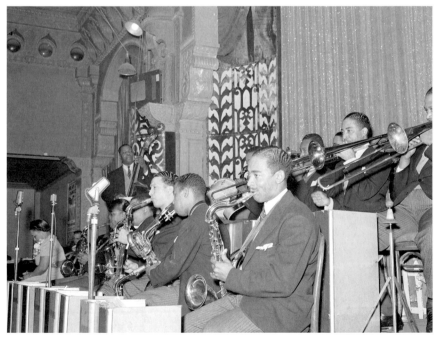

The [Basie] band at
the Savoy Ballroom.
Chicago, Illinois.
April 1941. Russell Lee.

Singer at a Pentecostal
church. Chicago,
Illinois. April 1941.
Russell Lee.

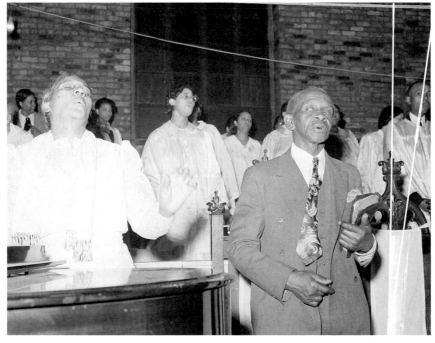

One of the leaders at
the Pentecostal church
directing the singing,
Chicago, Illinois.
April 1941. Russell Lee.

Children of family on relief playing.
Chicago, Illinois. April 1941.
Russell Lee.

Northeast

Ben Shahn, among the FSA photographers, had the greatest affinity for traditional music. He was friends with the Seeger family and, although not a musician, he appreciated folk music the way he appreciated all other forms of folk art.[1] Though his contributions to the file are as important as any of the photographers, Shahn was primarily a painter, and his photographs were created largely as reference for his paintings, drawings, and murals.

He considered the experience of shooting for the Resettlement Administration a transformative one. "My own painting then had turned from what is called 'social realism'," he recalled, "into a sort of personal realism," and he cited among his most meaningful interactions "the coal miner, a cellist, who organized a quartet for me—the quartet having three musicians" and "the five Musgrove brothers who played five harmonicas."[2] He doesn't appear to have made pictures of the Musgroves with harmonicas, but he did photograph three of them with stringed instruments (p. 185).

His shots of William Wilson playing alone and with his band (pp. 190–93) are the basis for his painting *Four Piece Orchestra*, depicting a quartet of three musicians (the harmonica being the fourth piece). In the photos, Wilson is playing what was a common range of homemade music for the time: violin, "Hawaiian"-style guitar, and "Spanish"-style guitar.

In Provincetown, Massachusetts (p. 186), the two guitarists, Joe "Phoebe" Souza (top) and George Perry (bottom) were known for playing cowboy and other western songs.[3]

In the 1930s, Ed Larkin (pp. 197–98), a Vermont farmer and syrup producer, was leading a revival of the nineteenth-century New England contra dance tradition. In contrast to the more recent contra dance revival, these affairs featured genteel dances and period costume. Larkin had been playing and calling dances since the 1880s, and in 1933 brought a group to the Tunbridge World's Fair. The following year they organized more formally as the Ed Larkin Contra Dancers, still active in Vermont.

In Colchester, Connecticut, where Jack Delano photographed the community band (p. 195), the Federal Writers' Project described a barn dance:

> Residents of this district often participate in barn dances, especially just before haying or after the fall harvest. Dimly lit by kerosene lanterns, the great barn floor, smoothed through the years by the thousands of shuffling feet, is alive with merry dancers doing the old-fashioned square dances. Prompters are enthroned in the loft or stand atop an old fanning mill. Music is furnished by violins, banjos, and harmonicas, and the musicians often crowd into a feed or harness room just off the main floor. The Lancers, the Quadrille, Paul Jones, Captain Jiggs, Turkey in the Straw, Pop Goes the Weasel, and many other dances, offer entertainment and pleasure for the customers as well as exercise for the leather-lunged prompter who shouts: "Get your partners for a quadrille! Four more couples! Two more couples! . . ." Hayseed and very dusty cobwebs fall from the ceiling onto the perspiring couples, fair faces are flushed, slick hair becomes dark with moisture, and the males rush for the cider jug the moment the last wailing note of the fiddle dies away.[4]

By the end of the Depression, it had been a half century since bands rode on top, when the *Washington Post March* became a national dance craze and Sousa's Marine Band were the nation's first and only recording stars.

The war was coming and the Depression ending. A new world was being born. It was brighter, cleaner, and better in many ways. There were more shoes and food to go around, and though few people were sorry to see the Depression coming to an end, there must have been, on some level, a certain melancholy in seeing the old days pass. Some of this music would disappear forever; some quietly tucked away in an obscure corner of collective memory would later be revived, but no one could have known that at the time.

In Louise Rosskam's shots of the community band in Lincoln, Vermont, with car headlights aimed at them like darkened spotlights, the gray-haired musicians prepared for their concert in the twilight. There is a sadness in its passing, but in the "business of deterioration" the blending of loss and beauty is inextricable.

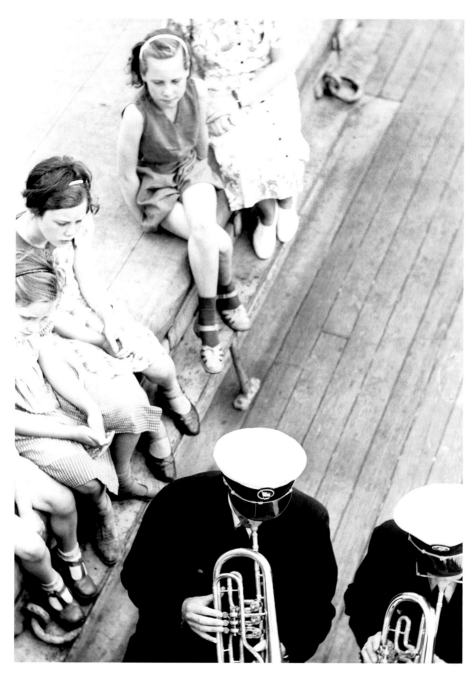

On board a Norwegian-American passenger liner enroute [*sic*] to New York. Children listening to the ship's orchestra. July 1938. Paul Vanderbilt.

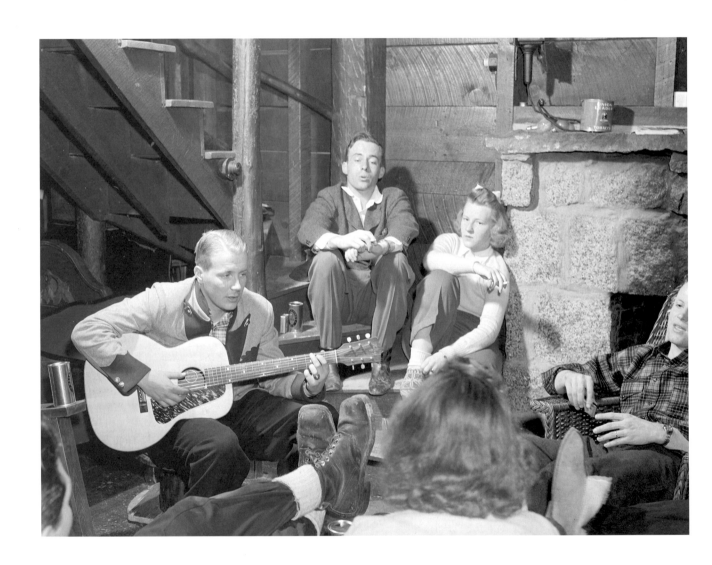

Skiers from Boston, Massachusetts,
relaxing in lodge at North Conway,
New Hampshire. March 1940.
Marion Post Wolcott.

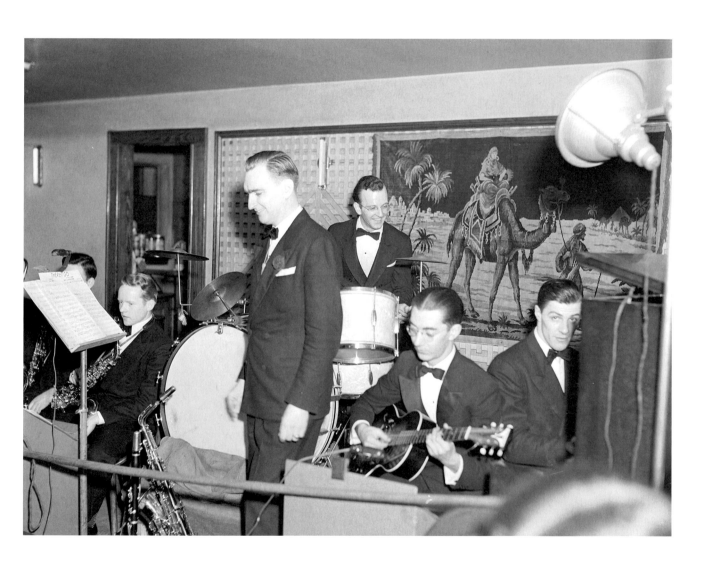

Orchestra at the Carlton Club.
Ambridge, Pennsylvania. January 1941.
John Vachon.

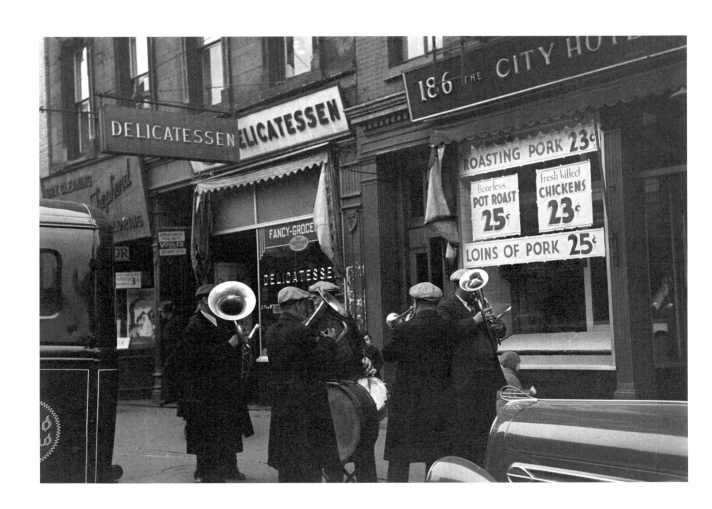

Street band in Yorkville, New York.
December 1937. Arthur Rothstein.

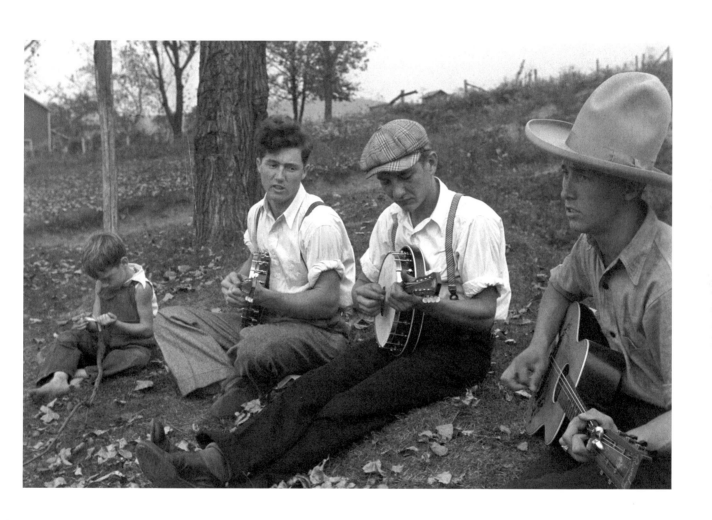

Members of Musgrove family.
Westmoreland County, Pennsylvania.
October 1935. Ben Shahn.

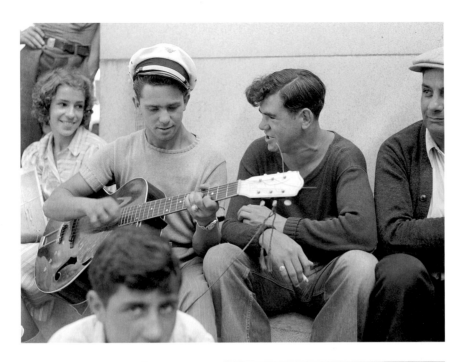

Local talent makes music on a Sunday
afternoon under soldiers' monument.
Provincetown, Massachusetts. August
1940. Edwin Rosskam.

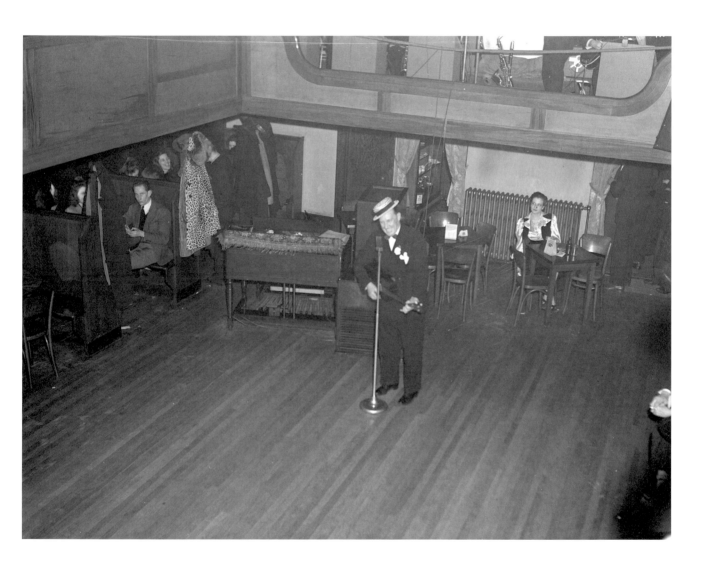

[Carlton Nightclub. Ambridge,
Pennsylvania. January 1941.]
John Vachon.

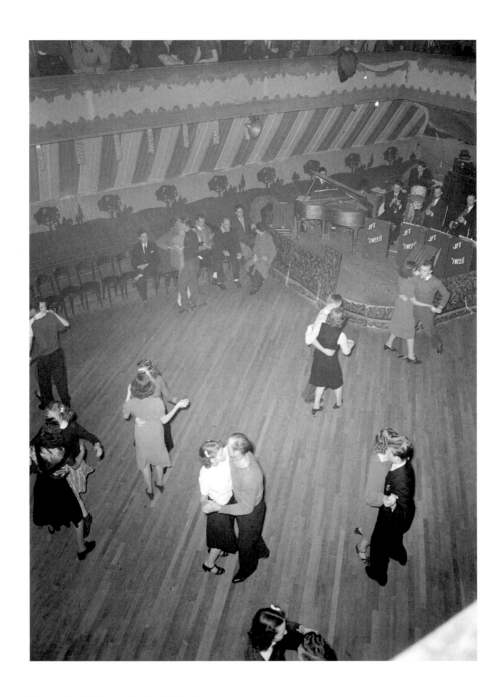

Shenandoah, Pennsylvania. Maher's
dance hall, showing orchestra
platform and dancers. 1938?
Sheldon Dick.

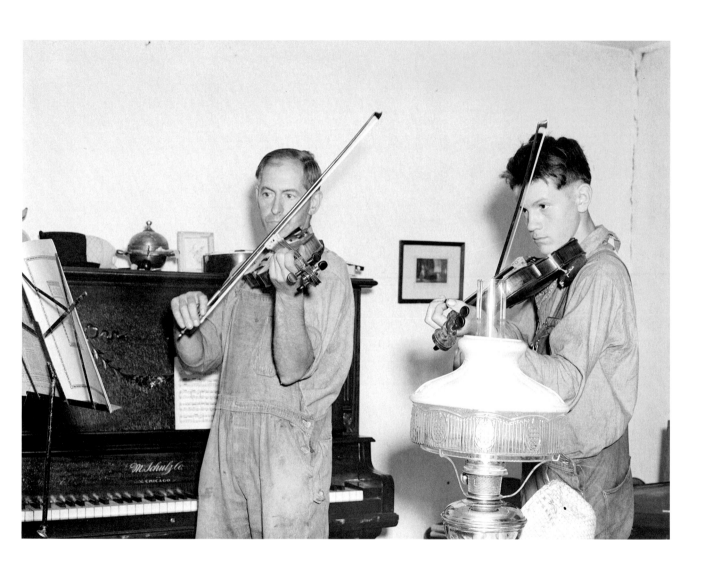

Barto, Berks County, Pennsylvania.
Thomas Evans, a FSA client, giving a
violin lesson to one of the neighbor's
boys. August 1938. Sheldon Dick.

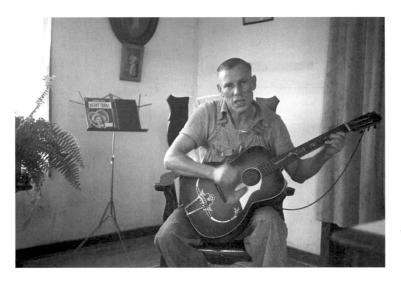

William Wilson, Westmoreland
homesteader, Pennsylvania. 1937.
Ben Shahn.

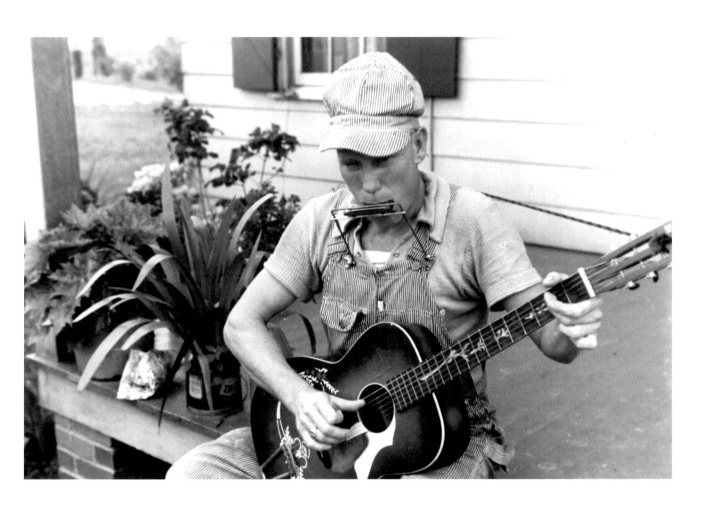

Westmoreland homesteader playing a
mouth organ and a guitar, Pennsylvania.
1937. Ben Shahn.

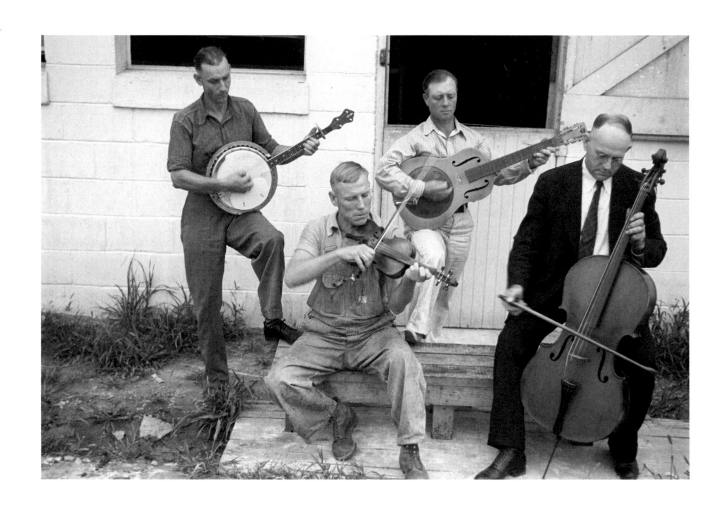

Practising [*sic*] for the Westmoreland Fair,
Pennsylvania. 1937. Ben Shahn.

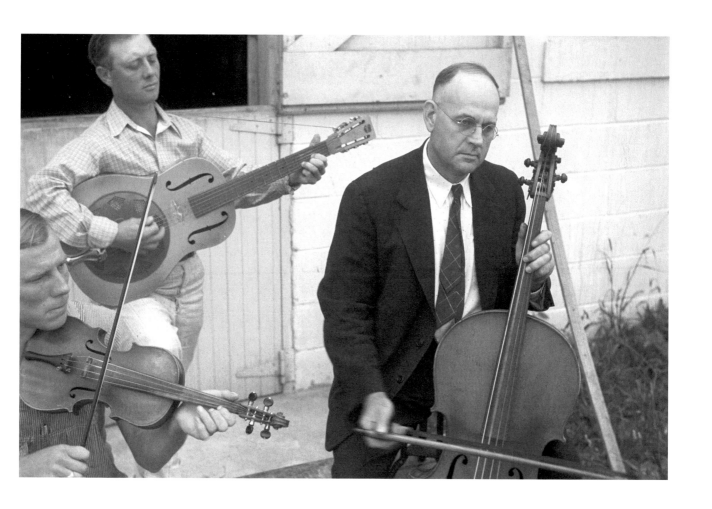

[Practicing for the Westmoreland Fair,
Pennsylvania. 1937.] Ben Shahn.

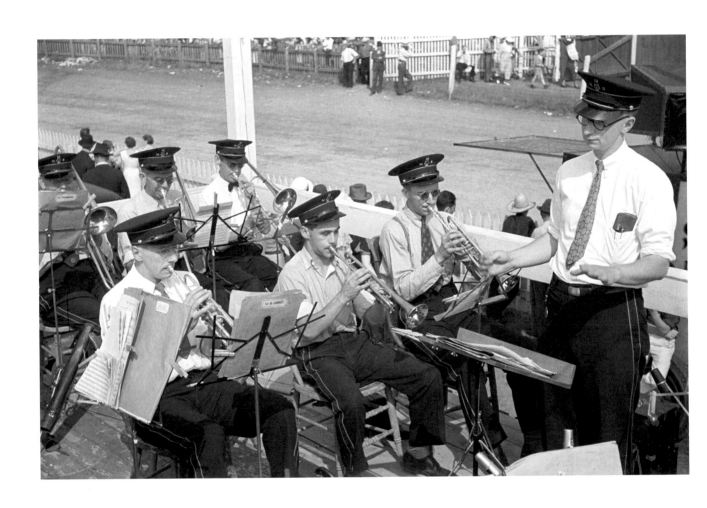

Band at the annual fair, Morrisville,
Vermont. August 1936. Carl Mydans.

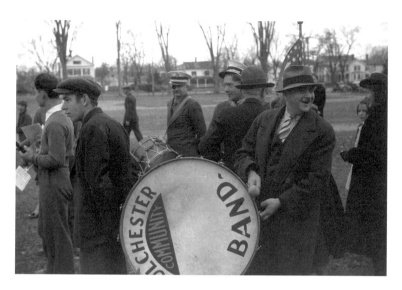

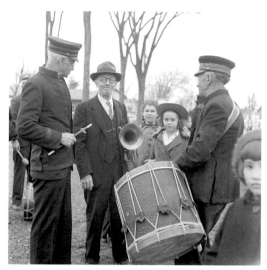

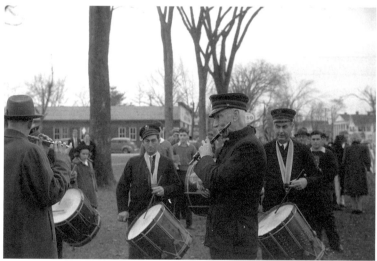

Colchester, Connecticut. Armistice
Day. November 1940. Jack Delano.

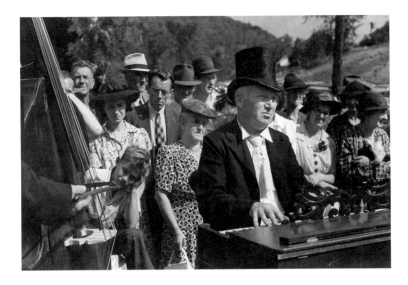

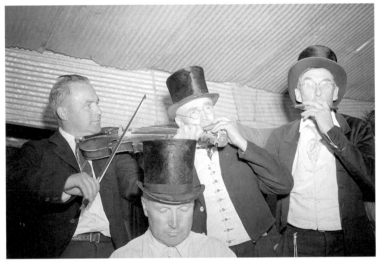

A quartet at an old-fashioned musical given at the "World's Fair" at Tunbridge, Vermont. September 1941. Jack Delano.

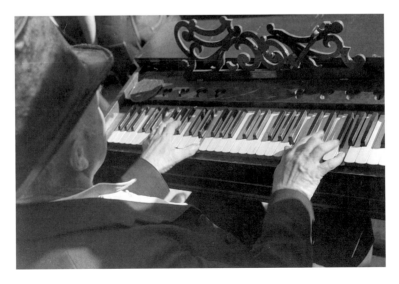

Playing an old organ for the period dances at the "World's Fair" in Tunbridge, Vermont. September 1941. Jack Delano.

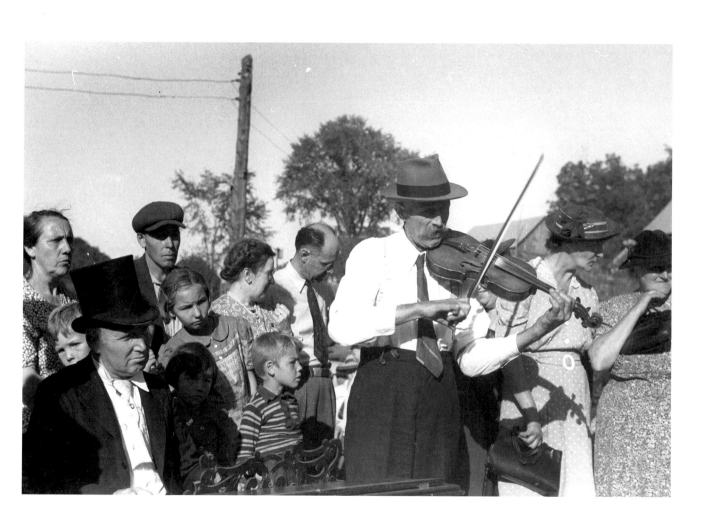

Mr. Ed Larkin, seventy-eight-year-old fiddler at the "World's Fair" in Tunbridge, Vermont. September 1941. Jack Delano.

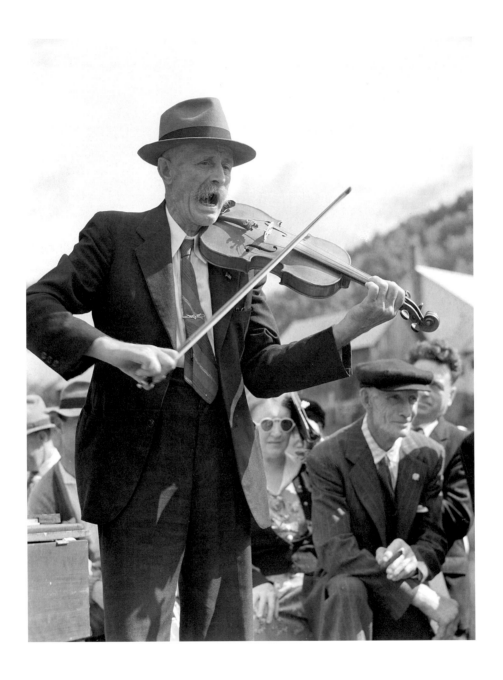

Fiddler (Mr. Ed Lorkin) [*sic*] for
square dances at the World's Fair at
Tunbridge, Vermont. September 1941.
Jack Delano.

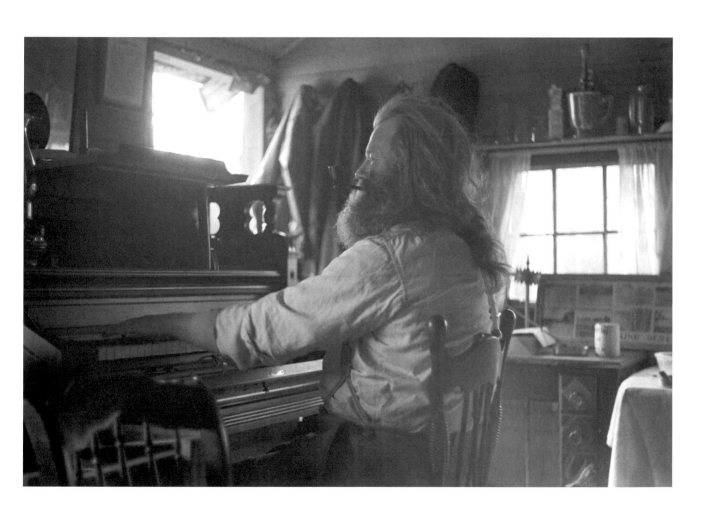

The "Hermit of Maine" playing the
unique musical instrument, Freeport,
Maine. March 1936. Paul Carter.

Music for the Saturday night square dances in Clayville, Rhode Island, is provided by this school teacher from a neighboring town and her son. They are also available for parties and weddings. December 1940. Jack Delano.

The family of Gottlieb Zahler in their new farm in Lacona, New York, to which they moved from the Pine camp relocation area. In their new home in Lacona, New York. August 1941. Jack Delano.

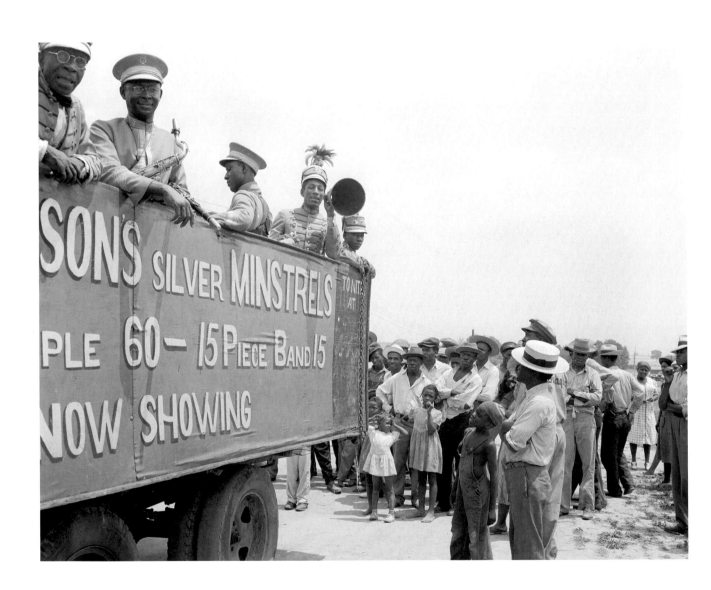

Bridgeton, New Jersey. FSA (Farm Security
Administration) agricultural workers' camp.
Colored minstrels advertising their show.
July 1942. John Collier.

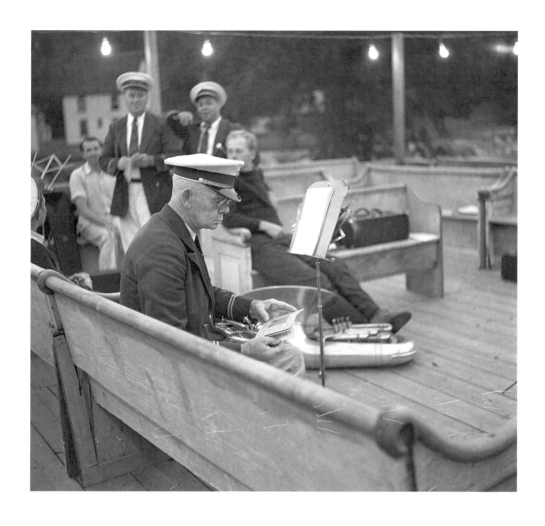

Band concert. Lincoln, Vermont.
July 1940. Louise Rosskam.

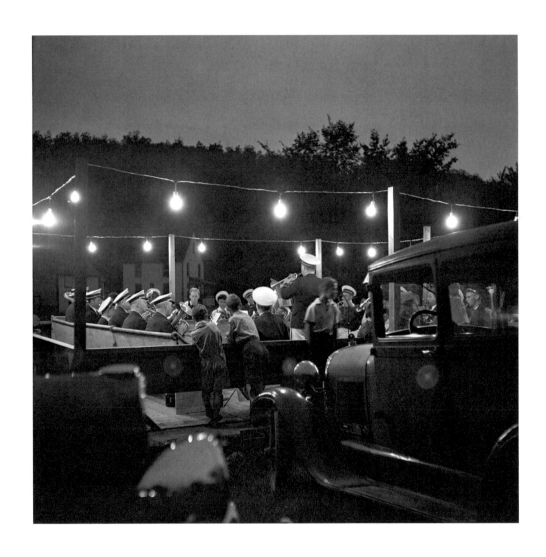

Band concert. Vermont. Lincoln.
July 1940. Louise Rosskam.

Afterword

Henry Sapoznik

For those of a particular generation, many of the images found in this new collection are as familiar as pictures from one's own family photo albums. Popular in their own day, resonant in ours, the FSA pictures—especially the music images—have come down to us as a powerful visual adjunct to what we know of that tumultuous era. Perhaps they still retain that power because during those prewar years, live music was a ubiquitous part of daily life for people of all classes and races, and in the unblinking documentation these photos were meant to be, we encounter it again and again, as an occupation, a recreation, or a consolation. And if these pictures have such a gripping resonance, the music they represent—popular and folk traditions of the regions where they were taken—it was in no small way due to the work of the two families, the Seegers and Lomaxes.

Charles Seeger and John Lomax — and their scions—were players in the New Deal–era cultural scene, and though neither was a policy maker at FSA, they, more than anyone, helped shape our received understanding of folk music and created the meaning and the orthodoxy of folk music and "the folk." Like the music they collected and interpreted, the FSA photos, created at the same time but with a different agenda, offer us another point of assessing the vernacular musical landscape of the time.

Charles Seeger tried early in his career to mix his politically progressive politics and love of music to bring culture to the masses, with decidedly mixed results. His work as part of the Composers Collective, penning willfully inscrutable art music for picket lines and sit-down strikes, was decidedly a failure, while his attempt to revivify community band music was moderately successful.

It was while teaching composition at New York's New School for Social Research in 1935 that Seeger was invited to Washington, D.C., to become part of the newly formed Resettlement Administration (RA), whose mission was to encourage struggling farmers to work collectively on federally owned land in order to learn more modern and efficient farming methods. Seeger thought that encouraging them to play music together would reinforce their ability to farm together. He became persuaded that traditional music would be the most effective medium to effect this transformation, largely because of the work/ influence of another recently transplanted Washingtonian: John Lomax.

Lomax—famous for his collection of Texas cowboy songs and, like Charles Seeger, a Harvard man—came to D.C. in 1932 on an invitation by Robert Winslow Gordon, founder of the fledgling Archive of American Folksong (today's American Folklife Center) at the Library of Congress, to join its staff and ramp up its field collecting. Like a Joad family in reverse, the Lomaxes—John, Alan, and sister Bess—loaded up the truck and headed east to Washington. Soon, father and son were recording music they insisted was "un-touched" by the modern influences of radio and records, eventually tooling around the heartlands in a tricked-out Ford Deluxe sedan with a 315-pound aluminum acetate disc recorder bolted into the trunk. One cannot overemphasize the influence the Lomaxes had, through the archives, books, records, and national radio to acquaint Americans with their own traditional music. In many ways, those were the seeds sown that would, over the years, bloom into the folk music era of the 1950s and '60s.

The Seegers were among those affected by the Lomaxes' work; Ruth Crawford Seeger helped transcribe the Lomaxes' field recordings, giving a young Pete Seeger his earliest taste of traditional folk music. It was on a father/son field trip in 1935 that Pete first heard old-time five-string banjo as played by Samantha Bumgarner (p. 5), inspiring him to give up the four-string tenor banjo for the instrument with which he would remain associated the rest of his life. In 1935, Charles Seeger formed a corps of field workers who would travel to the RA-sponsored "collective" farms and attempt to jumpstart the local community in the collection and performance of regional traditional music. For myriad reasons— everything from field workers imposing classical music on an unwilling constituency to communities resenting being characterized as "quaint" and out of touch—the project failed and, when the RA was reorganized into the FSA in 1937, Seeger left the agency.

Though Seeger was out, the work he helped to midwife was going forward. The photos taken for the FSA and the music collected by the Lomaxes were part of the same New Deal government agency infrastructure whose documentation brought the plight of the unseen American rural communities to a greater audience. And if the FSA pictures showed just how tough times were, the persistent presence of the traditional music the Lomaxes collected showed that these were also people with a will to surpass current hard times and hold onto to that which was most important to them. Even today, three-quarters of a century later, the pictures—like the music—retain the unmistakable aura

of that other time and place, and the roughhewn honesty that folk music promises. In fact, some might say that if the pictures of the FSA had a soundtrack, it would be made up of the Lomaxes' field recordings.

Just as Alan Lomax was the conduit through which the Seegers discovered American folk music, the Seegers returned the favor by introducing Lomax to the Popular Front during its heyday. The Communist Party had veered away from trying to win over Americans with Soviet-style martial music or composed anthems to the working class. Instead, the Popular Front enabled them to relax and realize the music that could best reflect that the "Communism is 20th-Century Americanism" mantra was there all along: authentic American folk music, and Alan Lomax was the man to make that happen.

But as much as Alan Lomax enjoyed flaunting his newfound progressive politics in rebellion against his far more conservative father, he did not rebel against the "shabby chic" patrician sense of entitlement he inherited, causing him to forever careen somewhere between impresario and overseer in his relationships with the artists he documented. As the arbiter of authenticity, Lomax conflated his prodigious collecting with his prolific pronouncements on the meaning and importance of the music, never once acknowledging that perhaps those who collect materials are not necessarily the best ones to interpret them.

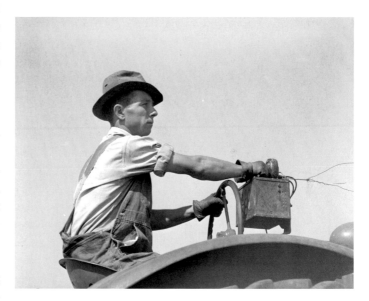

Lomax's quest for "authenticity" meant that if he actually couldn't find what he was looking for, he would dictate what his informants would play, how they would play it, and on what instrument. Perhaps his most egregious behavior was around the dynamic singer and twelve-string guitarist Leadbelly, whom the Lomaxes "discovered" at the Angola Farm prison plantation in Louisiana, where he was serving time for assault with attempt to murder. Securing his parole—Leadbelly's musical appeal for release was recorded by the Lomaxes—the Lomaxes quickly turned the former convict into their personal chauffeur and, among other things, exhibited him on stage wearing his prison stripes as opposed to the pinstripes he would have preferred, and appended their name to his original composition "Irene Goodnight" to share in his royalties.

Given the kind of social engineering of facts and contexts the Lomaxes engaged in, the FSA images come to us with far more fidelity as the documentation of real people. For, despite the proactive and propagandistic prime directive of the FSA—to document the ravages of the Depression and validate the New Deal—the pictures offer us surprisingly light editorializing; their subjects are less "objects" than one might expect from pictures taken with a didactic purpose. And when compared with other agencies employing photography in social service, FSA images are even more powerful. Photos taken for

the Department of Agriculture by L. C. Harmon, for example, show a series of black child field hands framed against billowy downy fluff of cotton bales and, with their wide toothy grins, they look less like exploited underage farm workers than blackface salt and pepper shakers.

Russell Lee's series from the National Rice Festival (p. 55–66) is nothing less than the capturing of a crystalline moment of cultural transition: the original photo annotation tells us about this Cajun "fais do-do" ("dance party"), where "most of the music was of the folk variety . . ." We see the edging out of the "folk" with the modern presence of saxophones, pianos, and even electric guitars. Or consider Arnold Rothstein's picture of

a Saturday night California dance band (p. 123) fronted by a ferocious wooden feline—the tip "kitty"—back when everyone got the joke.

From photographer Marion Post Wolcott we find two pairs of photos, one startling in its contrasts, the other remarkable in its similarities, from singing classes preparing for a 1937 May Day concert: one, African-American and the other, white children blacking up for a "Negro Song and Dance," and her February 1940 shots in Oklahoma of a white woman accompanied by a pianist and her African American woman counterpart. With both singers and their accompanists occupying the same part of the frame—down to the upright pianist with their backs to us—we are offered a startling and telling contrast about where the lines of culture cross.

And amid the homemade/handmade fiddles, banjos, and guitars—and the far more plentiful mail-order or modestly priced store-bought instruments—one encounters Dorothea Lange's 1939 portrait of a woman soldier in the Salvation Army winning souls armed with a rather expensive new Gibson L-7 arch-top guitar, a rather swanky uptown instrument for such a modest downtown gig.

The relative transparency of the FSA photos allows us to see a musical landscape not necessarily found in the Lomax field recordings—many of which are the musical equivalent of an antediluvian insect trapped in amber, something caught at a moment in time but with no discernible context. In contrast, the FSA images brim with a sense of place and time, offering a vibrant backdrop against which to frame the pictures. Among those images we see many examples of this: a band performing at a football game, musicians in juke joints, an ensemble playing for a Chamber of Commerce luncheon, a rodeo pit orchestra, a high school jazz band, a Salvation Army quartet—sonic landscapes inhabited by the subjects of the FSA pictures display immensely more tonality and diversity, and thus are far more representative of what real people were listening to and creating. This suggests that the men and women who wielded the cameras for the FSA were far less sure of their subjects—and, by extension, far less self-satisfied—than was Lomax.

With the end of World War II, the architects of the folk music world—Moe Asch, (founder of Folkways Records) and *Sing Out!* magazine co-progenitors Pete Seeger and Irwin Silber, among others—were, like Lomax, part of the same extended New Deal–era community that helped make the pictures possible and took part in its rediscovery. The championing and exploitation of the sound and image of the New Deal materials were their inheritance.

Sing Out! (and its subsidiary, Oak Publications) and labels like Folkways would eventually come to use these images liberally on their covers and throughout the pages of numerous "how-to" music books being issued to a folk music–crazed public. Part of the folk music craze attempted to bypass the urbanized reinterpretation of traditional music to, instead, channel its original sonic rural provenance. That spearhead came through the seminal old time music revival group, the New Lost City Ramblers, founded by Tom Paley, Mike Seeger, and John Cohen.

Introduced to the visual treasure trove of the FSA images by photographer Lee Friedlander, Cohen, who was already heading to Washington, D.C., in the spring/summer of 1958 for rehearsals with the newly formed New Lost City Ramblers, made a pilgrimage to the Library of Congress, where, for forty-seven cents each, he obtained original prints from the vast FSA collection. What he found was that the major divisions of the FSA files were regional and, within that, broken further into categories such as back yards, train stations, where people congregate, how women gather, how men gather.

There was also a subcategory for music, so Cohen checked out each listing from every region of the country, choosing music photos that—given his highly subjective choices based on feeling—imparted a sense of the setting or the songs' meanings. An FSA photo had already appeared on a record cover. RCA Victor had used one on a 78-rpm album of Woody Guthrie's 1940 *Dust Bowl Ballads,* but it had been out of print and inaccessible to the new legions of folk music enthusiasts.

For the breakout 1959 New Lost City Ramblers LP, Cohen cajoled Moe Asch to use a Russell Lee image on the cover ("Camp of Migrant Workers Near Prague, Oklahoma," p. 75). With a response as enthusiastic as Cohen had hoped, the Ramblers followed with three more LP covers featuring FSA photos: Ben Shahn's "Street Musicians, Maynardville, Tennessee" (p. 31) on *Songs from the Depression* (1959), and "Practising [*sic*] for the Westmoreland Fair, Pennsylvania" (p. 192) on *The New Lost City Ramblers, Vol. III* (1961), and Russell Lee's photo of a banjo player and his wife in Caldwell, Idaho (p. 140) on *On the Great Divide* (1973).

But the watershed use of these images in the service of traditional music came with the 1964 publication of the *New Lost City Rambler Songbook.* Cohen and co-compiler Mike Seeger chose the pictures, with Cohen himself overseeing the knowing and keen layout of those images.

More than a third of the eighty-five images in the NLCR songbook are from the FSA—the remainder being period country-performer ephemera, and current documentary photography—and they are cleverly and inexorably interwoven with the songs with which they are paired.

Ironically, at the time Cohen was working on this book, he was unaware that Mike's father Charles had once dreamed of doing the same thing. One of the unfinished projects abandoned prior to Seeger's departure from the FSA was a book of musical transcriptions from the Archive of American Folksong illustrated with music-themed photos culled from the still-emerging FSA library. For reasons unknown, the book, titled *We Come By It Natural,* was never realized.

In some ways that book emerged as Alan Lomax's 1967 *Hard Hitting Songs For Hard-Hit People,* a book long delayed from its proposed publication in the 1940s, and only finally published by Oak Publications in the successful wake of the New Lost City Rambler songbook. While in some ways a stand-in for the unrealized collaboration with Charles Seeger, Lomax's use of the FSA images feels more like an appropriation than do Cohen's, which may, perhaps, have something to do with the overweening sense of ownership Lomax perennially brought to his work.

Cohen's choice to use the images from the FSA to illustrate the music of the New Lost City Ramblers made sense: the commercial 78-rpm discs that were the band's style and repertoire sources exhibited a kind of diverse eclecticism, more accurately reflecting the multilayered music culture found in the FSA pictures than did the Lomaxes' far more austere and narrowly defined field recordings. Cohen, by repositioning the images as accurate reflections of lives lived, gave new meaning and momentum to this extraordinary photographic treasure.

The eventual 1970s discovery of these images by photography book anthologists meant that a new aesthetic was being used to view these images: more about composition and less about context. In the intervening decades, the base literacy about traditional American music of the period has blossomed with a new generation of scholars, players, and collectors.

What sets this book apart can be found in Rich Remsberg's knowing curatorial eye: his interest in the images is equally matched by his passion for the music they document. His artful culling of images from previously unpublished sequences creates layouts that offer not only the power of the original image, but also a unique insight into the working process of the photographers.

Like John Cohen, he shares a passion for both the images and the music culture they reflect, but unlike Alan Lomax, he is well qualified to interpret the materials he has collected.

As legatees of these images—both as Americans and as lovers of the music they document—it is clear how the generation that created them and the generations that inherited them used and encoded these images with meaning for their own time and place. Now we do, too, though we are as far from the FSA images as the photographers who took them were from the Civil War pictures of Mathew Brady and the birth of American photography. It only remains to be seen how they will once again be interpreted by future generations surely drawn to their irresistibly powerful sense of time and place.

Notes

Introduction

1. In general, I use the term FSA to encompass both the Farm Security Administration and the Resettlement Administration. When I refer to the RA, it implies circumstances that existed only during the RA years and did not survive the 1937 reorganization. However, I will draw a distinction with the Office of War Information (OWI), where the FSA was later absorbed. In spelling out, I refer to the larger agency; in using initials, I refer to the photographic components.

2. Arthur Rothstein, *Documentary Photography* (Boston: Focal Press, 1986), p. 36.

3. Bernarda Shahn, foreword to *A Vision Shared: A Classic Portrait Of American And Its People, 1935–1943,* by Hank O'Neal (New York: St. Martin's Press, 1976), p. 7.

4. O'Neal, p. 298.

5. The size of the entire collection, including OWI images, is closer to 170,000.

6. Rothstein, pp. 164–68.

7. Richard K. Doud, interview with Ben Shahn, 14 April 1964.

8. Colin Escott, "The Talking Machine: How Records Shaped Country Music" in *The Encyclopedia of Country Music,* ed. Paul Kingsbury (New York: Oxford University Press, 1998), p. 466.

9. Robert Gordon, *Can't Be Satisfied: The Life and Times of Muddy Waters* (Boston: Little, Brown, 2002), pp. 61–62.

10. Joe Klein, *Woody Guthrie: A Life* (New York: Knopf, 1980), p. 146.

11. O'Neal, p. 175.

12. Klein, p. 146.

13. Ulmann traveled with folk song collector and performer John Jacob Niles, and they were a good match. That should give readers with a musical background a good idea of what her photographs looked like and readers with a photographic background a good idea of what his music sounded like.

14. F. Jack Hurley, *Portrait of a Decade: Roy Stryker and the Development of Documentary Photography in the Thirties* (Baton Rouge: Louisiana State University Press, 1972), p. vii.

15. Lawrence W. Levine, "The Historian and the Icon: Photography and the History of the American People in the 1930s and 1940s," in *Documenting America, 1935–1943,* by Carl Fleischhauer and Beverly W. Brannan (Berkeley: University of California Press, 1988), p. 16.

16. Roy Emerson Stryker and Nancy Wood, *In This Proud Land: America 1935–1943 As Seen in the FSA Photographs* (Boston: New York Graphic Society, 1973), p. 19.

17. Klein, pp. 113–14.

18. Hurley, p. 137.

19. William Stott, *Documentary Expression and Thirties America* (London: Oxford University Press, 1973), p. 229.

20. Hurley, p. 173.

21. John Vachon, "Tribute to a Man," *Harpers,* September 1973, p. 99.

22. This line is often quoted to demonstrate the shift from the FSA to the OWI. It should be pointed out that Stryker wrote the comment sarcastically. Nevertheless, it demonstrates the tone in the department and what sort of pictures they were now after.

Southeast

1. David Parker Bennett, "A Study in Fiddle Tunes from Western North Carolina" (master's thesis, University of North Carolina, 1940), pp. 15–16.

2. Kerry Blech, e-mail interview with the author, 18 October 2007.

3. *Asheville Citizen,* 13 January–19 February, 1948.

South

1. Johnny Cash, *Cash: The Autobiography* (San Francisco: Harper, 1997), pp. 13–20; Christopher S. Wren, *Winners Got Scars Too: the Life and Legends of Johnny Cash* (New York: Dial Press, 1971), pp. 33–51; Johnny

Cash, *Man In Black* (Grand Rapids, Mich.: Zondervan, 1975), pp. 23–27.

2. I use the term here in the convenient modern notion; these performers' repertoires and identities were not confined to the blues.

3. O'Neal, p. 15.

4. Jack Delano, *Photographic Memories* (Washington, D.C.: Smithsonian Institution, 1997), p. 39.

5. Lawrence Cohn, *Nothing But the Blues: The Music and the Musicians* (New York: Abbeville, 1993), p. 266.

Louisiana

1. Lee to Stryker, September 16, 1938, quoted in Hurley, p. 108.

2. Harry Hansen, ed., *Louisiana: A Guide to the State* (New York: Hastings House, 1971), p. 86.

3. John Broven, *South to Louisiana: The Music of the Cajun Bayous* (Gretna, La.: Pelican, 1983), 35.

4. Ann Allen Savoy, notes to *The Early Recordings of Leo Soileau* (Yazoo Records, 2000).

Southwest

1. Agnes "Sis" Cunningham and Gordon Friesen, *Red Dust and Broadsides: A Joint Autobiography* (Amherst: University of Massachusetts Press, 1999), pp. 160–208.

2. Ibid., p. 191.

3. I have shown only three representative images; his complete coverage can be seen on the American Memory Web site.

4. Nancy Wood, *Heartland New Mexico: Photographs from the Farm Security Administration, 1935–1943* (Albuquerque: University of New Mexico Press, 1989), pp. 60, 64; see also Russell Lee, "Life On the American Frontier—1941 Version," *U.S. Camera*, October 1941, pp. 39–52, 88–89, 107–8.

5. Jean Lee, General Caption for New Mexico, Textual Records of the FSA (microfilm, reel 15).

6. Ibid.

7. Possible IDs include either Cornelio Sandoval or Juan Tafoya (p. 96, violin), Manuel Borrego (p. 97, violin), Adolfo and Mardoquio Lucero (p. 98, Adolfo, guitar; Mardoqueo, violin), Juan De Vargas (p. 99, guitar), Manuel Borrego (p. 100, violin, right), and the dancer, Jacob Bernal (p. 101, extreme left, dressed "Spanish custom"), who was also in charge of the Fiesta.

8. Julia Jaramillo and Jenny Vincent, telephone interviews with the author, 27–28 November 2007.

California

1. See Voices from the Dust Bowl: http://memory.loc.gov/ammem/afctshtml/tshome.html.

2. Charlie King, telephone interview by the author, 2004.

3. Lt. Col. Don McDougald, e-mail interviews with the author, October–November 2007.

Northwest and High Plains

1. Miles Orvell, ed., *John Vachon's America: Photographs and Letters From the Depression to World War II* (Berkeley: University of California Press, 2003), various.

2. Ibid., p. 145.

3. Ibid., pp. 218–19.

Midwest

1. Walter Carter, *Gibson Guitars: 100 Years of an American Icon* (Los Angeles: General Publishing Group, 1994), pp. 126–31.

2. Raoul Camus, interview with the author, 2004.

3. Jason Michael Hartz, "The American Community Band: History and Development" (master's thesis, Marshall University, 2003), p. viii.

Chicago

1. Nicholas Natanson, *The Black Image in the New Deal: The Politics of FSA Photography* (Knoxville: University of Tennessee Press, 1992), pp. 143–45.

2. Today Martin Luther King Drive.

3. Again, the complete coverage can be seen at the American Memory Web site.

4. Cohn, p. 155.

Northeast

1. Jonathan Shahn, telephone interview with the author, October 2007.

2. Ben Shahn, *The Shape of Content* (Cambridge, Mass.: Harvard University Press, 1957), pp. 47–48.

3. Marie Taves, e-mail interviews with the author, October–November 2007.

4. Federal Writers' Project for the State of Connecticut, *Connecticut: A Guide to its Roads, Lore, and People* (Boston: Houghton-Mifflin, 1938), p. 373.

viii	LC-USF33-004084-M3
3	LC-USF33-002184-M5
4	LC-USF33-021006-M1
5	LC-USF33-006257-M3
6	LC-USF33-006258-M2
7	LC-USF33-006258-M3
	LC-USF33-006258-M4
	LC-USF33-006258-M5
8	LC-USF33-006252-M4
	LC-USF33-006257-M1
	LC-USF33-006253-M3
	LC-USF33-006247-M1
9	LC-USF33-006304-M5
10	LC-USF33-020567-M3
11	LC-USF33-006118-M2
12	LC-USF33-006118-M4
	LC-USF33-006119-M4
13	LC-USF33-006118-M5
14	LC-USF33-006325-M1
15	LC-USF33-006324-M4
	LC-USF33-006326-M4
	LC-USF33-006327-M1
16	LC-USF34-055760-D
17	LC-USF34-061363-D
18	LC-USF34-061339-D
19	LC-USF34-056714-D
20	LC-USF34-062515-D
21	LC-USF34-061975-D
22	LC-USF34-056963-D
	LC-USF34-056962-D
23	LC-USF34-005840-E
27	LC-USF33-030321-M3
28	LC-USF33-006017-M2
29	LC-USF33-006017-M1
	LC-USF33-006018-M5
30	LC-USF33-006141-M3
	LC-USF33-006139-B-M4
31	LC-USF33-006139-B-M1
32	LC-USF33-002136-M4
	LC-USF33-011479-M3
33	LC-USF33-030592-M1
34	LC-USF34-032042-D
35	LC-USF34-052242-D
36	LC-USF342-008285-A
37	LC-USF33-006296-M4
38	LC-USF33-006292-M1
	LC-USF33-006284-M4
39	LC-USF33-006285-M2
	LC-USF33-006286-M5
	LC-USF33-006286-M3
40	LC-USF34-044600-D
41	LC-USF34-051557-D
42	LC-USF33-020888-M1
43	LC-USF33-021247-M3
44	LC-USF34-052907-D
45	LC-USF33-030651-M2
46	LC-USF34-060944-D
	LC-USF33-001898-M2
	LC-USZ62-13830
47	LC-USF34-008415-D
48	LC-USF34-051626-D
49	LC-USF34-051676-D
50	LC-USF34-044768-E
	LC-USF34-044770-E
	LC-USF34-044774-E
51	LC-USF34-080415-D
	LC-USF34-080416-D
52	LC-USF34-053746-D
55	LC-USF33-011736-M4
56	LC-USF33-011736-M2
57	LC-USF33-011735-M2
58	LC-USF33-011717-M2
	LC-USF33-011762-M4
59	LC-USF33-011717-M3
	LC-USF33-011762-M2
60	LC-USF34-031481-D
61	LC-USF34-031457-D
	LC-USF34-031458-D
62	LC-USF34-031462-D
	LC-USF34-031469-D
63	LC-USF34-031450-D
64	LC-USF34-031480-D
65	LC-USF34-031666-D
66	LC-USF34-031639-D
	LC-USF34-031632-D
67	LC-USF33-006159-M1
68	LC-USF33-011902-M2
69	LC-USF34-031753-D
70	LC-USF34-032875-D
71	LC-USF34-056505-D
72	LC-USF34-054368-D
75	LC-USF34-033418-D
76	LC-USF34-033765-D
77	LC-USF33-012488-M4
78	LC-USF34-032146-D
	LC-USF34-032101-D
79	LC-USF34-036804-D
	LC-USF34-036097-D
80	LC-USF35-312
81	LC-USF35-315
82	LC-USF34-035414-D
83	LC-USF34-035979-D
	LC-USF34-035396-D
84	LC-USF33-012605-M3
85	LC-USF33-012656-M2
86	LC-USF34-024973-D
87	LC-USF34-024994-D
88	LC-USF34-022038-D

LC-USF34-022037-D

89 LC-USF34-022052-D

LC-USF34-024998-D

90 LC-USF33-012648-M3

91 LC-USF34-035425-D

92 LC-USF33-012927-M3

LC-USF33-012928-M3

93 LC-USF34-035186-D

LC-USF34-035154-D

94 LC-USF33-012335-M1

95 LC-USF33-012335-M2

96 LC-USF33-012844-M4

97 LC-USF33-012870-M1

98 LC-USF33-012881-M5

99 LC-USF33-012869-M5

100 LC-USF33-012871-M1

101 LC-USF33-012870-M4

102 LC-USF34-037097-D

LC-USF34-037129-D

LC-USF34-037096-D

103 LC-USF34-037099-D

LC-USF34-037128-D

LC-USF34-037155-D

104 LC-USF34-022017-D

105 LC-USF34-022047-D

LC-USF34-032300-D

106 LC-USF33-012756-M2

LC-USF34-036598-D

LC-USF34-036649-D

107 LC-USF34-033020-D

108 LC-USF34-036930-D

109 LC-USF34-036955-D

110 LC-USF33-012784-M5

111 LC-USF34-036828-D

112 LC-USF34-035407-D

113 LC-USF34-035415-D

114 LC-USF34-036614-D

117 LC-USF34-019320-E

118 LC-USF34-016324-E

119 LC-USF34-018534-E

120 LC-USF34-018550-D

121 LC-USF34-018548-D

122 LC-USF34-071665-D

123 LC-USF34-024258-D

124 LC-USF34-071572-D

125 LC-USF34-071565-D

126 LC-USF34-019244-D

LC-USF34-019255-C

127 LC-USF34-019274-E

128 LC-USF34-019253-C

129 LC-USF34-019259-C

130 LC-USF34-019250-C

LC-USF34-019268-E

LC-USF34-019278-E

131 LC-USF34-019248-C

132 LC-USF34-081778-E

135 LC-USF33-003098-M2

136 LC-USF34-004942-E

137 LC-USF34-004962-E

138 LC-USF34-039123-D

139 LC-USF33-003074-M4

140 LC-USF34-039477-D

141 LC-USF34-070383-D

LC-USF34-039451-D

142 LC-USF34-004512-D

143 LC-USF346-027824-D

144 LC-USF34-020382-C

145 LC-USF34-065379-D

146 LC-USF34-008760-D

147 LC-USW3-002973-D

148 LC-USF34-027444-D

151 LC-USF34-063356-D

152 LC-USF33-016137-M4

153 LC-USF34-028275-D

154 LC-USF34-064589-D

155 LC-USF34-029463-D

156 LC-USF33-011248-M1

157 LC-USF34-010895-D

158 LC-USF341-010435-B

159 LC-USF33-006632-M3

160 LC-USF34-026727-D

161 LC-USF33-001643-M5

162 LC-USF34-061204-D

163 LC-USF33-002761-M4

164 LC-USF34-060564-D

165 LC-USW3-007051-D

169 LC-USF34-038543-D

170 LC-USF34-038565-D

171 LC-USW3-001483-D

LC-USW3-001533-D

LC-USW3-001497-D

172 LC-USF34-038557-D

173 LC-USF34-038558-D

LC-USF34-038587-D

174 LC-USF34-038757-D

175 LC-USF34-038595-D

LC-USF34-038795-D

176 LC-USF34-038746-D

LC-USF34-038765-D

177 LC-USF34-038797-D

181 LC-USW3-056245-E

182 LC-USF34-053418-D

183 LC-USF34-062306-D

184 LC-USF33-002676-M1

185 LC-USF33-006009-M1

186 LC-USF34-012735-D

LC-USF34-012709-D

187 LC-USF34-062340-D

188 LC-USF34-040410-D

189 LC-USF34-040211-D

190 LC-USF33-006370-M5

LC-USF33-006372-M4

LC-USF33-006373-M2

191 LC-USF33-006371-M3

192 LC-USF33-006363-M4

193 LC-USF33-006362-M5

194 LC-USF33-000800-M3

195 LC-USF34-043272-E

LC-USF33-020714-M3

LC-USF33-020714-M1

196 LC-USF33-021166-M4

LC-USF34-045947-D

LC-USF33-021184-M3

197 LC-USF33-021186-M2

198 LC-USF34-045807-D

199 LC-USF33-010028-M1

200 LC-USF34-042773-D

201 LC-USF34-045354-D

202 LC-USF34-083331-C

203 LC-USF34-012772-E

204 LC-USF34-012752-E

Index

RICH REMSBERG is an Emmy Award–winning image researcher and a documentary photographer. His credits include *Woody Guthrie: Ain't Got No Home* and *Johnny Cash at Folsom Prison,* as well as other PBS programs and independent films. As a photographer, his work has appeared in the *New York Times* and *Newsweek.com,* and he is the author of *Riders For God: The Story of a Christian Motorcycle Gang.* He lives in North Adams, Massachusetts.

NICHOLAS DAWIDOFF is the author of four books, including *In the Country of Country: People and Places in American Music.* He has been a Guggenheim, Civitella Ranieri, and Berlin Prize Fellow, and a finalist for the Pulitzer Prize. He is a contributing writer at the *New York Times Magazine* and has written for the *New Yorker* and the *American Scholar.* He teaches at Sarah Lawrence College and Princeton University.

HENRY SAPOZNIK is an award-winning author, radio and record producer, and performer of traditional Yiddish and American music. He has produced NPR's Peabody Award–winning *Yiddish Radio Project* and the Grammy-nominated box sets *Charlie Poole and the Roots of Country Music, People Take Warning! Murder and Disaster Songs,* and *Ernest V. Stoneman: The Unsung Father of Country Music.*

Music in American Life